Contemporary American Realism since 1960

nevada
museum
of art

Donald W. Reynolds
Center for the Visual Arts
E. L. Wiegand Gallery
160 West Liberty Street
Reno, NV 89501

gift of JOEL BARISH

Contemporary American Realism since 1960

Frank H. Goodyear, Jr.

New York Graphic Society, Boston
in association with the
Pennsylvania Academy of the Fine Arts

For my mother and father

This book was published in connection with the
exhibition opening at the Pennsylvania Academy of
the Fine Arts, Philadelphia, September 18, 1981.

New York Graphic Society books are published by Little,
Brown and Company. Published in Canada by Little, Brown
and Company (Canada) Limited.

First edition

Printed in the United States of America

Library of Congress Cataloging in Publication Data

Goodyear, Frank Henry, 1944–
 Contemporary American realism since 1960.

 "Published in connection with the exhibition opening at
the Pennsylvania Academy of the Fine Arts, Philadelphia,
September 18, 1981"—T.p. verso.
 Bibliography: p.
 Includes index.
 1. Photo realism—United States. 2. Realism in art—United
States. 3. Art, Modern—20th century—United States. I. Penn-
sylvania Academy of the Fine Arts. II. Title.

N6512.5.P45G6 709'.73 81-11012
ISBN 0-8212-1126-9 AACR2

Acknowledgments

This book could not have been written without the generous, enthusiastic assistance of many colleagues who have lent me every kind of support imaginable. I am indebted and grateful to each of them. Their contributions are everywhere in this book.

From the project's inception, I recognized two obvious points: the difficulty of adequately defining what initially seemed like an amorphous, if not indefinable, subject; and the need to make direct contact with as many as possible of the artists who make realistic work. My goal has been to deal with contemporary American realism inclusively, but without making its definition so broad as to be meaningless. Given the dearth of published material on the subject, the numerous conversations with many of the artists have been the most important factor in realizing such a definition. Their contributions to this book are inestimable. I interviewed the following artists: Lennart Anderson, Milet Andrejevic, Jack Beal, Robert Bechtle, Bill Beckman, Chuck Close, Robert Cottingham, John DeAndrea, Rackstraw Downes, Martha Mayer Erlebacher, Walter Erlebacher, Janet Fish, Paul Georges, Sidney Goodman, Theophil Groell, Duane Hanson, Ben Kamihira, Gabriel Laderman, Alfred Leslie, Richard McLean, Richard McDermott Miller, Alice Neel, Edith Neff, Philip Pearlstein, Stephen Posen, Joseph Raffael, George Segal, Susan Shatter, and Neil Welliver. My sincerest hope is that in a meaningful way this book will reveal the major, often unrecognized, talents of these and other realist artists in America.

I am particularly grateful to the following persons and staffs who extended themselves beyond normal expectations to assist this project: Allan Frumkin, Jean Frumkin, Patrick Montgomery, George Adams, and John Deckert of the Allan Frumkin Gallery; Ivan Karp, Carlo Lamagna, and Carol Ann Klonarides of the O. K. Harris Gallery; Nancy Hoffman and Charlene Green of the Nancy Hoffman Gallery; Prescott D. Schutz of Hirschl & Adler Galleries; Louis K. Meisel and Evelyn Ellwood of the Louis K. Meisel Gallery; Robert Miller and John Cheim of the Robert Miller Gallery; Jane and Bob Schoelkopf and Barbara Tipping of the Robert Schoelkopf Gallery; Peter Tatistcheff of Tatistcheff and Company, Inc. I am also thankful to Brooke Alexander of Brooke Alexander, Inc.; Gretchen Weiss of the John Berggruen Gallery; Terry Dintenfass of the Terry Dintenfass Gallery; Barbara Fendrick of the Fendrick Gallery; Aladar Marberger and Lawrence DiCarlo of the Fischbach Gallery; Bella Fishko of the Forum Gallery; Jill Kornblee and Annabel Bartlett of the Kornblee Gallery; Marian Locks of the Marian Locks Gallery; Douglas Walla of the Marlborough Gallery; Linda Stone of the Sunne Savage Gallery; Allan Stone and Joan Wolf of the Allan Stone Gallery; and David K. S. Kermani of Tibor de Nagy Gallery.

The following museum colleagues, scholars, critics, and friends have supported this project in numerous ways: Stephanie Barron, Los Angeles County Museum of Art; Carl Belz, Rose Art Museum; Josine Ianco-Starrels, Los Angeles Municipal Art Galleries; R. Peter Mooz, the Virginia Museum of Fine Arts; George Neubert and Terry St. John, The Oakland Museum. Barbara Sevy, Carol Homan, and the staff of the library of the Philadelphia Museum of Art have been unfailingly generous in their assistance and good cheer. Cynthia Close of the Boston Visual Arts Union, Lawrence Campbell, critic, and Thomas Albright, critic for the *San Francisco Chronicle*, shared valuable information with me. Ann Friedman, Christine Huber, and Robert Ewing helped in gathering information on realist artists in southern California, the South, and the Midwest respectively.

I would like to acknowledge the value of Linda Nochlin's many brilliant writings on realism to my own understanding of the subject. Robert Venturi's

Complexity and Contradiction in Architecture—although it deals with contemporary architecture—has also been extremely meaningful through its description of an aesthetic posture that has significant implications for contemporary American realism. Ironically, Venturi's "Gentle Manifesto" on his ambitions for a new mode of inclusive modern architecture is, to date, the piece of writing most relevant to contemporary realist painting and to the relationship of the architect, painter, or sculptor to the past, one of the most crucial issues for the contemporary realist.

The best collections of contemporary American realism have been formed by private collectors, not museums. The following collectors have always been extremely generous in making their collections available to me: Jalane and Richard Davidson, William Jaeger, Frances and Sydney Lewis, Elaine and Julius Litvak, Mr. and Mrs. Hubert Neumann, Mr. and Mrs. Edmund P. Pillsbury, Herbert W. Plimpton, and Richard L. Weisman.

In order to write this book, the trustees of the Pennsylvania Academy of the Fine Arts granted me a six-month sabbatical from the position of Curator. I am grateful to each of them, particularly to Henry S. McNeil, President, for allowing me this uninterrupted time away from the Academy. I would also like to acknowledge the support of Charles E. Mather, III, Chairman, Collections and Exhibitions Committee, and the other committee members, and of Charles Kenkelen and Herbert S. Riband. I am equally grateful to Bonnie Wintersteen, Mary Mather, Ted Newbold, and Jenny and Dan Dietrich, who have lent me every kind of support in pursuit of this project.

My fond memories of the late Charles F. Montgomery and his own example as an indefatigable scholar of American art continue to sustain me. Betty Childs, Senior Editor, and the staff of the New York Graphic Society have shown me every confidence and courtesy in bringing this project to realization. I am extremely grateful to them for all of their support.

Finally, a very large measure of thanks is due to persons who lived with this project on a daily basis for almost two years—the Academy's staff and my own family. I am grateful to Richard Boyle, Director, Pennsylvania Academy of the Fine Arts, for his genuine enthusiasm for this project, and to Elaine Breslow, Marcela de Keyser, Kathy Foster, and Susan Rappaport, who helped in countless important ways. My assistant, Betty Romanella, who helped in the preparation of the bibliography as well as working as the photo editor, aided me in every conceivable manner. My wife, Betsy, and our three children somehow managed to put up with me during the darkest moments and were unfailing in their understanding of my needs. All of these persons have my heartfelt thanks.

Frank H. Goodyear, Jr.
Philadelphia, Pennsylvania
June 25, 1980

Contents

Is there a "new" realism? This is invariably the first question to arise in any discussion of certain kinds of representational art being made in America today. On the one hand, there has been difficulty and disagreement in recognizing the parameters of this art, and on the other, there is an almost total lack of agreement, among critics and realist artists alike, on whether this art itself is new. Take, for example, the dissimilar reactions of three realist painters to the question. Neil Welliver, in affirming the newness of today's brand of realism, has written:

> These new pictures did not represent a minor shift in what was called the "mainstream" of American painting; but rather they stand for a complete reassessment of the direction in which things were moving — a reassessment not only in the intellectual, questioning sense but, more importantly, as an active part of the process of painting. . . . some thought this was a nineteenth century revival and that a new academy would form overnight. This was the most perfect nonsense of all.[1]

Stephen Posen, to the contrary, doubts the existence of a "new" realism, saying:

> I'm not sure that there is such a thing as New Realism. I think there are probably a lot of people who are working with imagery seen through photography and who are using a kind of precision with that imagery that hasn't been seen before. Because there is such a variety of sensibilities within that group, it is really hard to pin down any cohesive factor other than the use of the camera.[2]

Ralph Goings is still more ambivalent:

> I don't know. There are a lot of painters painting in a realistic manner. But I'm not too sure what a movement is to begin with. I think part of the answer would be yes and no.[3]

There does seem to be some agreement, however, on a number of issues related to contemporary American realism. Artists and critics alike have noted its pluralistic nature. Most have had difficulty in disassociating contemporary realism from earlier expressions of realism. And many, if not all, of the artists generally designated as realists are wary of the realist label. But in general there seems to be as much disagreement over the nature of contemporary American realism as there is over its "newness."

Some see it as an obvious extension of modernism; others see it as a reaction to modernism, as an anti-Cézanne imperative. Some see it as a revival, rooted in the traditions of the past, and call it academic; others consider it avant-garde. Some prefer to think of its relationship to the real world as phenomenological, while others diminish the importance of natural phenomena, avowing that contemporary realism's importance lies in the idea of translation—for instance, in translating photographic information into painting information. Some "stylistics" define contemporary realism in terms of a homogeneous paint surface or a shared attitude to the rendering of form and space or to subject matter. Some affirm the value of narration, while others see formal issues as the most important. Some want realism to be inclusive, others, exclusive.

What are some of the most important ideas shared (granted there are some) by contemporary American realists working during the past twenty years? The most important, at the root of realism's pluralism, is the realization that contemporary realism is not an art movement per se and thus shared ideas may be few. In other words, realism does not impose a dialectical imperative on artists who choose to paint realistically, a circumstance that goes a long way in explaining the heterogeneous look of the work. Rather, as Hilton Kramer has commented, "It leaves the individual artist free to renegotiate the relation of the pictorial to the observable in his own way, and thus free to choose whatever pictorial precedents he deems suitable to his individual vision."[4] What does bind contemporary realists is a basic concern with visual perception.

Philip Pearlstein remarks, "All I'm trying to do is see things as they are at a particular moment";[5] Joseph Raffael says, "Nothing is as it seems";[6] Chuck Close talks about "photographic information"[7] and employs a grid system to codify that information; Alfred Leslie says, "specificity is the essence of all great portraiture";[8] Don Eddy says that his process is involved with "the intensive translation of small amounts of information."[9] Each of these statements has different implications, but however diverse they are in their artistic intentions, each artist is asserting the importance of visual perception as fundamental to his work. Each of them — whether out of a phenomenological position or a position that values visual information ultimately used for the expression of formal concerns — stresses visual information. The best contemporary American realists give the viewer a lot to look at.

In recent years, historians, critics, and artists have begun to comment upon the demise of the avant-garde. As early as 1959, Alex Katz's response to the question "Is there a new Academy?" (that is, an academy of the avant-garde) implied that the avant-garde was undergoing serious challenges: "The look of conventional bad paintings has changed. Many resemble the more traditional of advanced New York paintings. This has created a reaction against their ideas in general."[10] Hilton Kramer wrote in 1977 that the "very notion of an avant-garde is now suspect, if only because the term seems to belong more to the realm of commerce than to esthetics, and young artists are no longer shy about openly defying the once-sacred injunctions of modernist theory."[11] Rackstraw Downes, also writing in 1977, perceived that all avant-garde periods, not only the recent one, which he found lacking in vitality, come to an end "whenever art begins to feel boxed in, its forms and canons hardened, its criticism regulatory,"[12] a situation indicated, he noted, particularly by the criticism of Clement Greenberg. The parallel demise of the avant-garde in architecture was epitomized in architect Robert Venturi's quip on stripped-down, self-consciously modern architecture: "Less is a bore."

At the same time that the avant-garde was coming under attack, a new artistic sensibility, at once reactionary and progressive, began to manifest itself in America. This sensibility was evident not only in painting and sculpture, but in other disciplines — architecture, photography, literature, and music. In these disciplines one has increasingly come to expect an openness — what one might even call a public-spiritedness — an inclusive rather than exclusive posture in the making and function of art. The result has been a broadening of artistic dimensions. Some of the best American artists in the past twenty years have led the way. Educated, rigorous, responsible, democratic, complex, challenging, the new contemporary American realism signifies a cultural sophistication of no small consequence.

Chapter One

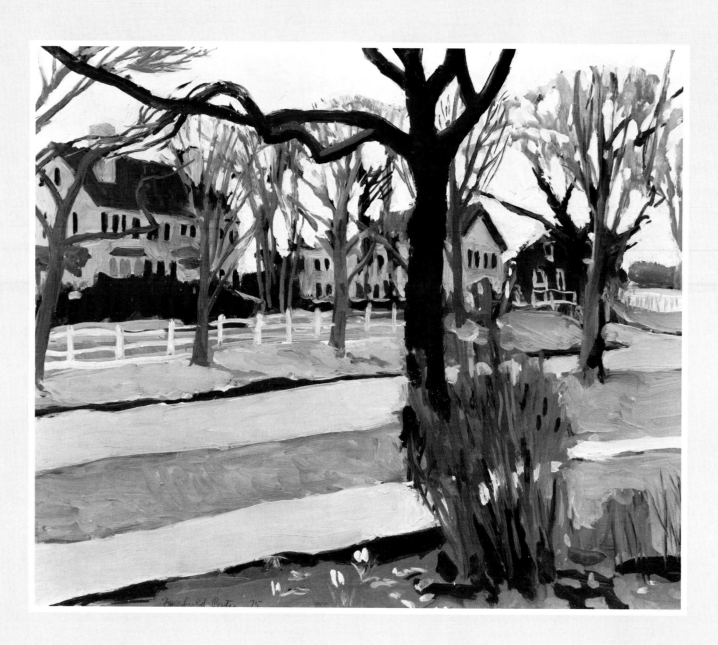

Fig. 1 Fairfield Porter. *April Overcast*, 1975. Oil on board,
18 x 22 inches. The Parrish Art Museum, Southampton,
gift of the Estate of Fairfield Porter

Contemporary American Realism
A Contemporary Definition

Realism was the prevalent style of American painting until the early years of the twentieth century, when its primacy was supplanted by an imported European modernism. When John Singleton Copley scrutinized the features of Mrs. Ezekiel Goldthwait to make an incisive likeness, when Frederic Church set out in search of Arctic icebergs or South American volcanoes to paint, when Thomas Eakins strapped his friend J. Laurie Wallace to a wooden cross set up on the roof outside his studio to serve as the model for *The Crucifixion* (1880), each of them was acting out the realist mentality — gathering and recording data with an uncompromising concern for their integrity. An Eakins brand of realism, relentlessly empirical and reflective of modern life, and an academic counterpoint to it, typified by artists like Kenyon Cox, steeped in idealism and nurtured by the past, became realism's legacy to the twentieth century.

Despite the vitality of these realist traditions in the late nineteenth century, the realist persuasion soon lost its following in the early years of the twentieth century. The realist style of painting and sculpting was generally rejected by young American artists, who were won over by the freedom and energy implicit in the new modernism. Such artists as Robert Henri, who not so long before had been considered radical, gradually became anachronisms after the Armory Show of 1913 as successive expressions of abstract, avant-garde art were introduced in America. American artists were quick to value the principles of artistic freedom, spontaneity, and personal expressiveness that defined the avant-garde. They wrote off realism, entrenched in nineteenth-century ideas, as too conservative, old-fashioned, and just plain dull. Unfortunately, realism has suffered from this perception ever since.

Modernist aesthetics dominated American art in the early twentieth century; nonetheless, diehard realists repeatedly attempted to revive realism's lost stature. The first attempt of any consequence, which took place during the Depression years in the 1930s, was totally reactionary. Known today as American Scene painting, the movement consciously sought to downgrade the importance of abstract art, which was branded "un-American," through the reassertion of genuine American themes that stressed the imperatives of place, social customs, and regional history in art. It was intended as a democratic art, easily accessible to ordinary Americans rather than as an art for a cultural elite. The paintings produced in the 1930s, both in the Regionalist and Social Realist veins, were timely and relevant, and even though painting of this kind was largely snubbed in the advanced artistic circles of New York, it was generally well received by the public. Today the stylistic influence of American Scene painting on contemporary American realists is insignificant, although its narrative voice finds expression, for example, in the art of Jack Beal.

In addition to American Scene painters, there were considerable numbers of realists who worked independently of movements, as well as semi-realists, artists of diverse sensibilities without a common aesthetic, who kept the option of realist painting alive in America during the dominant years of abstraction. The best of these artists — Milton Avery, Charles Burchfield, Guy Pène DuBois, Yasuo Kuniyoshi, Jacob Lawrence, Isabel Bishop, Robert Gwathmey, Edwin Dickinson, Kenneth Hayes Miller — were highly individualistic, antidoctrinaire, and eclectic. Of all the independents, only Edward Hopper was solidly — and brilliantly — camped on the realist side.

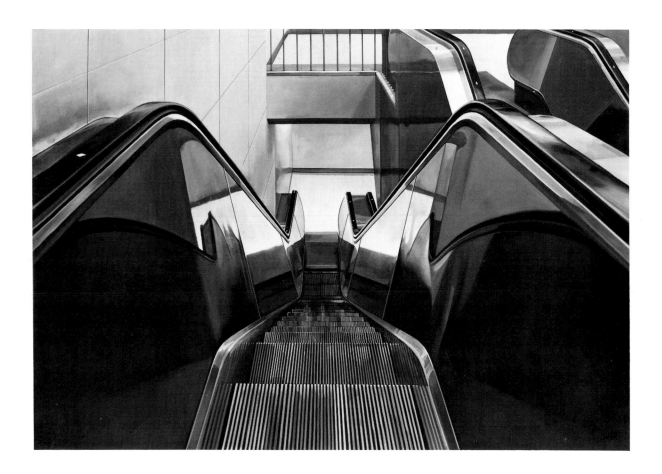

Fig. 2 Richard Estes. *Escalator*, 1970. Oil on canvas, 42½ x 62 inches. Private collection

In contrast to those brands of realism that arose in opposition to modernism or remained independent of it, a semirealistic style now known as Precisionism developed in the 1930s within the American modernist movement itself. It was a style predicated upon the precise rendering of forms, particularly of industrial objects, in a time and space that remained essentially nonparticularized. Precisionism was an intellectualized mode of painting dominated by the studio, idealized and technical (in that the camera served as a prime method of subject research), in which the medium was subordinated. Charles Sheeler, Ralston Crawford, Preston Dickinson, Niles Spencer, and Charles Demuth were Precisionism's major figures, with Sheeler the most consistent advocate. The work of Sheeler, for one, affords interesting parallels to the work of certain realist artists today. Richard Estes's *Escalator* (fig. 2), for instance, bears a remarkable compositional parallel to a small drawing by Sheeler entitled *Stairway to Studio* (fig. 3). Also, Sheeler's drawing *Rocks at Steichen's* (fig. 4) foreshadows Philip Pearlstein's southwest landscapes—for instance, *White House Ruin, Canyon de Chelly — Morning* (fig. 5). Estes and Pearlstein share with Sheeler a sort of clinical attitude toward objects—the medium is subordinated, the distinction between surfaces of different sorts of objects is minimal. Estes and Sheeler paint a cleaned-up, deodorized reality that one often encounters in photo-realism. Pearlstein and Sheeler also share (as does Precisionism with contemporary realism) an ambivalence over the questions of volume versus two-dimensional form and description versus generalization. In the end, however, Sheeler's solutions are predicated on Cubist aesthetics, Estes's and Pearlstein's on recent modern painting.

Although realist alternatives existed in pre–World War II American painting, one can safely conclude that none of the early manifestations of realism, with the exception of Sheeler's personal brand of Precisionism, has had a significant influence on the new American realism.

It is also accurate to say that in the decades of the 1940s and 1950s realism reached its nadir in American art. It had very few young exponents; its older practitioners carried on in the earlier,

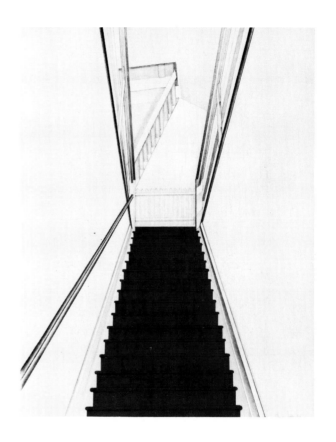

Fig. 3 Charles Sheeler. *Stairway to Studio*, 1924. Tempera, conté crayon, and pencil, 25½ x 20 inches. Private collection

16 conservative traditions of their training. Those who painted realistically were outcasts from the mainstream; to do so was to ask for anonymity and the label "academic." Realism had neither a direction nor an aesthetic; it was a polyglot survival without a sense of its own destiny.

There were, however, a number of major museum exhibitions in New York City during the forties and fifties that dealt specifically with realist painting and sculpture or included it among nonrealist exhibitions of contemporary American art. In 1943, Dorothy Miller and Alfred Barr, Jr., with the help of Lincoln Kirstein, organized an exhibition at the Museum of Modern Art entitled *American Realists and Magic Realists,* the purpose of which was to demonstrate what was then described as a "widespread but not yet generally recognized trend [realism] in contemporary American art."[1] Recognizing then as now the pluralistic nature of realism, the exhibition, which was prefaced by a selection of earlier American paintings, was limited in the main to "pictures of *sharp focus* and *precise representation,* whether the subject has been observed in the outer world—*realism*—or contrived by the imagination—*magic realism.*"[2] It was noted

that among the younger artists included (artists like Peter Blume, Paul Cadmus, Clarence Carter, Ben Shahn, and Andrew Wyeth, who have almost no common aesthetic ground), there seemed to be a new urgency in rendering the completely achieved visual fact—what Lincoln Kirstein described as the "New Objectivity."[3] The organizers of the exhibition were bold in their predictions that this so-called new trend in American realist painting would become increasingly relevant in the immediate years ahead, a prediction that proved egregiously inaccurate.

American Realists and Magic Realists, despite its limited scope, was one of the few exhibitions at the time that attempted to perceive realism within an ideological framework. Other museum exhibitions, such as the series of juried exhibitions of contemporary American painting, sculpture, watercolors, and prints held at the Metropolitan Museum of Art in New York between 1950 and 1953, or the annual exhibitions at the Whitney Museum of American Art, the Pennsylvania Academy of the Fine Arts, and the Corcoran Gallery of Art in the 1950s, all of which included significant numbers of realistic works, made little or no attempt to understand

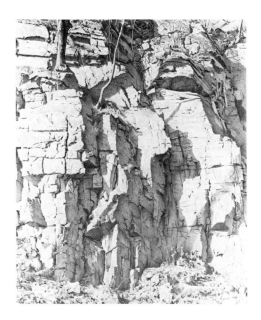

Fig. 4 Charles Sheeler. *Rocks at Steichen's,* 1937. Conté crayon on off-white wove paper, 16 x 13¾ inches. The Baltimore Museum of Art

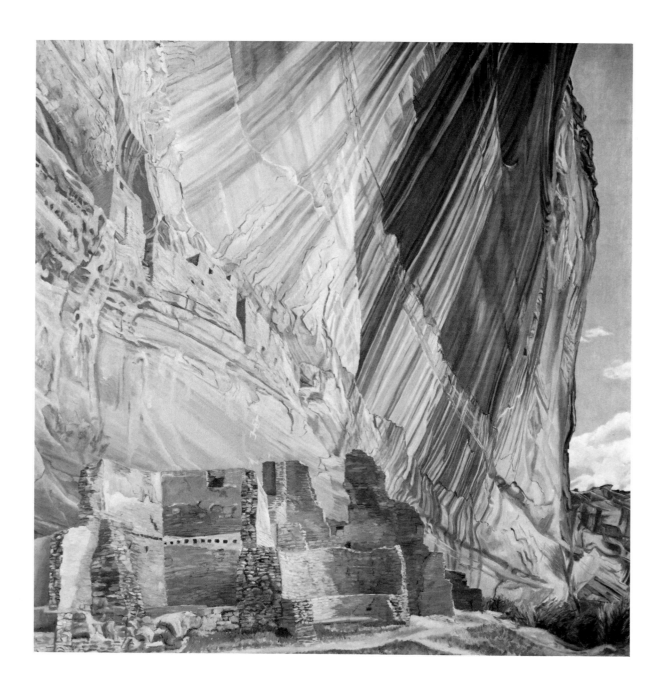

Fig. 5 Philip Pearlstein. *White House Ruin, Canyon de Chelly
 — Morning,* 1975. Oil on canvas, 5 x 5 feet. Collection
 of Graham Gund

realism in any other sense than that of the ongoing, conservative traditions of their own institutions. In such environments, realism semed more entrenched than it actually was.

During the early 1950s a number of artists' groups sprang up to defend the positions of realism against the notion that it was secondhand, second-rate art. In California, the Society for Sanity in Art, later known as the Society of Western Artists, was formed in the early 1950s "to fight for a fair deal for representational art."[4] In New York City, a number of artists joined together in a nameless group to discuss the problems they faced in the relationship of their work to nonobjective art. In a group statement they noted that their members' work was "highly diverse in style and conception," but their "kinship is a respect and love for the human qualities in painting."[5] In the first of three annual issues of this group's journal, *Reality: A Journal of Artists' Opinions,* published from 1953 to 1955, forty-seven artists, among them Milton Avery, Isabel Bishop, Aaron Bohrod, Charles Burchfield, Guy Pène DuBois, Philip Evergood, Robert Gwathmey, Edward Hopper, Yasuo Kuniyoshi, Jacob Lawrence, Reginald Marsh, Henry Varnum Poor, Moses and Raphael Soyer, signed their names to a statement of their artistic beliefs. It read in part:

> All of art is an expression of human experience. All the possibilities of art must be explored to broaden this expression. We nevertheless believe that texture and accident, like color and design, and all other elements of painting, are only the means to a larger end, which is the depiction of man and his world.[6]

In an additional statement, Edward Hopper summarized his own sentiments: "Painting will have to deal more fully and less obliquely with life and nature's phenomena before it can again become great."[7]

The three slight volumes of *Reality* not only expressed the feelings of the artists behind the publication (which was careful to point out that the group included artists working in a nonrealist vein as well), but also contained numerous letters of encouragement, criticism, and articles on humanistic art, as well as open attacks on what was called "the dehumanizing, neurotic, fear-inspired, standardized aspect of the abstract movement in art, particularly American non-objective art."[8] The members of the group were also highly critical of what they considered the policy of the Museum of Modern Art in exhibiting nonobjective art almost exclusively, and they called upon the museum to broaden its exhibition policy.

In spite of its short life, *Reality* did not go unnoticed. Both the editors of *Art Digest* and *Art News,* who took the journal's attack on nonobjective art personally, answered its criticism with even harsher words. The editor of *Art Digest* referred to *Reality*'s language of reaction as sinister and accused the artists behind it of being insecure, unimportant, and iconoclastic. The war between the nonobjective and objective camps was at a fevered pitch.

During this time, there were very few young artists joining the realist camp; the environment of even some of the more conservative art schools did not encourage objective work. Certainly during the 1950s there were abstract artists—Willem de Kooning, for example—who incorporated imagery into work that remained essentially abstract.[9] Unlike some, if not most, of his fellow modernists, who chose to work within a narrow ideological range, de Kooning did not allow his position as a modernist to isolate and restrict him. He denied, for instance, the notion that an artist was obliged to work in accordance with a logical historical development, always maintaining an open-mindedness to art of the past. He said that the modernist tenet of refusing to paint the figure was as absurd as insisting on painting it. He decried the whole notion of style in art and pledged himself to nature.

De Kooning's example served as one significant step on the conceptual road back to realism. He showed younger artists that not only were there reasonable possibilities other than nonobjective art, but that there were artists who dared to meet the challenges of being an objective painter. These younger people included initially Fairfield Porter, Larry Rivers, Jane Freilicher, and Nell Blaine, as well as an important group centered in California—David Park, Richard Diebenkorn, Elmer Bischoff, and Nathan Oliveira. Clearly, de Kooning's nonideological stance served as a major impetus to a number of artists, who began introducing meaningful imagery into their work. His openness to the idea that abstraction and figuration were not mutually exclusive experiences made it easier for artists like these to combine figuration and sensuous paint surfaces. His realist disciples (if one can call them that) were gestural

or painterly realists; consequently, in the early critical history of contemporary American realism they were "acceptable" realists — if they were considered realists at all — because the surfaces of their canvases, like those of action painters, were sensuous, immediate, and expressive, and conveyed the impression of directness and honesty.

The realist alternative to nonobjective painting must have come to seem more reasonable in the late 1950s and early 1960s; it was during this time that many of today's best-known realists — Alex Katz, Alfred Leslie, Robert Bechtle, Rackstraw Downes, Philip Pearlstein, George Segal, and Janet Fish, all of whom had worked as Abstract Expressionists up until then — began their careers as we know them today. Other, slightly younger artists, like Richard Estes and William Beckman, began working figuratively as students in the early 1960s. During these years also, some critical attention began to focus on this new manner of painting. It generally received favorable commentary from Lawrence Campbell and Fairfield Porter; in 1962 Fairfield Porter even went so far as to predict a renaissance in realist art in America. He defiantly challenged Clement Greenberg for denying the validity of a modern illusionistic art, arguing that to say that "you cannot paint the figure today is like an architectural critic saying that you must not use ornament."[10]

In the early 1960s the resurgence of realist painting coincided with the appearance of Pop Art, resulting in a confusion that temporarily caused the two to be seen as synonymous. It is not surprising, given the perspective of the 1960s, that Pop Art was then labeled the "new realism." Today the link has only historical interest, since it has become apparent that the realist component in Pop Art was greatly exaggerated.

The association of Pop Art and realism — a confusion resulting from the "real" images of Pop Art following closely upon a lengthy period of abstraction — was perpetuated by a number of museum and gallery exhibitions. In 1962 the Sidney Janis Gallery in New York presented an exhibition entitled the *New Realists,* with work by a diverse group of Pop artists (among others, Claes Oldenburg, Jim Dine, Oyvind Fahlstrom, Roy Lichtenstein, George Segal, Peter Blake, James Rosenquist, Christo, Wayne Thiebaud, Andy Warhol, Tom Wesselman, and

Robert Indiana). Three years later the Worcester Art Museum exhibited the work of a similar group under the title *The New American Realism.* The organizers of both exhibitions rejected the term "Pop artists" in favor of "realists," and both attempted to establish meaningful links between the new realism and the old realist style, as well as to define what was new about it. While John Ashbery, in his essay for the catalogue of the Janis exhibition, did distinguish some new aspects in this brand of realism — namely, the banal, prefabricated subject matter and the ambiguity with which it was treated — he concluded that the work had important ties to earlier expressions of realism. Referring to it as "another form of realism," he interpreted what he saw as art "at an advanced stage of the struggle to determine the real nature of reality which began at the time of Flaubert."[11] Ashbery saw the new realism as an art made possible by the Dadaists (whom he called the "heirs" of Flaubert!), notably by the ready-mades of Marcel Duchamp, and invoked the associations of nineteenth-century French realism, regardless of the fact that his new realism shared nothing with these traditions. Ashbery's views still have some currency. In some critical circles realism is still thought of as a nineteenth-century phenomenon, and that tradition (even though it is seen as one of the reasons for the degeneracy of realism) is both the validation for any new styles of realism and the aesthetic standard against which these styles are measured.

Since the early, and seemingly inevitable, association of Pop Art with realism, confusion about the definitions and parameters of contemporary realism has grown. For one thing, the traditional terms used to describe works of art that are not nonrealist have been loosely applied; realism, representationalism, naturalism, Social Realism, factualism, Magic Realism, even objectivism, are words that have distinct meanings, but their definitions have been blurred by casual usage. In addition, the descriptive language of contemporary realism has become ridiculously confusing; contemporary American realism has been called new realism, hard-edge realism, photo-realism, new/photo-realism, super realism, radical realism, neo-realism, neo-academic realism, thing-in-itself realism, unconventional realism, painterly realism, gestural realism, formalist realism, laconic literalism, organic realism, allegorical real-

ism, the new inhumanism, and even the orphan of modernism!

Exhibitions have further confounded the general understanding. The content of exhibitions devoted to contemporary realism in the past decade has seemed to express personal biases, particularly a narrow modernist bias that found only certain kinds of realism acceptable. The exhibitions did not offer any clear conceptualization of the broad pluralistic nature of contemporary realism, for while it is true that realism is not a coherent movement, one can discern common concerns. At the extreme, one of these exhibitions, *The Art of the REAL USA 1948–1968,* held at the Museum of Modern Art in 1968, had nothing to do with realism as a pictorial strategy, despite its title. It included the work of modern abstractionists like Carl André, Donald Judd, Ellsworth Kelly, Morris Louis, Barnett Newman, Jackson Pollock, and Mark Rothko, artists whose aim, according to E. C. Goossen in the catalogue, "was not to *represent* something, but to *make* something, something which had never existed in the world before."[12] These artists were not interested in whether their works referred to an illusion of fact; rather, they were interested in the fact itself. Other "realist" exhibitions were not sharply focused. In the documenta 5 *Realismus* exhibition in Kassel, Germany, in 1972, the majority of Americans included (Chuck Close, Richard Estes, Richard McLean, Ralph Goings, and Stephen Posen) were closely identified with photo-realism, but the exhibition also, rather inexplicably, included work by Jasper Johns, Neil Jenney, and Wayne Thiebaud. Even the three most important early exhibitions of contemporary realism in America — *Realism Now* (Vassar College Art Gallery, 1968), *Aspects of a New Realism* (Milwaukee Art Center, 1969), and *22 Realists* (Whitney Museum of American Art, 1970)[13] — exhibitions whose intentions seemed at the time to be definitional — had very little in common. Varying in size, each included a curious mixture of realist artists: some young, some old; some who worked in a traditional manner using traditional subject matter; some who worked in a post-Pop way from photographs; some who were gesturalists; and some independents whose inclusion seemed more than anything to reflect a personal interest of the exhibition's organizer. Of the forty-two artists in these shows, only Jack Beal, Robert Bechtle, Richard Estes, Gabriel Laderman, Alfred

Leslie, Malcolm Morley, Philip Pearlstein, and Sidney Tillim were in all three.[14] This ambiguous perception of contemporary realism lingers today even among realist artists. The 1979 exhibition *Figurative/Realist Art,* organized by a group of prominent realist artists for the benefit of the Artists' Choice Museum, a realist alternative museum in New York City, did nothing to define the subject of contemporary realism. While the exhibition included many of America's best realist artists, it entirely excluded photo-realist work, at the same time that it included work by Willem de Kooning, Aristodemos Kaldis, and Leland Bell![15]

It was not until the late 1960s and increasingly through the 1970s that realism became a viable alternative for the contemporary American artist, and that alternative has continued to gather momentum. In addition to a variety of realism exhibitions in recent years in America, in Canada, and in Europe, one-person museum exhibitions have been devoted to many of the best realists. Yet, despite the recent level of activity and support, a surprising number of the leading realist artists still feel estranged from the art establishment, particularly in New York City. The Figurative Alliance, an artists' club formed in the late 1960s in New York as a place for figurative artists to meet and discuss their work; the Artists' Choice group, with exhibitions in 1976, 1979, and 1980; and the developing plans for the establishment of the Artists' Choice Museum represent realist alternatives in New York City. The founding of such a museum, by artists "who wish to encourage people to make and look at Art which deals with life,"[16] is a direct response to the estrangement most realist artists feel and reflects their desire to give the public an opportunity to see a great deal of contemporary art that, in their opinion, it has been cut off from.

Realism and the Avant-Garde

American painting has almost always been defined by divergent needs and diametrically opposing attitudes. Such a condition prevailed in nineteenth-century America, in the careers of Washington Allston, Albert Pinkham Ryder, and Thomas Eakins, for instance, but perhaps nowhere more tellingly than in the frustrated ambitions of the landscapist Thomas Cole. Cole's dilemma, and the dilemma of others like him, were embodied in the popular ideological conflict between the "real" and the "ideal,"

a conflict that largely defined mid–nineteenth-century landscape painting in America.[17] Other conflicts defined (and continue to define) the seemingly inherent tendency to polarity that has persisted in American art.

The increasing polarity of the positions that American painters have occupied in the twentieth century is the result of the growing tensions throughout this period between the forces of representational art and abstract art. Since the Regionalists' challenge as an alternative to European-style modernism in the 1930s, the representational forces have been aligned against the abstract forces, and artists have increasingly identified with one polar position or the other. But until recently, the abstract forces have dominated. In simple terms, at the height of the achievements of American abstract art in the 1950s and early 1960s, abstract art was synonymous with the avant-garde, and realist art was seen as anti–avant-garde and retarditaire; abstract art was widely held to be inherently superior to realist, which was believed to be hopelessly mired in the sloughs of history. As Linda Nochlin perceived the situation in 1968, realism had been "relegated to the limbo of philistinism."[18] This attitude persists in many circles; as recently as 1979 Hilton Kramer commented on the ongoing prejudices against realism:

> There was Realism, of course, and its allied modes of representationalism in painting, but Realism was precisely what these curators could not bring themselves to countenance. Realism had always stood — in their eyes at least — for the counterrevolution. Realism was what they gave up an interest in when they took their professional vows, and its resurgence in the 70s has been a real nuisance to them — a sign of bad times. They might gingerly accept this or that manifestation at the fringe of the dread phenomenon — especially if, in either form or content, it was sufficiently attached to kitsch, and thus assimilable, even if distantly, to a taste formed on the conventions of Pop Art. But mainstream Realism remained—and remains—an anathema.[19]

That the status of contemporary American realism has been diminished by the role it has had to assume in relationship to the avant-garde is undeniable. Yet even such a vigorous proponent and rationalizer of abstraction as Clement Greenberg has admitted that the issue of style is irrelevant to the question of quality in art:

> Art is a matter strictly of experience, not of principles, and what counts first and last in art is quality; all other things are secondary. No one has yet been able to demonstrate

that the representational as such either adds or takes away from the merit of a picture or statue. The presence or absence of a recognizable image has no more to do with value in painting or sculpture than the presence or absence of a libretto has to do with value in music.[20]

Despite such a liberal statement, Greenberg and his circle have consistently taken an antirealist position, supported by a manufactured critical ideology that denies the validity of painting illusionistically today. He perceives the history of painting as a continuous linear progression not permitted reaction, and in the essay "Modernist Painting" argues that its true direction is toward the expression of qualities which painting shares with no other art form. He articulated these qualities as the flat surface, the shape of the support, and the properties of the medium. Recognition of these qualities is, he considers, essential in the self-identification of painting and would guarantee to painting standards of excellence as well as independence from other arts:

> Realistic, illusionistic art had dissembled the medium, using art to conceal art. Modernism used art to call attention to art. The limitations that constitute the medium of painting — the flat surface, the shape of the support, the properties of the pigment — were treated by the Old Masters as negative factors that could only be acknowledged implicity or indirectly. Modernist painting has come to regard these same limitations as positive factors that are to be acknowledged openly.[21]

For Greenberg and numerous critics like him, modern painting had to be purist, nonpermissive, and revolutionary. It presumed, in the utopian sense, perfection; it was (to borrow a metaphor from Jack Beal) the seventy-five-dollar dinner at a gourmet restaurant that consisted *only* of the "perfect green pea."[22] In other words, it was an "either-or" rather than a "both-and" art. Not surprisingly, with this pervasive ideology at work, realist painting was relegated to the ranks of a revivalistic anachronism. The dilemma of the avant-garde critic today, ironically, has been to rationalize and justify the importance of contemporary American realism in light of this Greenbergian ideology.

Realism: A Contemporary Definition

While contemporary realism has been impugned because of its anachronistic relationship to modernism, it has suffered equally from a theoretical problem of its own—the long-standing debate on what constitutes reality. Is the purpose of the artist to replicate reality? Does replication of its mere

appearance constitute a legitimate artistic goal? Or is there a higher reality where appearances give way to more universal truths? Shouldn't the great artist seek out this higher reality?

Historically, artists and critics have argued that the flaw in realist art has been its lack of selectivity toward nature; in other words, realism has sacrificed a higher reality for a lower one, one exclusively involved in appearances. It has been characterized by its adversaries as being a styleless style, a mirror of reality. Remorseless objectivity and impartiality toward its subject matter, one of realism's strategies, have resulted, the argument goes, in an art overly craft-oriented, and this technical emphasis does not allow for the creation of paintings that can serve as equivalents to higher moral or psychological truths. Without expression of these higher truths, it is argued, realist paintings offer only the image of the real, and that image is cheapened in contemporary life by its proliferation; it is, in the final analysis, too simple and perhaps even irrelevant in a mechanized world that can reproduce reality so easily.

Both the rejection of realist painting on ideological grounds and the long-standing dilemma over the meaning of reality as it pertains to painting raise questions about the general nature of reality.[23] In the first place, why is truth to the materials of painting (the flat canvas and the medium itself) now more important than truth to nature? What makes the universal truth of nature superior to the specific?[24] Why does painting have to be "pure," especially since perception is unavoidably conditioned by time and place? (If it weren't, a Claude Monet could have painted impressionist landscapes in Elizabethan England.) As E. H. Gombrich said, "If art were only, or mainly, an expression of personal vision, there could be no history of art."[25] And is it really possible for an artist to replicate nature's appearance? Isn't an artist, even the most meticulous one, limited by the number of marks he can make on the canvas? Doesn't any realist painting remain both a suggestion and an appeal to the viewer's imagination? The artists' varying responses to questions like these have determined in large part the heterogeneous look of contemporary American realism.

The diversity of recent realist art, or rather, the absence of stylistic homogeneity, was noted by early critics, who sensed from its stirrings in the early 1960s that it lacked any clear direction or "sense of mission, of a job that needs doing today."[26] Others noted its "divided commitment,"[27] particularly among those converted realists who refused to give up the gestural paint surface of their earlier expressionistic experiences even when it was combined with real images. There was also the matter of what was considered the challenge presented to realism by the photograph. Artist-critic Sidney Tillim thought that the extent of realism's ideological disunity was probably not a good thing, although far healthier, he admitted, than painting out of an academy mentality. Tillim saw no pervasive theory or manifesto, no "painted word" at work on the realists; quite rightly, he postulated that the style of realist painters was largely dependent on "where an artist stood in relationship to modernist art when he made his commitment to figuration."[28]

It seems inevitable, given the pluralistic nature of modern life, that there would be a "divided commitment" among contemporary realists, and that certain artists would even reject the appropriateness of the word "realism" in defining their work. After all, even Gustave Courbet, the quintessential nineteenth-century French realist, felt that the title "realist" had been imposed on him in the same way that many realists today feel it has been imposed on them. Besides the threat that such a label presents to an artist's sense of independence, the historical and didactic context of the word realism, it can be argued, imposes temporal ambiguity and moral dicta that may be irrelevant to the scope of contemporary work. Art-historical terms such as baroque, rococo, or neoclassical define style within a fairly distinct period of time. This is not true of the word realism; not only have there always been realists, but realism has always best been defined in nonstylistic terms as the history of the continuing struggle against "schemata" through the investigation of reality. While such a definition allows for many legitimate realisms, it has unfortunately *not* prevented the meaning of the word from taking on narrow, sometimes historical, connotations in the twentieth century.

In a contemporary context, the word realism has special limitations. In the first place, contemporary realism is inevitably interpreted in relation to nineteenth-century realism, which Linda Nochlin

has characterized as a "truthful, objective and im-partial representation of the real world, based on meticulous observation of contemporary life."[29] In this historical context, today's realism is deemed by its critics as being merely a revival, hopelessly nostalgic, even sentimental, lacking the originality of a legitimate modern art movement. It is decried as reactionary at the same time as its relationship to the present is denied. This attitude has prompted some critics, even some realist artists like Gabriel Laderman, to go so far as to deny the possibility of contemporary realism's ever becoming a modern movement.[30] To take such a position is not only to misunderstand contemporary realism's relationship to the past, but also to the present.

A crucial issue in the contemporary realist strategy is the nature of its relationship to the past. Courbet's attitude to tradition serves as a meaningful example; he stated, "All I have tried to do is to derive from a complete knowledge of tradition a reasoned sense of my own independence and individuality."[31] The realist landscape painter Neil Welliver, over one hundred and twenty years later, reiterated Courbet's sentiment when he remarked that contemporary realism's "relationship to the nineteenth century has to do with the need to be inclusive."[32] Welliver has no intention of becoming engaged in conventional revivals (there will be no neo-realism), but at the same time he disdains the exclusionary practices of the modernists and acknowledges the importance of the past to his own work. Rejecting the "history is irrelevant" banner, Welliver, like many of his contemporaries, faces history with an openness that allows it to be a useful element in his work. Many contemporary realists are not scared off by the idea of revisionism (as Rackstraw Downes has said, "The vocabulary of historical method is not limited to continuation; it permits reaction too."[33]); an important group of them live by Robert Venturi's dictum "Less is a bore." Interestingly, it was Venturi, an architect rather than a painter, who first described (in an essay entitled "Nonstraightforward Architecture: A Gentle Manifesto," published in 1966 in *Complexity and Contradiction in Architecture),* the "inclusivist's" position and who has developed it further than have any of the realist painters. Writing about the possibilities for modern architecture, Venturi said:

Architects can no longer afford to be intimidated by the puritanically moral language of orthodox modern architecture. . . . an architecture of complexity and contradiction has a special obligation toward the whole; its truth must be in its totality or its implications of totality. It must embody the difficult unity of inclusion rather than the easy unity of exclusion. More is not less.[34]

The "perfect green pea" is not enough.

The realist's attitude to the past has definite stylistic implications, both in the stridently anti-modernist paintings of Alfred Leslie and Jack Beal, for example, and in works with a less self-conscious relationship to the past. But what effect have the more immediate precedents of modern American painting had on contemporary realism? Has the current generation of American realist artists combined the influences of the past and the present in their work to reshape the definition of realism? If so, what is the "new" realism, and how has it revised our understanding of past realist traditions? Only with the increased activity in recent years has the realist phenomenon begun to reveal itself as a hybrid of attitudes and styles that are at the same time an extension of and an alternative to modernism. Within the hybrid, there are discernible groupings — gestural realists, photo-realists, traditional realists — who share mutual concerns, be it a painterly surface, an illusionism predicated on the camera's two-dimensional vision, or an art based on a phenomenological relationship to nature. But these concerns do not define closed boundaries, nor is there, as I have already stressed, a constraining dogma that defines contemporary realism. So much of twentieth-century art *is* conditioned by ideas that we have come to take dogma for granted, and a certain amount of readapting is necessary to accept the notion of an art not predicated on ideology.

The most essential point that can be made about contemporary American realism may seem simplistic — *there is a "new" realism.* To think otherwise is to totally misunderstand the nature of today's realism. Pluralistic in its attitudes (there is no one "new" realism), it reflects both a revisionist and an avant-garde bias. Contemporary realism cannot be understood in any other sense, encompassing as it does the complexities and contradictions of contemporary life. Therefore it does not constitute a school or movement in the usual sense. Clearly, the amount of disagreement and

24

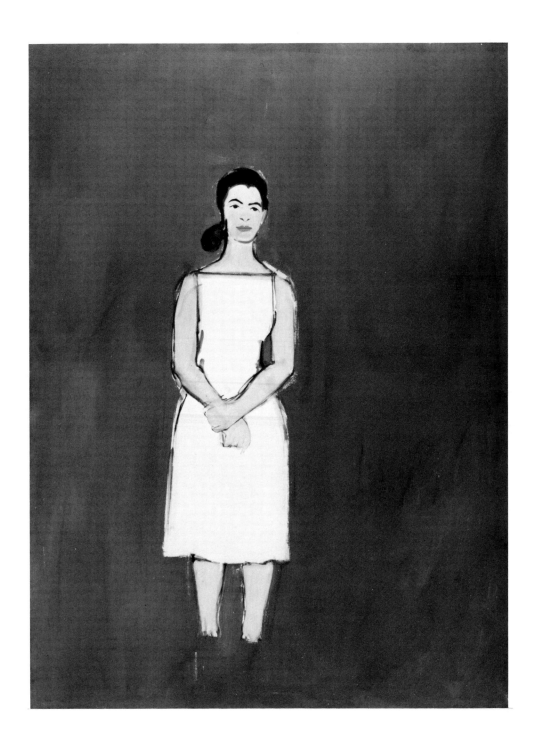

Fig. 6 Alex Katz. *Ada with White Dress*, 1958. Oil on canvas,
60 x 48 inches. Collection of the artist

the fact that so many of the artists involved disapprove theoretically of each other's work militates against any consensus. If there ever was a shared objective (and this would have been most likely during realism's formative years in the 1950s), it was "to enlarge and increase the resources of painting"[35] more than to oppose the forces of abstract art. Alex Katz's work during the decade of the 1950s is indicative of this attitude. Katz, who was a great admirer of Jackson Pollock, was inspired by Pollock to paint spontaneous, all-over abstract works like *Winter Scene* (see fig. 65). As Katz developed, his ambition was to paint modernist figurative pictures, like *Ada with White Dress* (fig. 6), a work that did enlarge upon pictorial possibilities by its use of subject matter within the context of a modernist vocabulary. By the early 1960s Katz had established himself as one of the leading modernist figurative artists, having achieved that position through a gradual enlarging of his own ambitions and the possibilities of modern painting.

Modernism's influence on the "new" realism has been profound, even among the staunchest anti-modern realists, and it is this influence that has helped to form partially the look of contemporary realism. When Malcolm Morley remarked in the mid-1960s that he was "looking for a house in which no one was living,"[36] he was not denying his immediate past, but searching for a new way to express it. This situation was not uncommon to many other emerging realists who were looking for a way of getting away from well-traversed ground without breaking completely with their own past. It is significant that a large number of realists in America today began their careers as abstract painters and many of them still consider themselves abstractionists.

Neil Welliver said of contemporary realism that "its vitality comes from its immediate predecessors,"[37] referring to the fact that many, if not most, realists today are either consciously working within the conventions of modern abstraction or are reluctant or unable to let go of them. The concept of the "divestment" of these conventions as a necessary prelude to the creation of sincere work advocated by Jack Beal has generated little support among other realists, who prefer a more pluralistic, open-minded art.[38] The same qualities by which Green-berg defines modernist art — the assertion of the flatness of the picture plane and of the properties of the pigment used — inform much of the best realist painting being made today. For example, Welliver's *Breached Beaver Dam* (Pl. 1) reveals the flatness of his painted image, though it reads as a landscape, and the assertive fluidity of an all-over paint surface. Typical of other realists with pluralistic concerns, Welliver has stated his pictorial objectives in modernist terms: "to make a natural painting as fluid as a de Kooning."[39]

The assertion of the flatness of the picture plane as an aesthetic issue has been reinforced by realism's interface with photography and reproductive imagery in general. While the camera has been used by artists almost since its invention in the mid–nineteenth century, it has become (along with reproductive images, television, and movies) a pivotal mechanism in the conceiving of realist art, playing a more important role than at any other time in its history. It literally shapes the way many realist artists view not only their art but the world. Artist Tom Blackwell has said: "Today, photographic images, movies, TV, magazines, etc. are as important a part of our reality as actual phenomenon. They strongly affect our perception of actual phenomenon."[40]

No two realist artists use the camera or the photographic image in the same way. Some who use photographs in their work feel uncomfortable taking their own photographs (John Salt says, "I dislike taking the picture. I never know whether I should aim the camera and try to make a composition or whether I should just point it around"[41]). Others not only take their own photographs, but develop the prints with infinite care. Some are not specifically interested in the way the camera transforms reality, but rather in the information it is able to collect. They use photographs as a convenience, instead of making drawings. Generally they take several, or even dozens of, photographs of a subject, combining details from numerous prints to make a final synthesized image. The process — revealed in works like Don Eddy's *Silverware V for S* (fig. 12), a sort of painted photographic pastiche— is rightly described by Eddy as "anti-photographic."[42] Interestingly, those realist artists who aim to record as accurately as possible the specific information contained in a photograph or photo-

Fig. 7 Chuck Close. *Robert I/154*, 1974. Ink and graphite on paper, 30 x 22 inches. Ohio State University Art Gallery

Fig. 8 Chuck Close. *Robert II/616*, 1974. Ink and graphite on paper, 30 x 22 inches. Ohio State University Art Gallery

graphs are consistently surprised by the deep gulf between the real object and their finished painting of it.

Others who work from photographs are interested in comparing the camera's perception to that of the human eye. The exploitation of these perceptual differences, and the process of translating photographic information into painting information, occupies many of the best photo-realist painters. Chuck Close describes this relationship:

> I am trying to make it very clear that I am making paintings from photographs and that this is not the way the human eye sees it. If I stare at this it's sharp, and if I stare at that it's sharp too. The eye is very flexible, but the camera is a one-eye view of the world, and I think we know what a blur looks like only because of photography. It really nailed down blur. It's this elusive thing, and the camera gives you information that was too difficult to deal with otherwise.[43]

Since 1967 all of Close's work has proceeded from photographs; more than any other realist work being made today it is involved in the "visual exploitation of previously neglected seeing possibilities,"[44] particularly in the area of unfocused seeing. Close has explored the phenomenon of focus through serialized works using similar images whose sizes increase at the same time that the visual information in them becomes more detailed. In the series of five drawings of Robert (figs. 7–11), visual information is minimized when the number of grid points is small, and increased beyond our perceptual abilities when a large number of grid points are used. In works like *Robert/104,072* (the number referring to the grid points, of course), unequal focus confronts the viewer with the dilemma of rationalizing differences, if not contradictions, in perceptual methods. This dilemma has been at the center of Close's work and that of other contemporary photo-realists, including David Parrish, Tom Blackwell, Jack Mendenhall, and William Nichols.

Not only has the camera opened up "previously neglected seeing possibilities," but it has changed our perception of the tangible world. The modern vision of the world has become photographic; artists who do not even use the camera in their work often, nonetheless, see reality in photographic terms. Philip Pearlstein, for instance, whose art is not based on photographs, employs the photographic technique of cropping to heighten the reality of his work; almost any of Pearlstein's figure

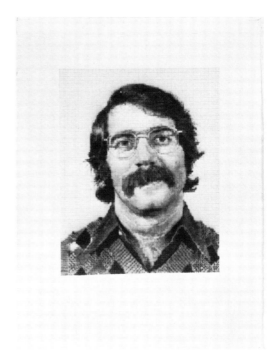

Fig. 9 Chuck Close. *Robert III/2464*, 1974. Ink and graphite on paper, 30 x 22 inches. Ohio State University Art Gallery

Fig. 10 Chuck Close. *Robert IV/9856*, 1974. Ink and graphite on paper, 30 x 22 inches. Ohio State University Art Gallery

paintings (see Pl. 14) depict the figure as one might see it through the lens of a camera.

Photography, either as a source or as a subliminal presence, has also conditioned the attitude of many contemporary American realists to subject matter. "To paint from photographs," writes Lawrence Alloway, "is basically a post-Pop way of working, by which I mean it comes after and is inconceivable without it."[45] Alloway was referring to the parallel between the introduction of found objects in Pop Art and the intercession of photography in photo-realist art. Both are basically "process-abbreviated" steps; the alternative steps would be to make the objects that the found objects replace and to make the drawings that the photographs replace. In both Pop Art and photo-realism the process results in works of art that manifest a quality of detachment, neutrality, and impersonality, qualities that were loathsome to critics who had become used to the highly personal, romanticized images of Abstract Expressionism. In the case of photo-realism, the artist's neutral attitude to the subject matter is less the result of the subject's inherent banality (as was the case in Pop Art) than of the dominant role the photograph has played in detaching the artist

from direct contact with his subject matter. This neutrality is also conditioned by the relative lack of importance given subject matter by many contemporary realists.

Just as nontraditional attitudes to subject matter have helped to define contemporary realism, so has subject matter itself been a factor in that definition. By the mid–nineteenth century, the subjects of painting had been broadly democratized. What was once not deemed fit for portrayal — the life of the laboring poor, industry, the modern city, the modern woman — became acceptable. With the vast expansion of subject matter, it can safely be said that by the mid–nineteenth century everything was fair game for the artist.

The same condition prevails today for realist artists, whose subject matter far exceeds what was thought liberal by the standards of the mid–nineteenth century. All of contemporary life provides the range of appropriate subject matter, which had seemed to be extended to its utmost in the infinitely rich images of urban life made current by Pop artists. Their seemingly limitless range of new subjects was an immediate and important precedent for contemporary realists. As Robert Cottingham said, "Pop

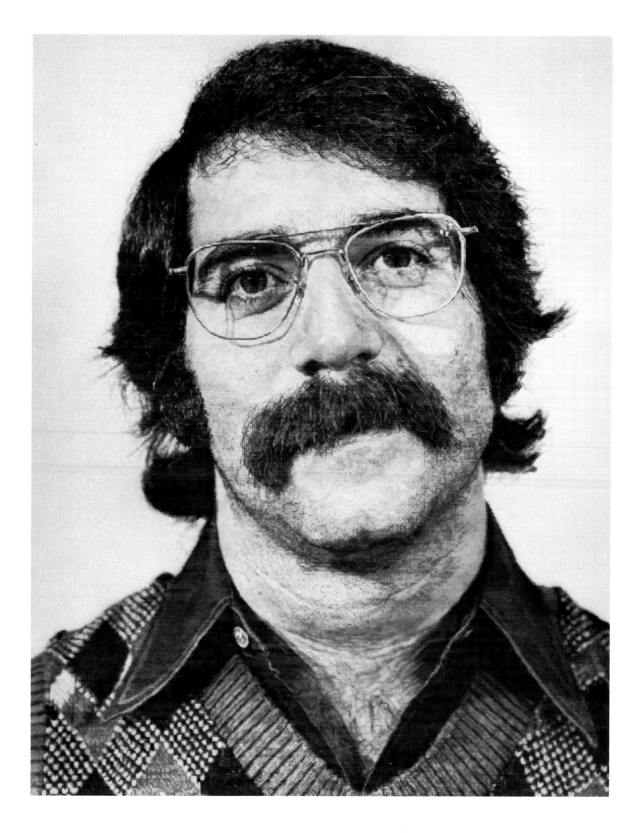

Fig. 11 Chuck Close. *Robert/104, 072*, 1973–1974. Synthetic
polymer paint and ink with graphite on gessoed
canvas, 108 x 84 inches. Collection of The Museum of
Modern Art, New York; fractional gift of J. Frederic
Byers III and promised gift of an anonymous donor

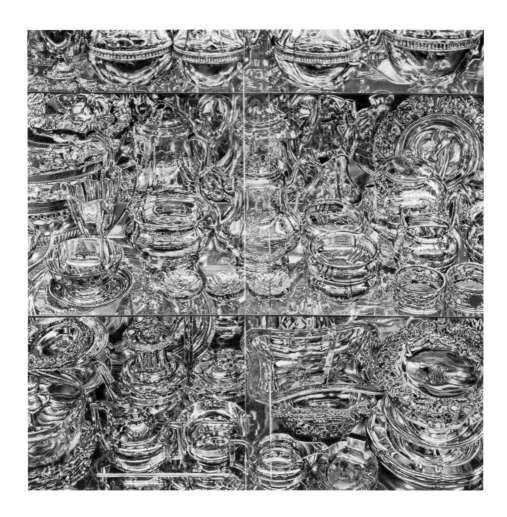

Fig. 12 Don Eddy. *Silverware V for S*, 1977. Acrylic on canvas,
40 x 40 inches. Collection of Sarah Eddy

showed us that there was a lot more subject matter around than we were paying attention to."[46] The imagery of Pop Art, however, was purposely familiar, whereas realism's generally is not; although it may be equally familiar, it may also be remote, exotic, impersonal, idiosyncratic, or bizarre. There are no constraints on what is acceptable subject matter for contemporary realism, just as there are no articulated goals. Unlike earlier American realist styles, it has no need to document the look of America or to reinforce its way of life. Its identity is the result of many different personal choices, with none imposed from without.

There are many artists considered realists who care little about subject matter, and some, to the contrary, who care a lot. The range in attitudes is so varied as to be meaningless. Pearlstein, for example, says, "I'm interested in abstraction—subject matter never interests me in any work except Dickens."[47] Similarly, many of his realist contemporaries, and most of the photo-realists, are interested in formal problems of realist painting and not in issues of content. Stephen Posen, in spite of highly illusionistic works like *Variations on a Millstone* (Pl. 2), disassociates himself from the earlier *trompe l'oeil* traditions of painting, decrying the goal of "cheap-shot illusionism, facsimile and reproduction."[48] For him each painting poses new formal problems; he wants a painting that is "a state of mind (fluid, structured, expressive and accessible) rather than a representation of a state of being."[49] William Bailey claims that he is bothered by being called a realist painter because he thinks that the designation has come to mean that representation is the primary value.[50] He thinks that all painting is abstract, even though he wants the objects in his paintings, like the crockery in *Monte Migiana Still Life* (Pl. 3), to have the credibility of real objects. Don Eddy, in denying the value of subject matter in his work, asserts the value of painting as "the activity which makes self-definition a possibility."[51]

There are as many realist artists who value subject matter as those who deny it. Alfred Leslie's anti-formalist remark is now famous:

> I wanted to put back into art all the painting that the Modernists took out by restoring the practice of pre-twentieth-century painting. I started with portrait painting. I made pictures that demanded the recognition of individual and specific people, where there was nothing to be looked at other than the person—straightforward, unequivocal, and with a persuasive moral, even didactic, tone.[52]

This statement goes a long way toward summarizing the position of those realists who place a primary value on subject matter. At the heart of this philosophy is the belief that art should be about life and not about art. Jack Beal believes that modernism has been destructive of both life and art; he wants an art that returns to nature, an art about life that is open and accessible to more than an elite few. Since the early 1970s nearly all of his paintings have been predicated upon a publicly oriented moral consciousness. Works like his *Virtues and Vices* series (see figs. 13, 26, 53, 61) are intended to affect the conduct of those who view them. To realist artists like Jack Beal, subject matter is the ultimate (and only) justification for painting.

It is interesting that even those contemporary realists who vigorously assert the primacy of subject matter cannot help interpreting it in the context of modernism. In the first place, modernism's oversize scale has become the format preferred by most contemporary realists. Alfred Leslie's *Americans: Youngstown, Ohio*, 1977–1978, for instance, measures 9 by 24 feet. (There does seem to be a trend emerging for small-scale realist paintings, however.[53]) Secondly, modernism's emphasis on frontality and shallow pictorial space is reflected in the work of many of the more traditional realists: Leslie's obsessively frontal portraits (see fig. 14), William Beckman's *Double Nude (Diana and William Beckman)* (Pl. 4), or the portraits of Alice Neel, for example. Realists like Fairfield Porter, Neil Welliver, Paul Georges, and Janet Fish, whose work falls between more traditional brands of realism and modernism, see the painted surface as an expression of, among other things, their modernist position.

Fortunately, the traditions of realism in Western art allow for a very broad interpretation of realism itself. For the contemporary expression, this latitude is essential; those who would prefer a more strict definition end by excluding much of the best realist work being made in America today. Those who are unwilling to admit to the pluralistic nature of contemporary American realism are either unwilling to submit to its vitality or are exercising a pigeonhole mentality.

Fig. 13 Jack Beal. *Hope, Faith, Charity*, 1977–1978. Oil on
canvas, 72 x 72 inches. Courtesy of Allan Frumkin
Gallery, New York

The question remains: what are the common denominators of contemporary realists as a group? One is a wariness about being described as a "realist," not only because of the reluctance to be stereotyped, but also because for many the artistic concerns lie beyond the traditional definitions of realism. This is understandable, but it also points up the difficulty of disassociating the word realism from its nineteenth-century context.

Is there a common stylistic ground? Sidney Tillim has said that realists share a "lusting after tactility, after strongly modeled form, clear contours, and deep illusionistic space,"[54] noting that even second-generation Pop artists work more illusionistically than their first-generation counterparts. And yet style alone is not a realist determinant; neither is a homogeneous paint surface, nor a shared approach to the rendering of form or the use of line, nor a consistent attitude to subject matter, nor a standard use of space.

Linda Nochlin has described contemporary realism in terms of the artist's attitude to the external world. She sees commonality in the shared "assertion of the visual perception of things in the world as the necessary basis of the structure of the pictorial field itself." She goes on to say that not since the Impressionists "has there been a group so concerned with the problems of vision and their solution in terms of pictorial notation and construction."[55]

The assertion of the visual perception of things based on two radically different aesthetics — one a commitment to the value of phenomenological information as the basis of art, the other an affirmation of the process and value of its translation into pictorial information — defines contemporary American realism. In either aesthetic, illusionistic images based on external evidence in the real world serve as the basis of pictorial structure; just as there were no "angels" in the oeuvre of Gustave Courbet, there are none in contemporary American realism.[56]

It is not surprising that realism has become a significant mode at a time when Americans place a high premium on the material universe and at a time when the world has been exposed to a tremendous proliferation of images, facts, and statistics. The meaning of reality has been altered by what our advanced technological society has taught us. Contemporary life is unlike anything that has come before, and contemporary American realism, as Alex Katz has said, has "its own particular kind of information and energy."[57] It could not be otherwise.

1 Neil Welliver. *Breached Beaver Dam,* 1976. Oil on canvas,
96 x 96 inches. Collection of the North Carolina Museum of
Art, Raleigh, N.C.

2 Stephen Posen. *Variations on a Millstone*, 1976. Oil on
canvas, 86½ x 68½ inches. Pennsylvania Academy of the
Fine Arts, Philadelphia

3 William Bailey. *Monte Migiana Still Life*, 1979. Oil on
canvas, 54 x 60 inches. Pennsylvania Academy of the Fine
Arts, Philadelphia

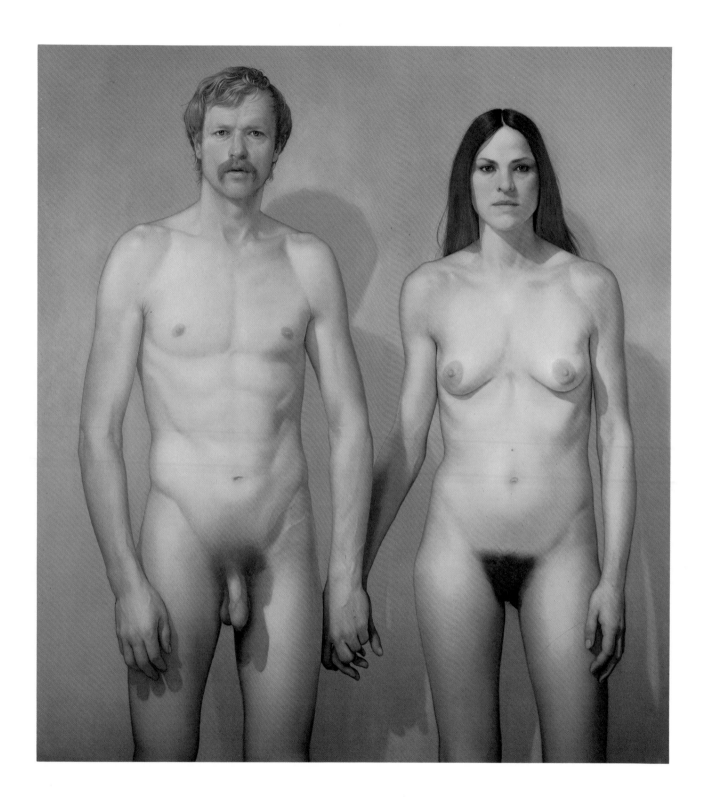

4 William Beckman. *Double Nude (Diana and William Beck-
man)*, 1978. Oil on wood panel, 64 x 59 inches. The Herbert
W. Plimpton Collection on extended loan to the Rose Art
Museum, Brandeis University

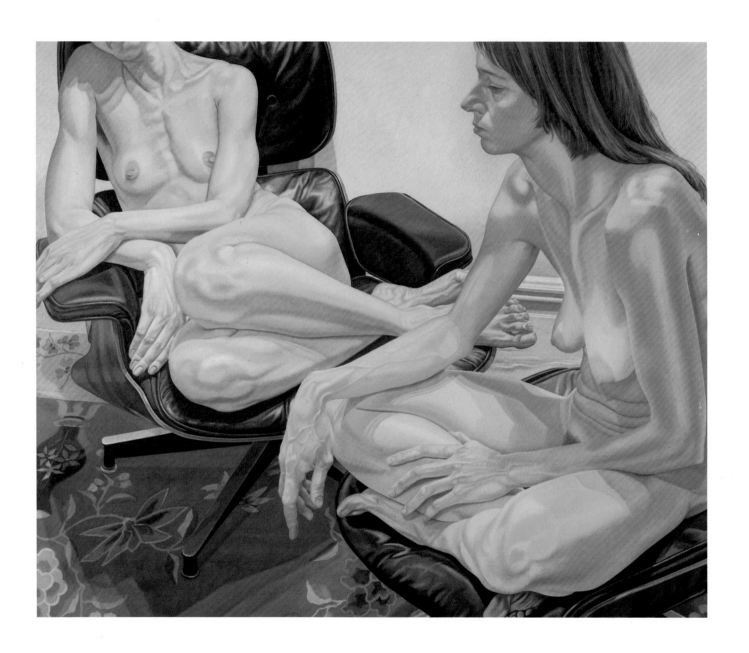

5 Philip Pearlstein. *Two Female Models on Eames Chair and Stool*, 1976-1977. Oil on canvas, 60 x 72 inches. Milton D. Ratner Family Collection

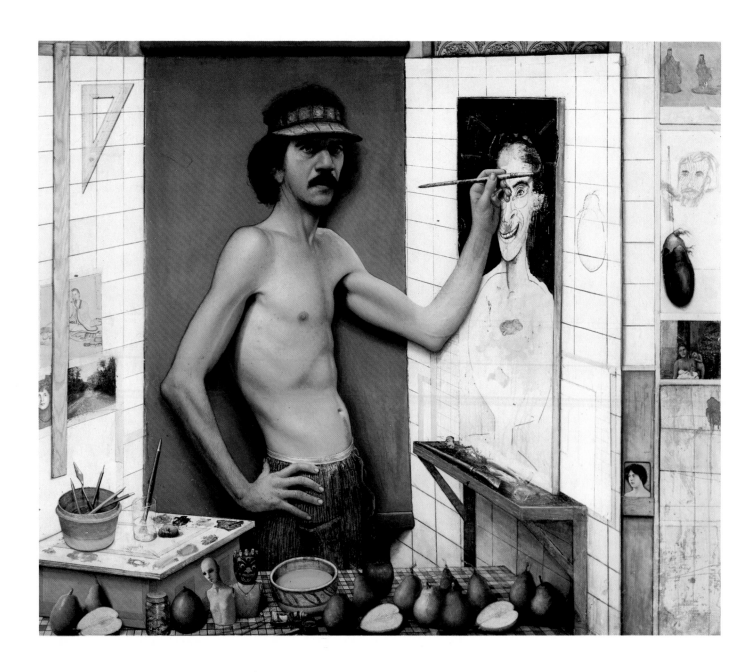

6 Gregory Gillespie. *Myself Painting a Self-Portrait,* 1980. Oil
and alkyd on plywood, 57 x 96 inches. Courtesy of Forum
Gallery, New York

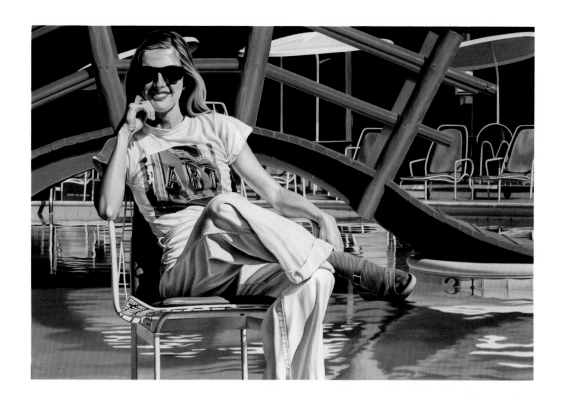

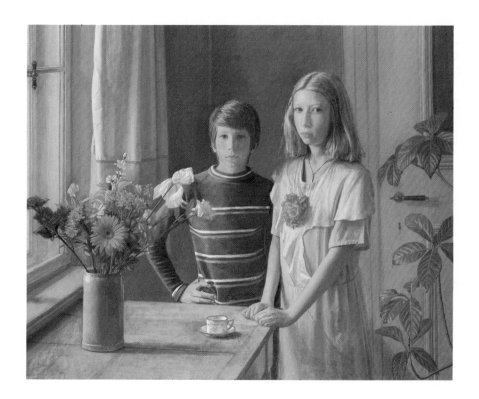

7 D. J. Hall. *Self-Realist,* 1975. Oil on canvas, 39 x 57 inches. Private collection

8 Paul Wiesenfeld. *Portrait of the Artist's Children*, 1979. Oil on canvas, 41 x 51 inches. Courtesy of Robert Schoelkopf Gallery, New York

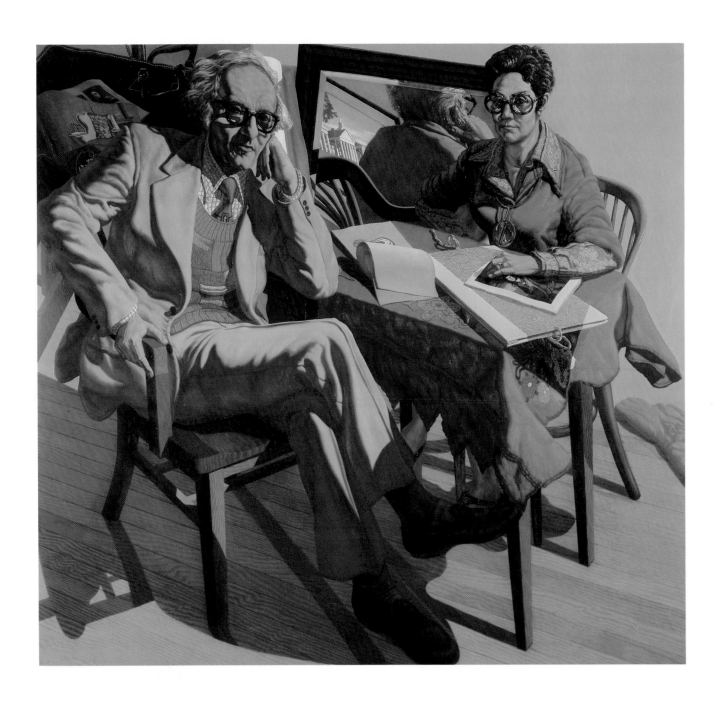

9 Jack Beal. *Sydney and Frances Lewis,* 1974–1975. Oil on
canvas, 72 x 78 inches. Collection of Washington and Lee
University

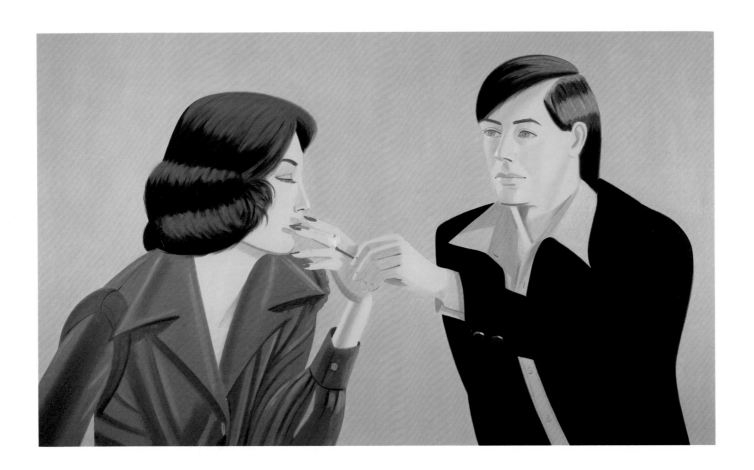

10 Alex Katz. *The Light #3,* 1975. Oil on canvas, 72 x 120
inches. Collection of Mr. and Mrs. Samuel H. Lindenbaum

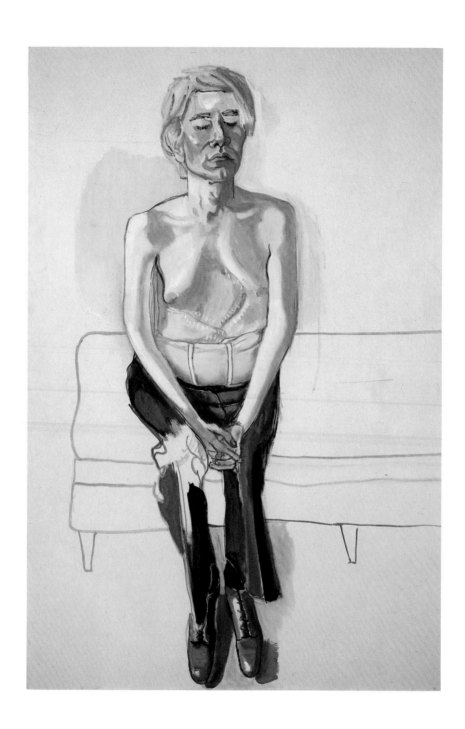

11 Alice Neel. *Andy Warhol,* 1970. Oil on canvas, 60 x 40
 inches. Collection of the Whitney Museum of American
 Art; promised gift of Timothy Collins

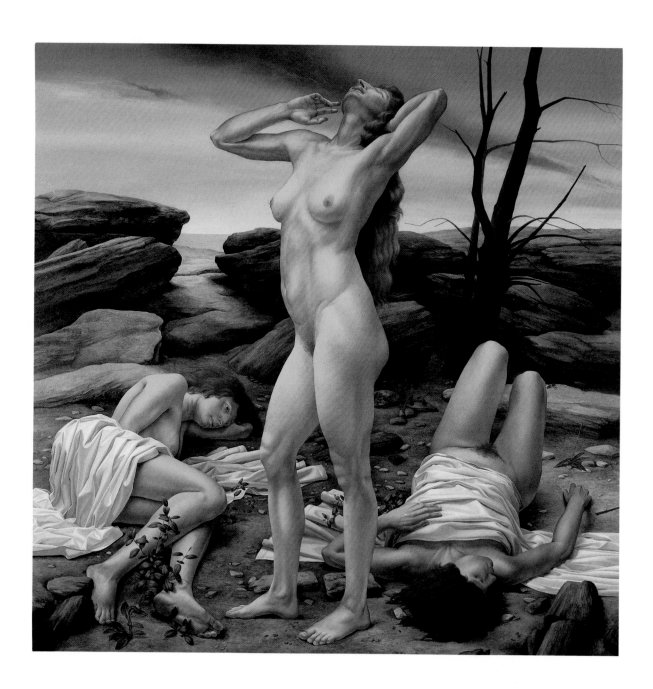

12 Martha Mayer Erlebacher. *In a Garden,* 1976. Oil on
canvas, 64 x 64 inches. Courtesy of Robert Schoelkopf
Gallery, New York

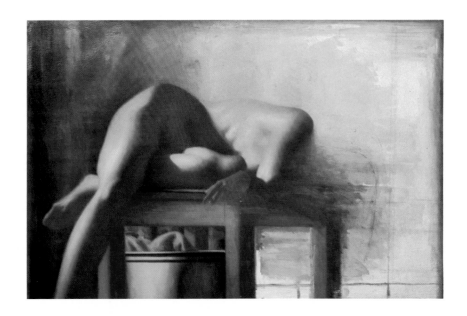

13 Sidney Goodman. *Nude on a Red Table*, 1977–1980. Oil on canvas, 53¼ x 78 inches. Pennsylvania Academy of the Fine Arts, Philadelphia

14 Philip Pearlstein. *Female Model on Ladder*, 1976. Oil on canvas, 72 x 96 inches. Courtesy of Allan Frumkin Gallery, New York

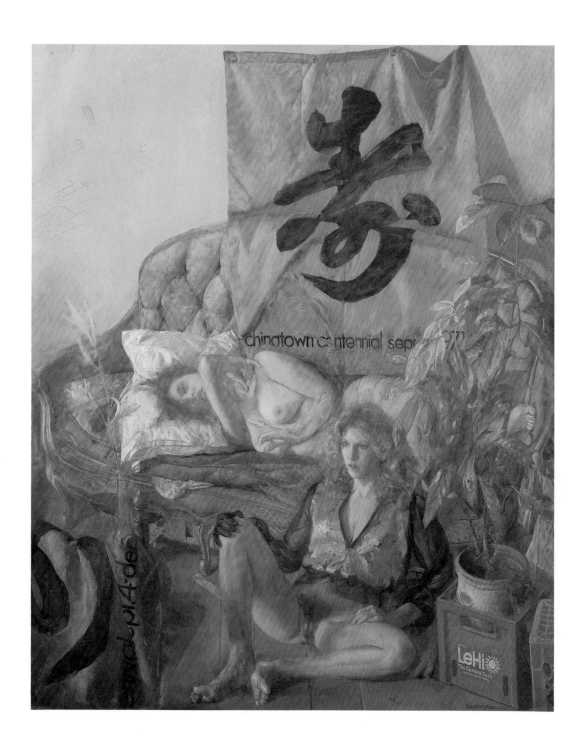

15 Ben Kamihira. *Chinatown Centennial,* 1974–1978. Oil on
canvas, 66⅛ x 54½ inches. Collection of Dr. and Mrs.
Chalmers E. Cornelius, III

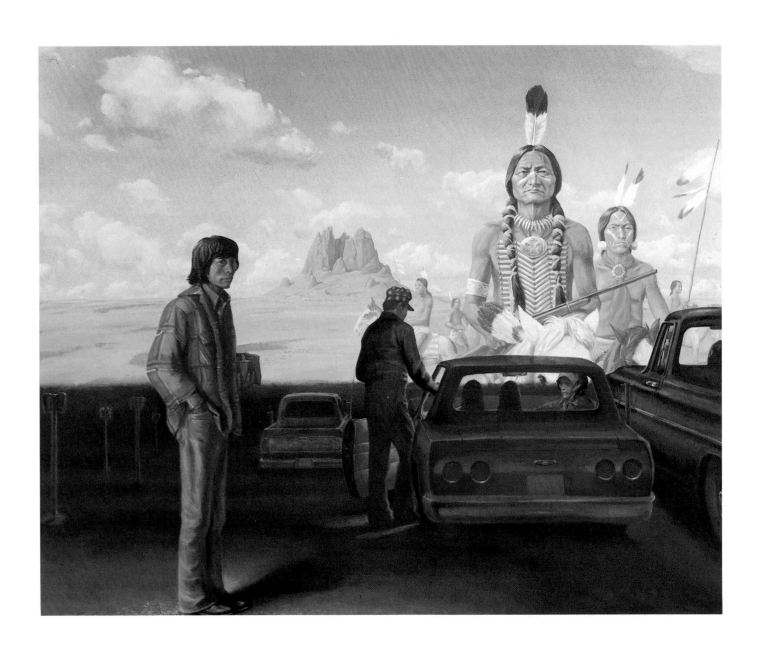

16 Willard Midgette. *Sitting Bull Returns at the Drive-in*,
 1976. Oil on canvas, 108 x 134 inches. Collection of
 Donald B. Anderson

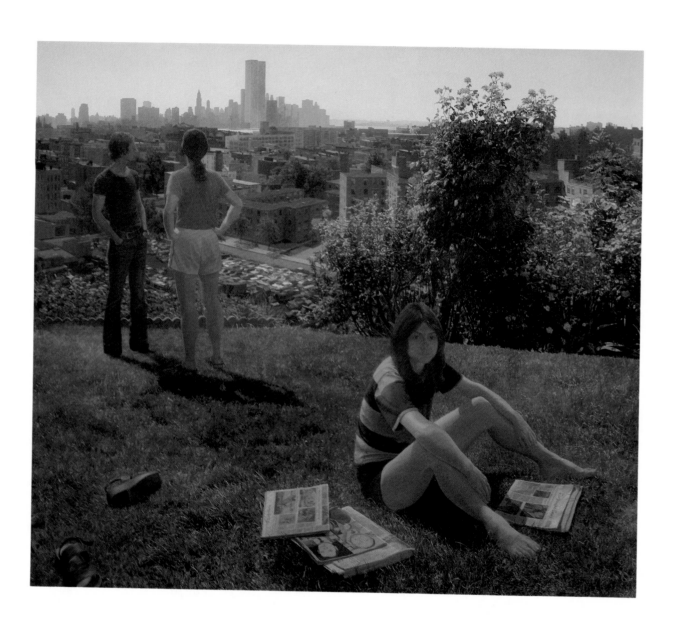

17 Catherine Murphy. *Elena, Harry and Alan in the Backyard,*
1978. Oil on canvas, 39½ x 45½ inches. Private collection

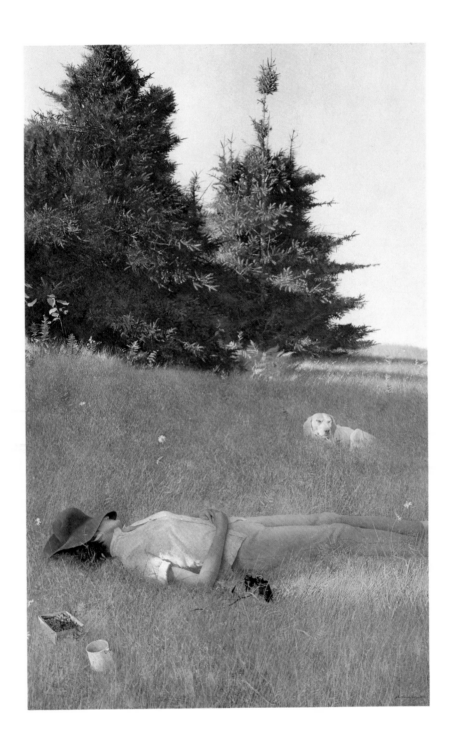

18 Andrew Wyeth. *Distant Thunder*, 1961. Tempera, 47½ x 30
inches. Private collection

Chapter Two

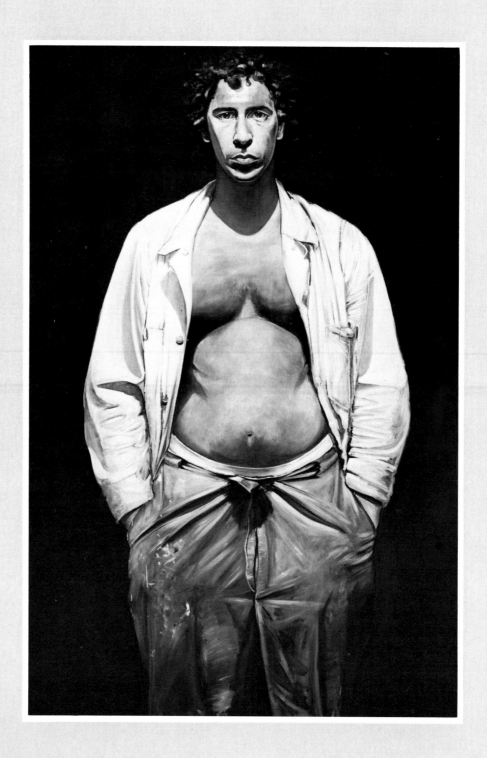

Fig. 14 Alfred Leslie. *Alfred Leslie*, 1966–1967. Oil on canvas,
108 x 72 inches. Collection of the Whitney Museum
of American Art, gift of the Friends of the Whitney
Museum of American Art

Portraits, Nudes, and the Figure Outdoors

The figure has almost always been at the ideological center of American art. Its painting has taken many forms and filled many needs, not the least of which has been the artist's own need to meet the challenges that painting it implies. Of all painting genres, the figure places the most complex demands on the artist.

Until the rise of abstract styles of art in the early twentieth century, the painted figure was the ultimate American icon. With unforgettable images like an anonymous New England limner's record of the aged Mrs. Anne Pollard (1721); Copley's portraits of Boston patricians; Ralph Earl's indomitable Roger Sherman (c. 1777); Gilbert Stuart's immortalizing "Athenaeum" portraits of George and Martha Washington; Thomas Sully's stylish young ladies; George Catlin's picturesque Indians; or Thomas Eakins's penetrating likenesses, figure painting helped to shape our understanding of America. These, in addition to heroic narratives of the country's history, and genre paintings that record the daily lives of its citizens, express the individual and collective values of America through its pre-modern history. Historically, figure painting in America has been edifying.

Increasingly in the twentieth century, the validity of the figure as subject came under attack; as a subject replete with its own meaning and dimensions it was no longer deemed important by most avant-garde artists. The idea that the human figure served both the formal structure and the content of painting gave way to the idea that the figure was acceptable only as the starting point of painting.[1] It became the task, if not the moral obligation, of the avant-garde artist to transform the figure into an artistic expression of oneself.

Figure painting (along with other realist genres) reached its nadir in the 1940s and 1950s, when its image became so distorted and disrupted that for all practical purposes it ceased to exist in the mainstream of American art. As early as 1942 Clement Greenberg declared that it was no longer possible to be an artist and to paint the figure. Since in his view art must progress linearly, he argued that there was nothing left to be done in painting the figure. Greenberg's ideas were pervasive and their currency made it increasingly difficult for representational artists to survive. Figure painting during these decades was truly an "underground activity."[2]

Even though the now-famous *New Images of Man* exhibition at the Museum of Modern Art of 1959 contained a significant group of works devoted exclusively to interpretations of the human figure, the works shown were without exception expressionistic abstractions or personal notations on the human predicament. The exhibition included no works in which the integrity of the figure's form was not violated. In the catalogue, Paul Tillich responded to the exhibition's content with the question, "what has happened to man?"[3] After a moment of anger, even hostility, directed at the artists who he felt had distorted man's image, Tillich recognized that it was these very artists who, more than any others, were *again* trying to include the figure in their work:

> They want to regain the image of man in their paintings and sculptures, but they are too honest to turn back to earlier naturalistic or idealistic forms, and they are too conscious of the limits implied in our present situation to jump ahead into a so-called new classicism. They tried to depict as honestly as they could, true representations of the human predicament, as they experienced it within and outside themselves.[4]

Peter Selz in the same catalogue said:

> These images [of man] do not indicate the "return to the human figure" or the "new humanism" which advocates of the academies have longed for, which, indeed they and their social-realist counterparts have hopefully proclaimed with

great frequency, ever since the rule of the academy was shattered. There is surely no sentimental revival and no cheap self-aggrandizement in these effigies of the disquiet man.[5]

Fairfield Porter agreed with Selz that "there can be no 'return' to the figure"[6] in American art—that is, no return in the sense of academic revival. He did predict, nonetheless, in 1962 that there would be in the coming years a new, and increasingly vital, figurative art. In noting that the "movement toward painting the figure will be new not renewed,"[7] he favored neither the "new imagist" type of figure painting nor the so-called new classicism, but rather he hinted that the strength of new figure painting in America would come from a group of younger artists like Alex Katz and Paul Georges, who "paint the figure without affectation, sentimentality or evasiveness, and who do not follow criticism, but precede it."[8]

The *New Images of Man* exhibition in 1959 was followed rather closely by another exhibition of contemporary American figure painting at the Museum of Modern Art (1962–1963), entitled *Recent Painting USA: The Figure*. Its organizer, Alfred H. Barr, Jr., was careful to note "the prodigious variety of forms even this small exhibition · suggests,"[9] a statement perhaps prompted by the narrowness of the Modern's earlier "figure" exhibition, which Barr obviously much preferred. The paintings in the later show, which Barr characterized as "traditional or at least precedented in their overt subject matter, that is, the situation and the states-of-mind explicitly suggested by the painted figures,"[10] did encompass a broad spectrum of recent American figure painting but, contrary to Barr's assessment, even those of the most conservative persuasion hardly seemed traditional. Included in the exhibition, although then working very differently, were a number of contemporary realists: John Button, Sidney Goodman, Ellen Lanyon, Eugene Leake, and Paul Wonner.

In spite of encouraging signs pointing to a new level of interest in figure painting, the situation in the early 1960s had not markedly improved. In 1962, Philip Pearlstein, then a recent convert from Abstract Expressionism to figure painting, questioned the sanity of choosing the figure as a subject in the twentieth century:

It seems madness on the part of any painter educated in the twentieth-century modes of picture-making to take as

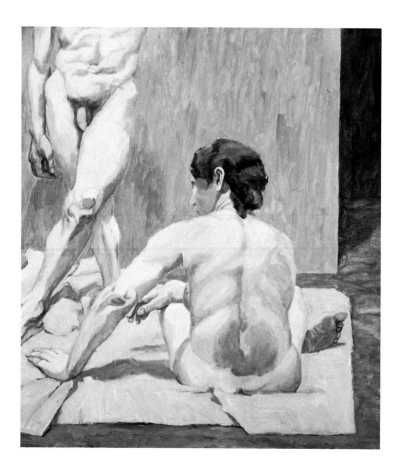

Fig. 15 Philip Pearlstein. *Models in the Studio V*, 1962. Oil on canvas, 50 x 44 inches. Collection of Dorothy Pearlstein

his subject the naked human figure, conceived as a self-contained entity possessed of its own dignity, existing in an inhabital space, viewed from a single vantage point. For as artists we are too ambitious and conscious of too many levels of meaning. The description of the surface of things seems unworthy. Most of us would rather be Freudian, Jungian, Joycean, and portray the human by implication rather than imitation.[11]

And yet Pearlstein pursued the "madness," abandoning his abstract landscapes of the late 1950s in order to paint the naked human figure. Nonetheless, even in the early 1960s Pearlstein understood that his commitment to the figure was not a commitment to its subject potential; he deliberately chose not to be "Freudian, Jungian, Joycean." Rather, he used the figure to pursue his interests in abstraction. As early as 1962 Pearlstein's figure paintings demonstrate these interests: *Models in the Studio V* (fig. 15) in its radical cropping and in the basically abstract spatial relationship established by the figures, is prototypical of Pearlstein's developed style. It demonstrates his solution of how to paint the figure realistically in what was for him a nonsubject context, a particular dilemma of the realist.

Pearlstein's recognition of the "madness" of his pursuits was shared by other artists;[12] in a broader context his work was understood as evidence of a personal strategy to gain acceptability in modern terms for realist figure painters—for artists like himself, as Pearlstein put it, who make paintings in which "the number of toes and fingers can be counted."[13] Disdaining those artists who used the figure as a story-telling device, his modernist strategy was predicated on both a challenge and a concession: he challenged the modernist principle of flatness as a formal prerequisite at the same time that he conceded contemporary figural artists should find innovative ways to express their modernity. He suggested, rather cynically, strategies that would allow realist figure painting to gain modernist acceptability; they included, first, the introduction of the proper psychological implications in line with current popular sympathies about the figure, and, second, the use of a gestural paint surface, restrained but reminiscent of Abstract Expressionism. Whether Pearlstein's strategies were meaningful for other figural artists (his own work hardly reflected these positions) is not so important as the fact that they implied a personal commitment to make figure painting relevant in a modern context.

There have been various explanations for the renewed activity in the genre. It has been suggested that the road back from the "new image" type of figure painting to realistic figure painting was bridged by life drawing.[14] Fairfield Porter said, erroneously, I believe, that the renewed interest in the figure represented the renewed interest of critics and popular audiences rather than of artists, who, he argued, had never given up figure painting in the first place.[15] Others have interpreted its renascence in terms of sociological determinants or seen its rise as a natural reaction to abstraction. Whatever the reasons, and they are many and complex, it is true that among both older and younger artists there was an increasing commitment to painting the figure by the early 1960s.

Realistic figure painting partakes of the ideological and stylistic complexities of contemporary American realism as a whole. Many of the best realists who paint the figure are working in a postmodern manner while others are doggedly antimodern. The look of contemporary realist figure painting is anything but homogeneous and the issues it raises are very diverse. One problem, however, that confronts all realist figure painters today (and always has) is the verification of the subject, an issue of weightier consequence to the figure painter than, for instance, to a landscapist. We know (and care) much more about how the body looks than a tree. The figure painter's dilemma is to include enough specific information about the figure to make the image recognizable, but not so much as to destroy the painting's challenge as a work of art. Clearly, when a figure study or portrait does not transcend literal description, it fulfills only the purposes of illustration.

Contemporary realist figure painters have chosen to work on *all* levels of significance, exploring the full range of figure genres in contemporary life: commissioned portraits, self-portraits, and portraits of the artist's family and friends; nudes; figures in landscape, interior, and urban settings; large-scale narrative compositions. It is essential that this diverse work be interpreted at its own level of significance for what it is rather than what it might seem to be, for there is little doubt that art in a realistic style (and this is *particularly* true in figure painting)

tends to be interpreted only in terms of verisimilitude when verisimilitude may be only a secondary concern.

The example of four realistic figure painters, Chuck Close, Philip Pearlstein, William Beckman, and Jack Beal, serves this latter point well. On one level, that of accurately recorded information, their paintings show a common concern; the amount of visual information provided is almost excessive. And yet each of these artists values that level of information for radically different reasons, reasons that ideologically separate rather than unite them.

Chuck Close has repeatedly affirmed that his main objective in painting is the translation of photographic information into painting information. His portraits are some of the most illusionistic being made today, although likeness is a by-product of the way he works.

Like Close, Philip Pearlstein is a modernist who disdains the use of the figure as a narrative device and puts a lot of visual information into his work, but Pearlstein's interest in the figure is radically different from Close's. Pearlstein paints directly from the model, and although his cropping of the figure suggests the influence of photography, he is not interested in how the camera sees, but rather in his own perception. Since an artist cannot control the meaning of a subject painting, especially one of a nude body which has its own self-contained meaning, the figurative artist (he has said) ought to pay attention only to those aspects of painting that *can* be controlled, namely the formal elements: composition, line, color, light, and brushwork. Pearlstein paints the human figure as a "constellation of still life forms";[16] he is interested in the abstract possibilities of painting within a realist style. The figure is used as a convenience. William Beckman, like Pearlstein, paints directly from the model, but unlike Close and Pearlstein, he is principally interested in accurately recorded information as a means of satisfying his own requirements as a portrait painter. His constant search for form and his fascination with the details of the body, coupled with his unwillingness to minimize, distort, or idealize reality, indicate his belief in the sanctity of nature and its status as the fittest subject of art. Again unlike Close or Pearlstein, he believes that the artist must learn to deal with reality as the subject of painting rather than to replace it with something extraneous.

Jack Beal, who paints from nature, shares Beckman's belief that the figure should embody the meaning of figure painting, but he is more interested than Beckman in exploiting its expository possibilities. Believing that the artist should be a moral force in society, he uses the figure as the vehicle to this end, investing in it specific information appropriate to the narrative message.

The fact that the paintings of these four artists share a principal feature—a high degree of specific information about the figure—and that they put this common feature to entirely different ends underscores the complex, pluralistic nature of contemporary American realism. It also underscores the necessity of carefully evaluating the various levels of significance in any realist work of art.

The Self-Portrait

Artists have always been fascinated by their own images; whether they became their own subjects out of convenience (Chuck Close has said that the first self-portraits he made in the late 1960s just happened because he was the only person in the room), a search for immortality, or as a means of self-analysis, confrontation, or documentation, the self-portrait remains an essential act for most artists, objective and nonobjective alike. Pop artist Jim Dine has said, and he surely speaks for others, "the value of doing self-portraits for me has always been the reaffirmation that I do exist."[17]

Self-portraits continued to be painted during the time when the major twentieth-century artists in America were working abstractly, or at least nonrepresentationally. But the self-portrait changed from the traditional likeness to the painting in which likeness was not seen as important and in which it was not always possible to recognize the subject. Charles Sheeler, for instance, who made at least one realistic self-portrait, also chose to depict himself in his *Self-Portrait* of 1923 (fig. 16) as an almost imperceptible image reflected in a window behind a telephone set on a table. Sheeler, like so many of his contemporaries, used the self-portrait to raise the art of perception to the substance of reality. Among more recent abstract artists the self-portrait occupies a different peda-

Fig. 16 Charles Sheeler. *Self-Portrait,* 1923. Conté crayon, water, and pencil, 19¾ x 25¾ inches. The Museum of Modern Art, gift of Abby Aldrich Rockefeller

gogical position. The autobiographical function of self-portraiture, in place of description or the use of symbolic equivalents, was achieved by the Abstract Expressionists through the implications of a personal gesturalism. The rationale was that this very gesturalism expressed more about the person making the work than a factual likeness would. For an artist like Willem de Kooning, the painted surface (spontaneous, original, aggressive, and visually domineering) and the ordering of forms (chaotic, dislocated, and arbitrary) synopsized the artist's perception of the real world, affording the perceiver a deeper understanding of the artist/subject than would a conventional portrait. In this sense, all of de Kooning's paintings function as self-portraits.

The nondescriptive self-portraiture of the Abstract Expressionists or that brand of self-portraiture in which the presence of the artist is noted by a symbolic equivalent (for instance, the self-portraits by Jim Dine in the bathrobe series of the mid-1960s) seems to indicate that many abstract artists placed more significance on their work than on themselves.

Fig. 17 Claes Oldenburg. *Symbolic Self-Portrait with Equals,* 1970. Pencil, colored pencil, spray enamel on graph paper and tracing paper, 11 x 8½ inches. Moderna Museet, Stockholm

Fig. 18 Jasper Johns. *Souvenir,* 1964. Encaustic on canvas with objects, 28¾ x 21 inches. Collection of the artist

56 This attitude also prevailed among the Pop artists of the 1960s, and many of them—including Jasper Johns, Claes Oldenburg, and Andy Warhol—made self-portraits in these terms. Although the images in them are generally recognizable (even Oldenburg's face is recognizable in *Symbolic Self-Portrait with Equals,* fig. 17), they are recognizable only in support of a larger iconographical meaning. Jasper Johns's self-image in *Souvenir* (fig. 18) or Claes Oldenburg's *Jello Mold* (of his own face) not only helps to define the Pop aesthetic in terms of its relationship to reality, but exists as a statement about the public's perception of art and the artist. The indistinct image of Johns's face on a plate, like the cheap, mass-produced popular images that are sold as souvenirs, exemplifies his belief that art exists in common objects found in popular culture and is suitable material for artists, while the gelatin image of Oldenburg's face, produced in multiples, defines, in his mind, the place of the artist in contemporary society. If Johns's face can be "dished up" on a plate to an art-hungry public, Oldenburg's severed head can be served for the public's consumption.

Pop artists used the self-image principally to affirm an aesthetic ideology which coincidentally also affirmed their own existence. Among contemporary realists, the role of the self-portrait is reversed; it first fulfills the role of self-verification and then by implication stands as a validation of a personal aesthetic posture. It is almost never a mindless recording of fact; in the hands of the contemporary realist, the self-portrait is one of the most fulfilling images, for self-revelation, self-aggrandizement, self-pity, self-esteem.

In American art, the self-portrait has for the most part been executed on a relatively small, personal scale. There has been a modesty to it that not only underscores one of its common purposes, the family keepsake, but also, ironically, serves as a commentary on the artist's uncertain position in America. Today, the situation is more complex. Self-portraiture is almost nonexistent in some realists' oeuvre (for instance, that of Alice Neel). Some realists make self-portraits primarily as drawings, for instance, Sidney Goodman (fig. 19) and William Bailey; some make self-portraits that appear surprisingly incidental; while others practice the form both obsessively and on a large scale.

Fig. 19 Sidney Goodman. *Profile in the Dark,* 1977–1978. Charcoal, 23 x 21½ inches. Private collection

Philip Pearlstein, for instance, has painted many commissioned portraits, but has almost completely ignored the self-portrait; the closest he comes is in *Standing Female Model and Mirror* (fig. 20), where only the upper half of his head (which would be unrecognizable in any pictorial context other than one of his own paintings) is reflected in a mirror behind the model, a cropped presence that underscores one of his basic stylistic tenets at the expense of his own actuality. Other realist artists reveal only slightly more about their self-image. Arthur Elias in *The Artist's Reflection* (fig. 21), for example, employs the same kind of minimal, mirrored image of the artist, surrounding its reflected presence with a curious mixture of primitive carved heads, a human skull (which endows the painting with allegorical overtones), and artist's materials. The limit of realist obfuscation of the self-portrait is found in Jamie Wyeth's *Pumpkin Head* (fig. 22), in which Wyeth substitutes a carved pumpkin head for his own.

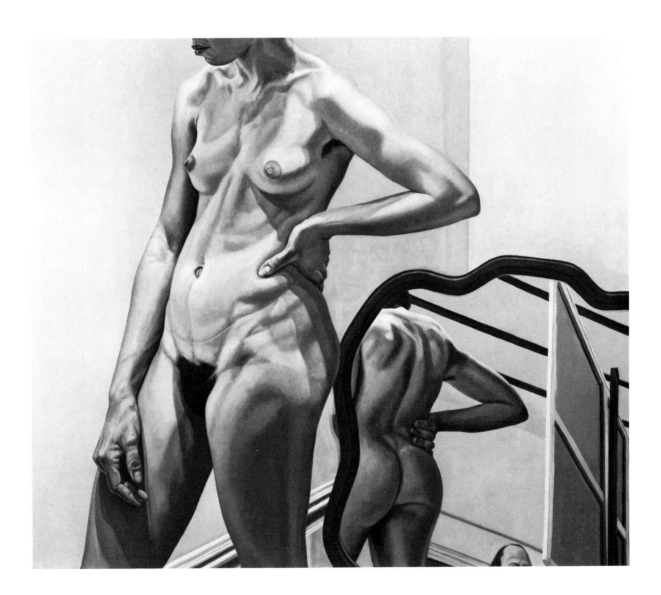

Fig. 20 Philip Pearlstein. *Standing Female Model and Mirror,*
1973. Oil on canvas, 60 x 72 inches. Private collection

58 Wyeth has said of this painting, in which the whole notion of self-portraiture is challenged (obviously without the artist's identification one could not tell this was a self-portrait of Jamie Wyeth), that it "represents what the artist feels about Halloween —pumpkins—and himself—imaginative, mystical, chillingly horrific."[18] Unconventional, even surreal, *Pumpkin Head* guarantees the artist anonymity; at least the painting will never tell.

Self-portraiture among contemporary realists is more generally characterized by a directness and lack of pretension that often may seem overly analytical. The self-portraits of Martha Mayer Erlebacher (fig. 23), William Beckman (fig. 24), and Gregory Gillespie (fig. 25) are among the least pretentious. Reduced in scale, frontal, seen from close up, including only the head and upper torso, stark except for the startlingly real rendering of the figure's form against a shallow backdrop, these self-portraits are, despite their smallness, compelling, even haunting (particularly Gillespie's) images of self-perception and independence. Each of them, three-dimensional in its almost clinical approach to rendering forms accurately, is a testament to what Gillespie called "looking without having art in the way."[19] They reveal substantially similar attitudes toward the treatment of the surface reality, but also show a striving for another reality, an attempt to perceive a deeper consciousness. As Gillespie said, "I know that there are other structures of reality existing there at the same time that we can't see. I know that, and I want that to be in the painting too."[20]

Gillespie and Beckman have involved themselves in self-portraiture to a greater extent than almost any other contemporary realists. Gillespie has even said that he has considered painting the self-portrait exclusively. For both, the expediency of using oneself (Chuck Close's "only person in the room" situation) was the initial cause for such a commitment, and it is still convenient, primarily because of the exceedingly slow pace at which both Gillespie and Beckman work. Coincidentally, however, both artists have used the self-portrait for ends other than pure autobiography. In recent larger-than-life-size works like *Double Nude (Diana and William Beckman)* (Pl. 4), Beckman seems obsessed

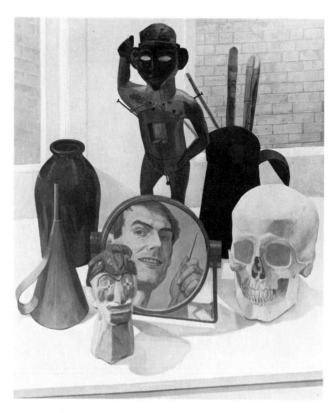

Fig. 21 Arthur Elias. *The Artist's Reflection,* 1979. Oil on canvas, 48 x 40 inches. Collection of the artist

Fig. 22 Jamie Wyeth. *Pumpkin Head,* 1972. Oil on canvas, 30 x 30 inches. Collection of Mr. and Mrs. Joseph M. Segel

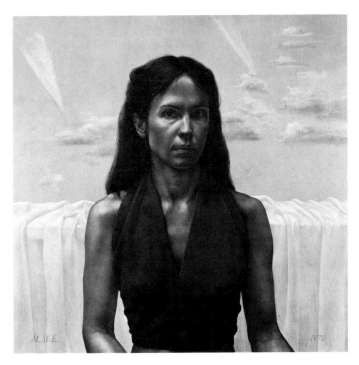

Fig. 23 Martha Mayer Erlebacher. *Self-Portrait*, 1975. Oil
on canvas, 22 x 22 inches. Courtesy of Robert
Schoelkopf Gallery, New York

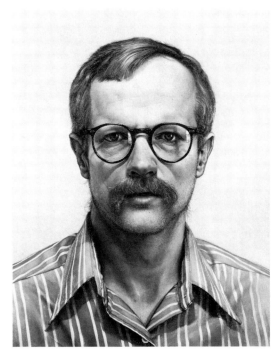

Fig. 24 William Beckman. *Self-Portrait*, 1978. Oil on
wood panel, 16¼ x 13⅜ inches. Private collection

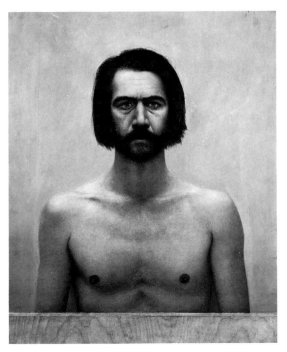

Fig. 25 Gregory Gillespie. *Self-Portrait*, 1975. Oil and
magna on wood, 30¼ x 24¾ inches. Sydney and
Frances Lewis Collection

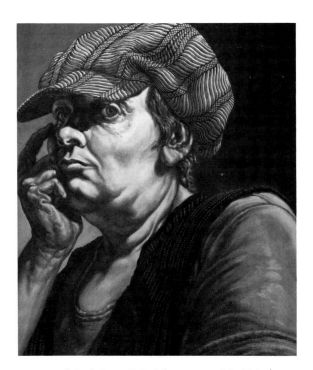

Fig. 26 Jack Beal. *Envy*, 1977. Oil on canvas, 26 x 22 inches.
Collection Galerie Claude Bernard

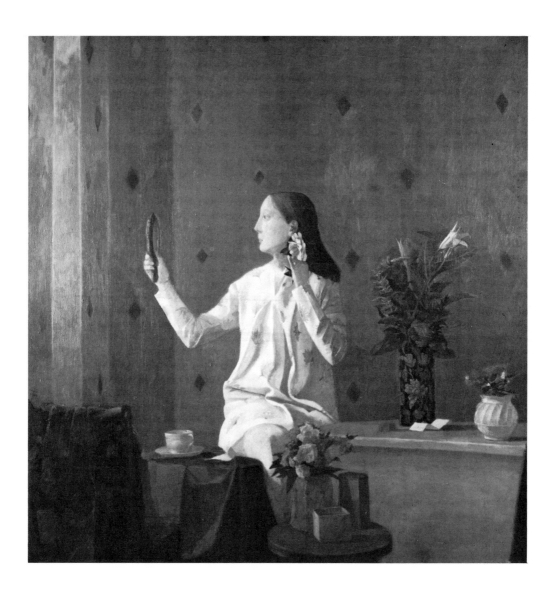

Fig. 27 Gillian Pederson-Krag. *Interior: Woman with a Mirror,*
1974. Oil on canvas, 53 x 52 inches. Collection of the
artist

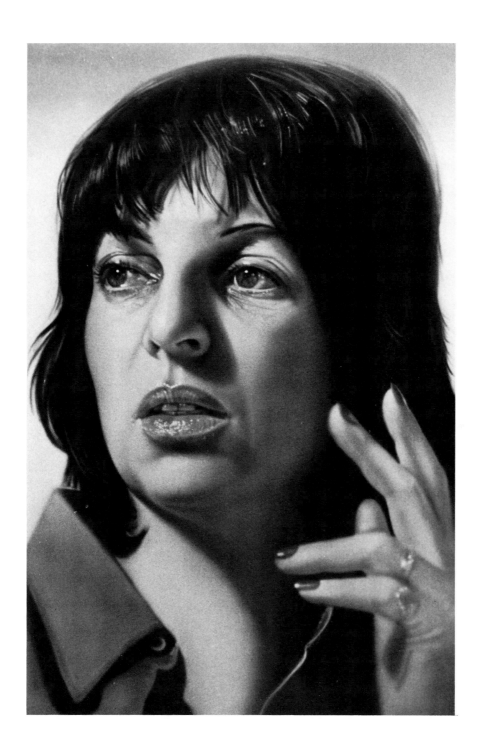

Fig. 28 Audrey Flack. *Self-Portrait*, 1974. Acrylic on canvas,
80 x 64 inches. Private collection

62

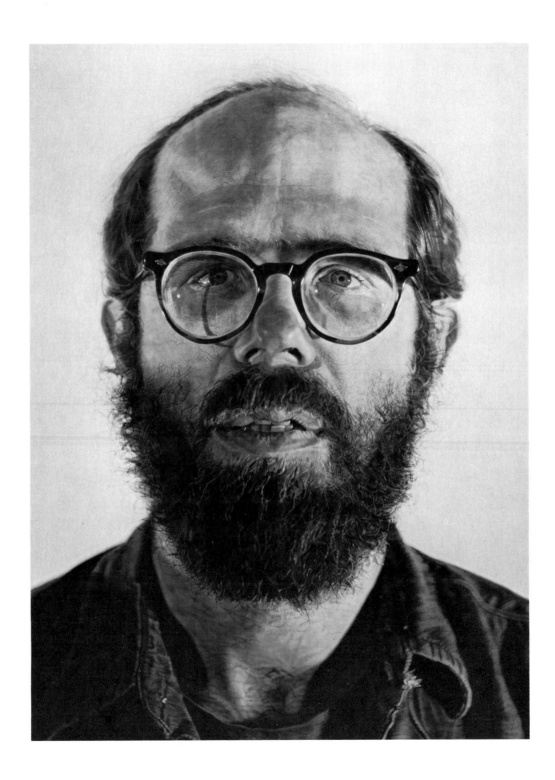

Fig. 29 Chuck Close. *Self-Portrait,* 1977. Watercolor on paper
mounted on canvas, 81 x 58¾ inches. Museum of
Modern Art, Vienna; The Ludwig Collection, Aachen

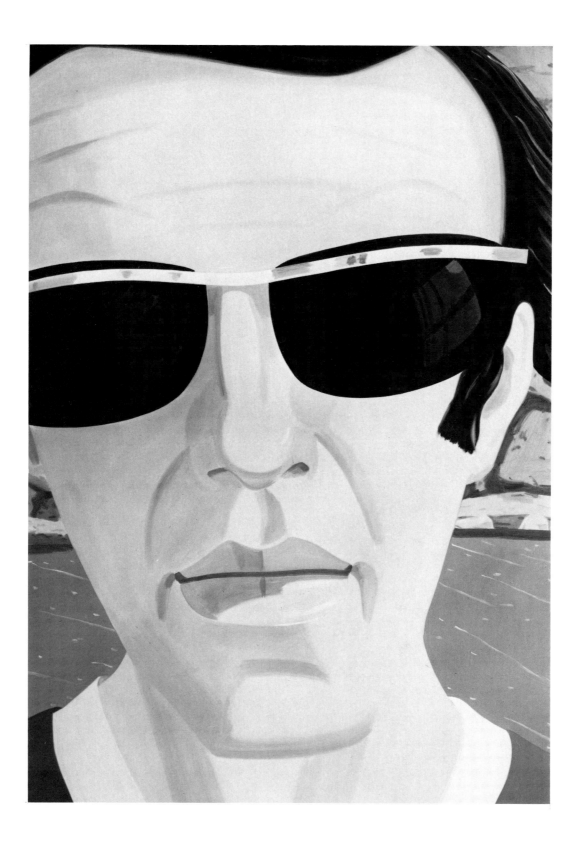

Fig. 30 Alex Katz. *Self-Portrait with Sunglasses*, 1969. Oil on
canvas, 96 x 72 inches. Collection of Mrs. Robert B.
Mayer, Chicago

with the accurate recording of visible information; this is also true of Gillespie's *Myself Painting a Self-Portrait* (Pl. 6). But in both paintings the artist also has narrative goals that transcend the idea of self-verification. Beckman's *Double Nude* — reminiscent of Grant Wood's famous *American Gothic* of 1930 and also very much an icon of its own time — reveals unabashedly, even defiantly, the facts of his own body and those of his wife. But, unlike earlier self-portraits, it also exists as a metaphor on artistic independence and marital solidarity; just as it declares the value of independent thinking, it also speaks to the idea of a couple's love and desire to stand together in support of each other. Similarly, Gillespie's most recent self-portrait is fanatical in its self-exposition. Gillespie, standing in a space which appears to have no exit, exposes himself as one almost fiendishly obsessed by painting to the exclusion of everything else.

Other artists also use the self-portrait for personal verification as well as for narrative and pictorial ends. Much of what is considered documentary self-portraiture transcends the idea of verification. This is true of Gillian Pederson-Krag's *Interior: Woman with a Mirror* (fig. 27) for instance, a contemporary *vanitas* painting. It is equally true of Jack Beal's self-portrait entitled *Envy* (fig. 26), one in his *Virtues and Vices* series. *Envy* stands as a metaphor of the contemporary realist's relationship (or at least of Beal's) to the high artistic achievement of the past, which Beal envies. Similarly, Alfred Leslie's self-portrait (see fig. 14) of 1966–1967, one of the first important contemporary self-portraits in a realist style, has another level of meaning. The painting was conceived out of despair shortly after his studio fire in 1966. It embodies the artist's feeling that life must be lived with courage and vulnerability.

In general, self-portraits painted in a photo-realist style, in spite of their verisimilitude, are pictorially motivated. D. J. Hall's *Self-Realist* (Pl. 7) implies by its title that *how* the subject is painted is of greater importance than *who* she is. The self-portraits of Chuck Close show the same bias. These date back to the late 1960s when he was searching for a way to avoid the ''hot subject matter'' of large-scale female nudes. His decision to paint only the head and his own availability as model resulted in numerous self-portraits. The largest and most realistic of these is a watercolor on paper of 1976-1977 (fig. 29). Close has since employed a wider range of media—graphite, pastel, conté crayon, watercolor, inks — and a range of techniques, but these self-portraits are works about perception based on different levels and kinds of visual information provided by the camera rather than about himself. Close is not interested in developing traditional aspects of portraiture; his colossal heads read more like greatly enlarged aerial photographs, topographical maps of the head, than human likenesses.

Audrey Flack, like Close, also is more interested in how a camera codifies information and in the process of transforming that information into another medium than her own self-image. Curiously, her *Self-Portrait* (fig. 28), while revealing more visual information about herself, is less autobiographical than many of her still lifes; a recent still life like *Queen* (see fig. 102) embodies not only private images of childhood memories but also reflects her thoughts on womanhood and femininity, while *Self-Portrait* is involved almost entirely with pictorial strategies. In its simulation of a photographic source it provides a masterful display of Flack's airbrush technique: layer after layer of a fine spray of acrylic paint is applied to replicate the photographic image, an image reinforced by the use of a gray framing border, like the mat of a photography studio portrait.

Like the self-portraiture of the photo-realists, self-portraiture based on other realist strategies tends to be more concerned with art than with people. This is certainly true of the works of Fairfield Porter, Paul Georges, and Wayne Thiebaud, all artists who have used self-portraits as manifestos on their painting. Likeness is, however, essential to these works, even though it is seen through an assertive style of painting. An analogous situation prevails even in the work of an artist who makes careful life drawings as a way of gathering specific information about his subjects, Alex Katz. In Katz's *Self-Portrait with Sunglasses* (fig. 30), the reduction and stylization of that information result in a painting that reveals as much, if not more, about his art as it does about the subject. This is typical of all of Katz's portrait work.

Artists have traditionally painted themselves in their studios, documenting and celebrating the artistic process. Contemporary American realists

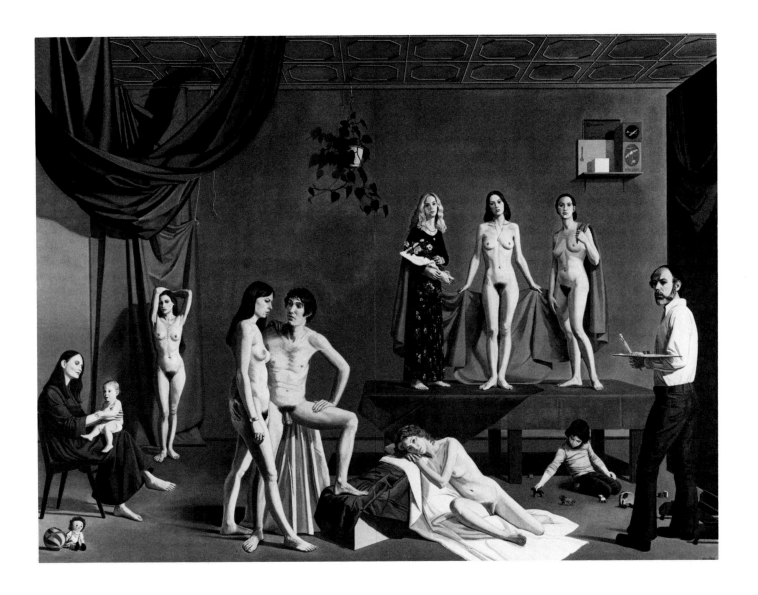

Fig. 31 Vincent Arcilesi. *Duane Street Loft,* 1976–1977. Oil on
canvas, 108 x 144 inches. Collection of the artist

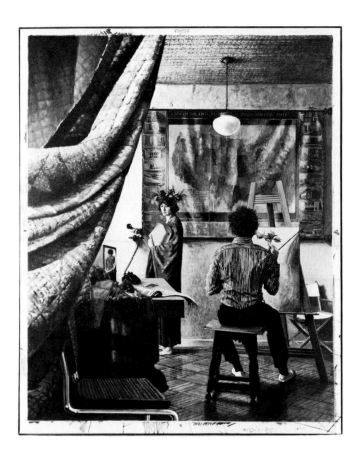 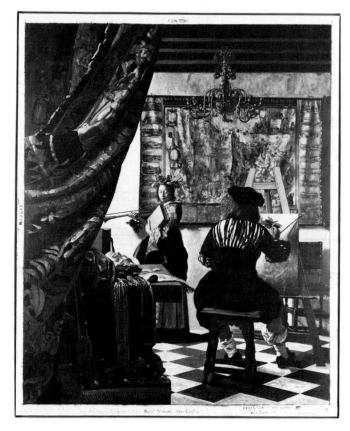

Fig. 32 George Deem. Diptych: *The Artist in His Studio*, 1979.
Left: *New York Artist in His Studio;* right: *Vermeer's
Artist in His Studio*. Each panel, oil on canvas, 53 x 44
inches. Collection of the artist

have responded to this tradition. Bruno Civitico's *Self-Portrait* of 1976 follows the time-honored convention of depicting the artist standing at his easel, in a momentary lull, with a canvas seen obliquely from the side. This sort of self-portrait directs our attention to the artist and his work without telling us much about either. In Vincent Arcilesi's *Duane Street Loft* (fig. 31) the associations are far more egocentric and ambitious. The artist is pictured standing full-length with his painter's tools in hand, surrounded by his family and his models, each apparently oblivious of the others; the figures form a self-conscious, awkward classical composition, complete with requisite staging and folds of drapery. Arcilesi obviously admires, and in fact mimics, the grand manner of French neoclassical painting, and in referring to this tradition is not only attempting to update but to associate (and thus elevate) himself with it.

In an even more overt associational fashion, George Deem in his diptych *The Artist in his Studio* (fig. 32) pays homage to Jan Vermeer. Deem, who has often borrowed the great seventeenth-century Dutch painter's imagery, refers specifically in this diptych to Vermeer's *Interior with an Artist Painting a Model,* a subject Malcolm Morley also painted in 1968. Unlike Morley, who painted an image that copied the image of the Vermeer, Deem unites the Vermeer image in one canvas of the diptych with an updated version of it in the other. In the updated version, he substitutes a modern artist, presumably himself, for Vermeer, chooses a modern light fixture in place of Vermeer's elaborate chandelier, introduces modern furniture, changes the background hanging from a map of Europe to one of the United States. In modernizing virtually every physical element of the Vermeer painting while retaining the composition of the original, he reinforces the importance of Vermeer and the value of the past for his own work. And, in portraying himself from the rear in the act of painting, as Vermeer did, he implies that his work and the actual process of painting are more important to him (and to us) than is his self-image.

Along with these various types of single-image self-portraits, there is a large body of works related to contemporary realists' families. These portraits of wives and husbands, children and grandchildren, mothers and fathers, in-laws, even family pets, expand upon the artist's personal life and can be as revealing of the artist as self-portraits. Such paintings stand as celebrations as well as testaments of affection, and allow the artist to explore and understand close relationships. Most portrait artists prefer to paint persons close to them, even though it actually may be harder to paint someone known intimately than a relative stranger.

Alex Katz, Alfred Leslie, and William Beckman have painted many images of their wives, Ada Katz, Constance Leslie, and Diana Beckman; these images stand as the symbolic alter egos of the artists. In the past when paintings of this kind were made, they were generally private and intimate records of a family — in celebration of the birth of a child, for instance, or some family milestone. Their scale was generally relatively small. Today, however, they have a public scale that emphasizes their public role. The family portrait has come out of the family parlor.

Almost without exception, the family portraits show little deviation from the particular artist's established approach in other paintings. Philip Pearlstein's 1967 *Portrait of the Artist's Daughters* (fig. 33) and 1974 portrait of his daughter Julia on Fire Island may be less severe (even touching and cute, as in the former), and Alice Neel's family portraits may be less satiric and critical, than the usual work of either artist, but even Neel's are well within her tradition. Paul Wiesenfeld's *Portrait of the Artist's Children* (Pl. 8) may be atypical of the artist's recent work, but it reveals, nonetheless, interest in the ordering of forms and their sensuousness that characterizes his work in general. Similarly, the many family portraits by Alex Katz, Alfred Leslie, and William Beckman (as well as those by Fairfield Porter, Catherine Murphy, Sidney Goodman, or Andrew Wyeth) are painted without making concessions to the subject matter.

Portraits: Commissioned and Otherwise

It has been said, and rightly, that at the very time that American art reached its maturity, after World War II, portraiture came to a "dead halt";[21] it became the exclusive domain of commercial artists and photographers. In fact, the halt was really not all that sudden; the portrait genre had

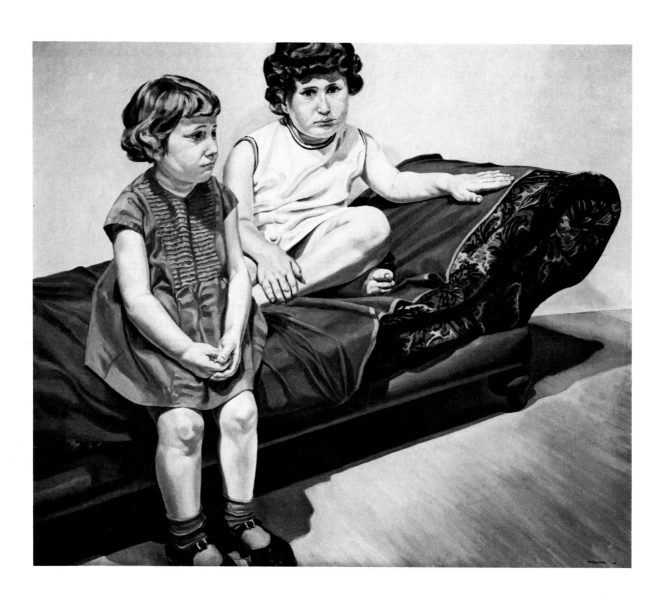

Fig. 33 Philip Pearlstein. *Portrait of the Artist's Daughters,*
1967. Oil on canvas, 60 x 72 inches. Collection of
Dorothy Pearlstein

only minor advocacy during the early decades of the twentieth century in America. Those mainstream artists who did work within the definitions of portraiture during this time did not do so out of the more traditional concerns of portraiture; they expanded upon the possibilities of the portrait, creating a valuable legacy.

The great American expatriate artist James Whistler, in his typically witty and perceptive fashion, defined a portrait as a picture where something is always wrong with the nose. Whistler's remark was in response to the seemingly inevitable question of what constitutes portraiture. Is it tied to mere description? Shouldn't it encompass other ends? Among contemporary realists there is no agreement; the extremes range from Alfred Leslie, who believes in "specificity," to portraitists who use the portrait form to make paintings that are more in an "autobiographical than a biographical form" [22] — where, as Philip Pearlstein said, "the imager becomes the image." [23]

Traditionally, portraiture has meant the recording of the visual data of the sitter. The degree of accuracy with which this was done or the amount of information that was required to satisfy the demands of the sitter has been anything but constant. Similarly, the value of recording the visual data of the subject has always been measured against the artist's ability to plumb his sitter's "inner life," to reveal the real person and not just his appearance. Alex Katz has expressed the traditional view: "If you work strictly in the portrait form, the likeness is a factor in how good the picture is. Strangely enough, if you don't have a good likeness, you don't have a good picture." But, he went on, "you can wreck a painting very easily if you get too obsessive about likeness," [24] a remark that supports the feeling generally held that there is nothing in art quite so unrewarding as a "plain" portrait.

Among realist portraitists there are traditionalists (those who care about likeness), modernists (those who don't, or who see it as a by-product of their work), and inclusive modernists (those who care about likeness, but in the context of a modernist ideology). Alex Katz is the quintessential inclusive modernist portrait painter. Katz, who began painting portraits about 1957, has repeatedly reaffirmed through his paintings the importance of what he calls the portrait form: "Any digression from the form — like painting from a photograph — would be to me an intellectual compromise of that form. The portrait form is where the challenge is. It's much easier to make a 'modern' picture outside of the form." [25] But he also has recognized the problems confronting the modern artist who sets out to paint portraits, having questioned since his student days at Cooper Union whether a painting that was a portrait could be valid in the context of modern art. In portraits like *The Light #3* (Pl. 10), Katz resolved this question (as he has in all his work) by being truthful to *both* the subject and the nature of the materials of painting. His preliminary pencil drawings, *Phyllis* (fig. 34) and *Carter* (fig. 35), were made as a means of gathering specific information about his subjects, which he incorporated into the final painted versions. In *The Light #3* he has not digressed from the portrait form, which is nonetheless expressed (as it is in much smaller aluminum cutout sculptures of the same subject) in his own modern terms.

Unlike Katz, contemporary modernist portraitists like Close (and the photo-realists as a whole) and Pearlstein regard likeness as a secondary issue. Close has said that he wants to paint something that other people care about and prefers the discipline that is imposed by the portraits; nonetheless, he ultimately picks the photograph that he will work from on the basis of what kind of painting experience it will provide. He has said, "Likeness is an important by-product of what I do, but only to the extent that if the photograph I paint from looks like the person the painting will look like the photograph." [26] He has never chosen to paint a portrait because of a person's physical attributes (the "you'd be great to paint" response), but rather, he scans contact sheets of photographs that he has taken, looking for images that contain visually stimulating information. The fact that the final paintings are many times life-size allows Close to disassociate the face from reality — as he has said, "to rip it loose from the context in which we normally confront a person's face." [27] The scale inevitably distinguishes the experience of a portrait by Close from the usual portrait experience.

Pearlstein, who has painted realistic portraits since about 1965, maintains that he is even less interested in the portrait as subject than are most

70

Fig. 34 Alex Katz. *Phyllis*, 1975. Pencil on paper, 15¾ x 22½ inches. Courtesy of Betty Greenberg Gallery, New York

Fig. 35 Alex Katz. *Carter,* 1975. Pencil on paper, 14½ x 22 inches. Courtesy of Marlborough Gallery, New York

Fig. 36 Philip Pearlstein. *Portrait of Mr. and Mrs. Edmund Pillsbury,* 1973. Oil on canvas, 48 x 60 inches. Collection of Mrs. John S. Pillsbury, Sr.

72 modern portraitists. He has even gone so far as to deny the right of people to have themselves painted by him as anything more than extensions of his own painting ego — sitters arrive as individuals and leave as Pearlsteins. He has said, "I'm not painting people. I'm dealing with what you see, how you see, and how you depict what you see. . . . I'm concerned with the human figure as a found object."[28] This long-standing commitment to painting how things look has resulted in portraits that, while drained of emotion and more often than not unsympathetic, are, nonetheless, highly realistic. The sitters in his portraits are easily recognized. His best portraits are those of married couples. Like the double portrait of Mr. and Mrs. Edmund Pillsbury (fig. 36), these develop the fullest possibilities of painting in terms of abstract design and spatial tensions at the same time that they reveal — more as result of Pearlstein's method of working than of his own innate sensibility — the essential individuality of his subjects. For, in spite of the artist's denial, some degree of the subject's independence comes through even if it is seen through the artist's trenchant presence.

Other realist solutions toward validating portraiture in the context of modern art have resulted in expressionistic portraits, many of which lack a high degree of finish but do provide enough information to reveal the identity of the subject. Likeness has less importance for Fairfield Porter, Larry Rivers, and Paul Georges than it does for Katz, but each of them used the portrait as one of the many ways of pursuing their interests in painting.

The portraits of Alice Neel are both more independent and more subject-oriented than most expressionistic portraits. Neel, who was born in Merion, Pennsylvania, in 1900, has been a portrait painter for more than fifty years. (She actually refers to herself as a figurative painter, disliking the word "portrait," which to her connotes a stuffy formality and the idea of commissions, of which she has purposely done very few.) She loathes the notion of a conforming bourgeoisie (her least successful portraits, some of which were commissions, are of bourgeois subjects), preferring sitters who reveal through their personalities the trauma and struggle of modern life. These subjects are drawn from a broad socioeconomic background, for while

Fig. 37 Theo Wujcik. *Philip Pearlstein*, 1979. Silverpoint on prepared board, 24 x 36 inches. Collection of Jalane and Richard Davidson

Neel has painted many members of New York's art establishment, she has also painted its derelicts and waifs. She has called herself "a collector of souls," attempting through her portraits to penetrate the social mask to reveal the sitter's vulnerability. Her portraits, like the one of Andy Warhol (Pl. 11), often combine a sense of reality and caricature. Her long-standing habit of drawing, at the heart of her aesthetic, enables Neel to see and understand the essentials of a form quickly. In her portrait of Andy Warhol she reveals these essentials —his soft, fleshy body, his pallid skin, the well-publicized scar from a near-fatal assault, a hauteur and vanity suggested by his stylish shoes—with an unrelenting, even cruel, exposition of fact. If Philip Pearlstein's portraits are revealing as a result of his scrutinizing method of work, Neel's are revealing because of her acute sensitivity to humanity.

The largest number of contemporary realists who make portraits employ a traditional methodology in which drawings and sketches are crucial, formative studies. While the act of drawing does not define any particular attitude to portraiture (Katz, Close, Pearlstein, and Neel all make drawings for different reasons), it seems true that portrait drawings made by many traditional realists are among the best figurative drawings being made in America today. The drawings fall into two categories: those in fine graphite or silverpoint, minutely finished; and those in rougher charcoals. In the first group are the silverpoint drawings of Theo Wujcik, like *Philip Pearlstein* (fig. 37), and pencil drawings by William Bailey, William Beckman, Martha Mayer Erlebacher, and Catherine Murphy; in these the quality of line is delicate and refined, the forms often have a faint, almost ethereal, presence. The drawings in charcoal, with which pencil is often combined, are more quickly executed (or at least they have that feeling). Jack Beal, Alfred Leslie, and Sidney Goodman make figurative drawings in this manner. In Leslie's 1976 drawing *Dina Cheyette* (fig. 38), the artist's hand is immediately obvious in the rigorous and active lines of varying thickness and density that define, along with a strong light, the image's forceful presence.

Leslie uses line and light to define the essentials of form; his approach to portraiture is largely predicated on his attitude to drawing. A die-hard traditionalist, Leslie has aimed to make "pictures which

Fig. 38 Alfred Leslie. *Dina Cheyette,* 1976. Pencil on paper, 39¾ x 30 inches. Private collection

74

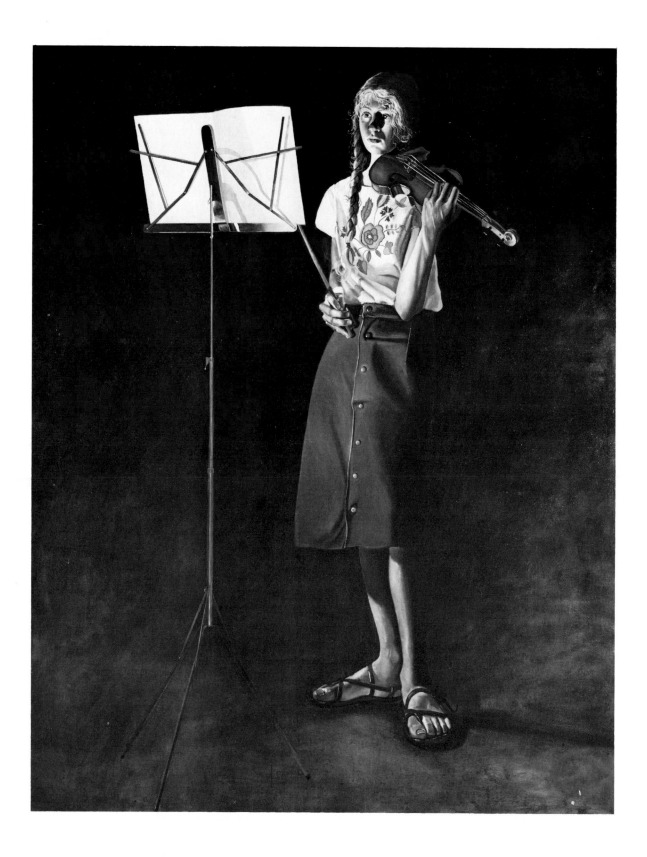

Fig. 39 Alfred Leslie. *Angelica Fenner*, 1978. Oil on canvas,
108 x 84 inches. Collection of Alfred Leslie © 1978

None

demanded the recognition of individual and specific people, where there was nothing to be looked at other than the person—straightforward, unequivocal and with a persuasive moral, even didactic tone."[29] Leslie believes that specificity is the essence of all great portraiture. From his first portraits, which date from the early 1960s, he has insisted on painting large canvases, for he wants his work to have an institutional life; he prefers to paint the whole body, sometimes nude, believing that the information about a person is best expressed by more than the face alone. He also prefers to paint working-class people (he admires the French nineteenth-century painter Jean-François Millet), seeking to express their dignity, or people whose appearances don't conform to ideal specifications ("not everybody has to look like a *Vogue* magazine person"[30]).

The portrait format initially preferred by Leslie was the single, full-length, standing figure, frontal, placed in the exact center of the canvas and seen from below. His self-portrait (see fig. 14) is typical; the figure has an awesome presence, inescapable, demanding of the viewer's attention. While this early format remains essentially intact, Leslie has expanded upon its possibilities; in recent single-figure paintings, like *Angelica Fenner* (fig. 39), the figure is notably less frontal, existing in a deeper space. It is also embellished with revealing associations (Angelica Fenner is a violinist) that relieve it of its starkness.

Whereas Alfred Leslie's use of the figure has always been motivated by both portrait and narrative concerns, Jack Beal's has not. Although Beal now shares Leslie's strong antimodernist sentiments, when Beal first began to paint the figure in the 1960s he was essentially an abstract painter. Figures in his work prior to 1970 are bloodless, cold, and synthetic, like the interior spaces and furnishings that transform them into inanimate shapes. Since Beal's "conversion" in the early 1970s his paintings have become increasingly humanized and didactic; he has used the painted figure to express his ideas about life.

Beal was forty-three when he received his first portrait commission, the double portrait of Sydney and Frances Lewis (Pl. 9). Not only does it remain his best portrait, it also typifies the demands he has since placed on all his work. In painting the

Lewises, Beal wanted more from the painting than portraiture. Likeness was important—he made charcoal studies of both sitters—as were references in the painting to some of the Lewises' interests and associations (collecting and the law school of Washington and Lee University, of which Sydney Lewis is a graduate). Yet likeness and references were not enough for Beal; the portrait also had to support a higher moral purpose. The painting of the Lewises, who had achieved success through hard work, commitment, and initiative, was commissioned to hang in the law school of Washington and Lee University. There it would be seen by students starting to make their way. Beal wanted the portrait to stand as a moral lesson, particularly to the young students, like a Puritan sermon on the value of good works and the pursuit of excellence. Thus the painting satisfies, Beal believes, the requirements of portraiture as a social force and as a moral force. In this way, portraiture can extend its usefulness beyond the immediate private domain.

The Nude

The painting of the nude among contemporary American realists also has no ideological center. As always, there are artists who are drawn to the nude by the formal and psychological challenges it presents. Whether the challenge lies in correctly rendering anatomical form, as in Martha Mayer Erlebacher's work, or in controlling the associative level (something Pearlstein insists is beyond the ability of any artist who represents the nude), the infinite complexities of painting the nude continue to challenge. The multiple issues the genre raises are both inherent in it and arise out of historical and contemporary perceptions. These issues relate to (among other areas) anatomy, psychology, social mores, sexuality, eroticism, voyeurism, caricature, narration, and feminism.

The French nineteenth-century poet-critic Charles Baudelaire challenged artists to find contemporary situations for representing the nude. Among contemporary American realists almost every artist who has painted the figure has also painted (or drawn) the nude at one time or another; it is ubiquitous and answers Baudelaire's challenge. The best of these have most often been painted in the studio, for while the nude has been painted outdoors (by Neil Welliver, Andrew Wyeth, Martha

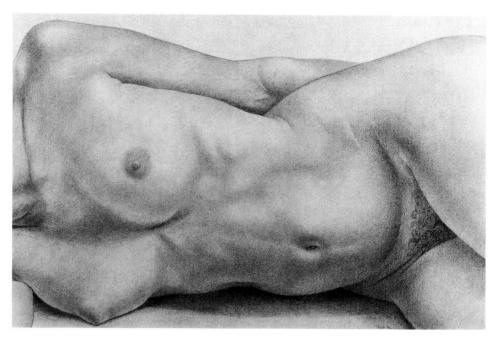

Fig. 40 Martha Mayer Erlebacher. *Red Torso #141*, 1976. Red pencil and pink chalk on paper, 12½ x 19 inches. Collection of Jalane and Richard Davidson

Mayer Erlebacher, Theophil Groell, and Jerry Ott, for instance), it remains a more comfortable indoor subject.

The most basic motivation for painting the nude today is still a fascination with the natural beauty and forms of the human body. Whereas anatomical correctness is not generally a primary goal (it is often said that anatomy is not an issue *unless* it distorts the form), the ability to render the human form correctly is still a challenge. To Martha Mayer Erlebacher anatomy is a vital concern; the body of the central figure of *In a Garden* (Pl. 12) is so obsessively studied that the figure reads more like an anatomy lesson than a real body. Its natural sensuousness has been reduced by its being over-anatomized; in spite of the fact that the anatomy may be accurate, the body doesn't seem right. This is not true of Erlebacher's red chalk and pencil drawings of the nude, among the most beautiful and sensuous realist drawings being made today. In *Red Torso #141* (fig. 40), for example, the anatomy is not overstressed; the torso forms are drawn with an exquisite naturalness that reveal the soft, voluptuous nature of the female body.

Martha Erlebacher's level of commitment to anatomy per se is not generally shared by other realists (except for some realist sculptors). Even William Beckman and Gregory Gillespie, whose fascination with the forms of the body and whose degree of surface finish equal Erlebacher's, paint what they can see more than what they know about the body. Both maintain that figure painting does not require a strong commitment to anatomy. In their search for realist form, Beckman and Gillespie are interested in creating volumetric forms on a flat surface with flat strokes of pigment, forms that occupy space and also read as surface. Sidney Goodman, Gabriel Laderman, and Theophil Groell, like Beckman and Gillespie, paint the nude out of a *primary* interest in the forms of the body, but they also use the nude to explore structural levels of meaning in painting. For instance, in Sidney Goodman's *Nude on a Red Table* (Pl. 13), the subject presents both an academic exercise in posing and painting a reclining nude figure and a vehicle for exploring formal issues. Structure is the dominant formal element in a Goodman painting and in this regard his tendencies are strongly classical; he favors an imposed, rational order that will give his work the

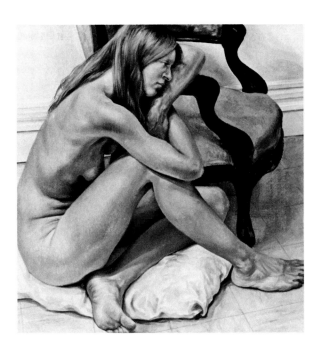

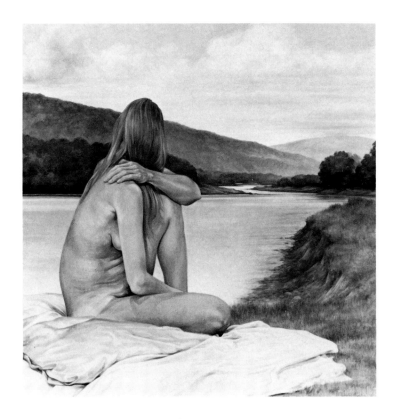

Fig. 41 Theophil Groell. *Seated Model with Chair*, 1979. Oil on canvas, 14 x 14 inches. Courtesy of Tatistcheff & Co., New York

Fig. 42 Theophil Groell. *Figure in a Landscape #5 (The River's Source)*, 1979. Oil on canvas, 20 x 20 inches. Courtesy of Tatistcheff & Co., New York

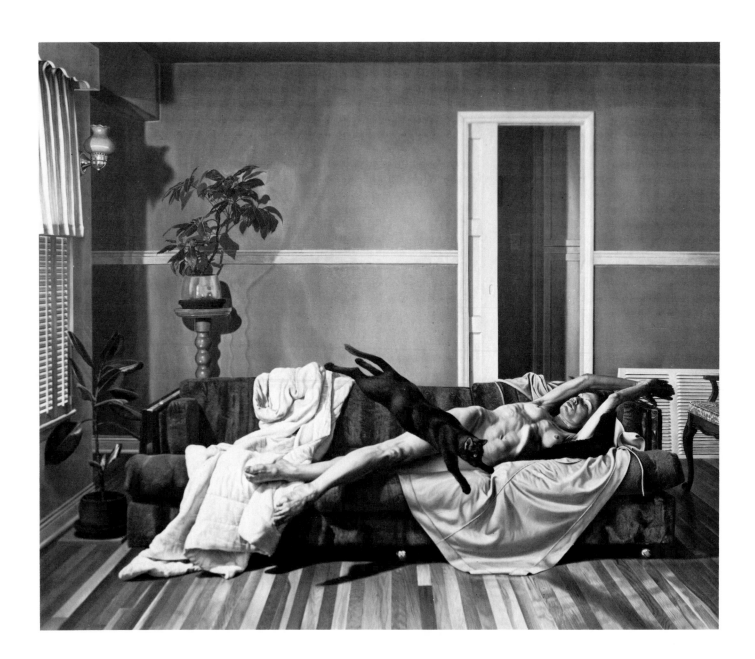

Fig. 43 James Valerio. *Reclining Dancer*, 1978. Oil on canvas,
 84 x 100 inches. Collection of the artist

proper balance or synthesis of the diverse influences that preoccupy him. Similarly, Theophil Groell's *Seated Model with Chair* (fig. 41) and *Figure in a Landscape #5 (The River's Source)* (fig. 42) are studies of the way in which a body occupies and defines space. Interesting comparisons, these works illustrate the effect of interior and exterior spaces on the figure. Although the union between the figure and the landscape in *Figure in a Landscape #5* seems forced, if not artificial, the figure itself, depicted against an open airy space, seems more three-dimensional than its counterpart in the shallower interior space.

If the nude figure as a collection of volumetric shapes is used to explore structural levels of meaning in painting, it is also used as a found object. Pearlstein, who is more closely identified with the nude than any other American realist painter, is among the least interested, ironically, in the nude as subject. Claiming that the biggest breakthrough in his career was the realization that "they [the nudes] were doing nothing but sitting there while I painted them," [31] Pearlstein declares that he uses the nude model as a convenience; he is interested in the description of its surface, its contours, and the way it occupies space. In a remark reminiscent of Gustave Courbet's advice to art students to paint the human figure as one would an apple, Pearlstein has referred to the nude human figure as a "constellation of still-life forms." [32] In fact, his nudes, mostly of women, a few of women and men in the same composition, and almost none of men alone, reveal a remarkable degree of detachment to the fact of nudity, as if he actually were painting a still-life form. Anonymous, unappealing, decidedly unsensual, the nudes in works like *Two Female Models on Eames Chair and Stool* (Pl. 5) or *Female Model on Ladder* (Pl. 14) are endowed with a neutrality based on Pearlstein's unwillingness to differentiate between the texture of the flesh and the textures of inorganic surfaces. As visually bold and brassy as his nudes may be, they are not sexually arousing images, and certainly not the perverse or filthy images that some would have them.

While it may be argued that all art devoted to the nude embodies a certain degree of erotic feeling, eroticism may nonetheless be irrelevant to a good deal of nude art. Alice Neel, like Pearlstein, denies the importance of the erotic element; she paints the nude as a means to penetrate through the social mask of clothes. As for Alfred Leslie, his nudes behave as if nudity were indeed the natural state of man.

Eroticism is, nonetheless, a major element in much nude art being made today, and its presence is fed by a sexually obsessed culture. Some erotic images follow the traditional odalisque formats of earlier erotic art in a nonspecific way. James Valerio's *Reclining Dancer* (fig. 43) combines the image of an inviting woman, a modern-day reclining Venus, with that of a black cat; the cat, to heighten the sexual symbolism of the painting, has an obvious reference to the literary and artistic traditions of mid–nineteenth-century France when cats were frequently combined with depictions of courtesans. John Clem Clarke's series of paintings on the Judgment of Paris, predicated on the idea of renewing the meaning of certain classical myths, is another instance of the link with tradition. The blatantly sensual images of Ben Kamihira, as in *Chinatown Centennial* (Pl. 15), reflect aesthetic links with the Oriental tradition that conditions Kamihira's style and attitude to his subject matter.

Historically, erotic art has been created by male artists painting the female. Now some women artists have reversed the situation. In *Imperial Nude: Paul Rosano* (fig. 44), Sylvia Sleigh has painted a male nude body in a traditional female pose — in fact, as an odalisque. However, unlike the females painted as sex symbols by males, Sleigh's nude, despite its title, is more a personal statement — couched in typically facetious, exaggerated terms — of Sleigh's ideal, an ideal that departs significantly from the stereotyped ideal male body.

The most erotic of all contemporary realist paintings of the nude are made by photo-realists like Jerry Ott, Hilo Chen, John Kacere, and Manon Cleary. Their works play up the sexuality of nude forms, achieving a heightened eroticism through a heightened illusionism. Jerry Ott's nude females assume larger-than-life, pin-up dimensions. Typically, in *Elaine/Studio Wall* (fig. 45), the erogenous areas are accentuated by the frontal pose. In many of Ott's paintings, the female figures exist as fanciful or real trophies of the artist. Hilo Chen's equally illusionistic nudes are even more erotic, although in *Bathroom #19* (fig. 46), Chen also shows interest in comparative surface textures; the smooth

80

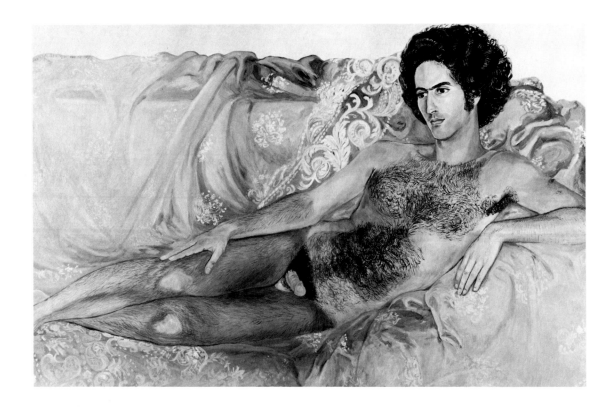

Fig. 44 Sylvia Sleigh. *Imperial Nude: Paul Rosano,* 1975. Oil on
canvas, 42 x 60 inches. Private collection

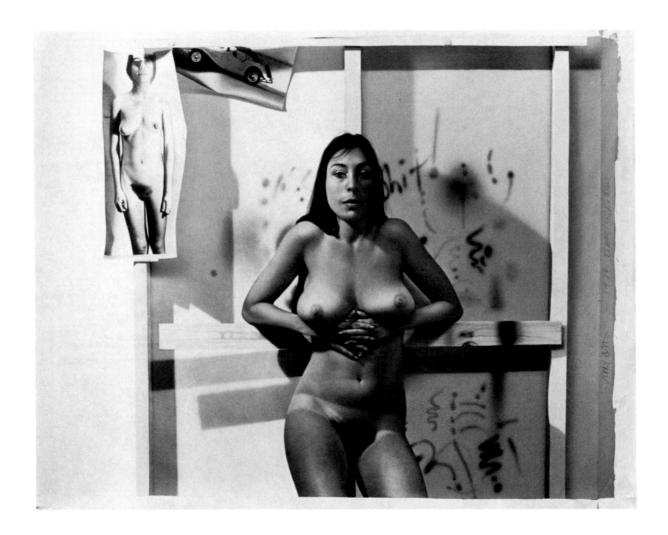

Fig. 45 Jerry Ott. *Elaine/Studio Wall*, 1974. Acrylic on canvas,
55 x 70 inches. Private collection

Fig. 46 Hilo Chen. *Bathroom #19*, 1978. Oil on canvas, 54 x 80
 inches. Private collection

83

Fig. 47 Hilo Chen. *Beach 60*, 1979. Oil on canvas, 54 x 36 inches. Private collection

Fig. 48 John Kacere. *Maude*, 1977. Oil on canvas, 36 x 54 inches. Private collection

84

finish of the bathroom tile and the sharp reflective surface of the rear mirror are played against the sleek, taut skin of the bathing nude. Chen's *Beach 60* (fig. 47) is even more aggressively sexual through its heightened finish and radical cropping. There is literally nothing else to look at (or think about) in *Beach 60* except breasts. John Kacere's favorite subjects have been the lower torsos of scantily clad women — *Maude* (fig. 48), for instance, squeezed into tight-fitting panties, viewed from close up. Like Chen, he follows the example of Pop artist Tom Wesselman and heightens the erotic level of his work by isolating and enlarging upon sexual forms. While lacking a pornographic intent, photo-realist nudes similarly place the observer in the role of voyeur.

The Figure Outdoors

The problems inherent in painting the figure outdoors are different from (and perhaps greater than) those of painting it indoors. The major problem is one of control: in the studio, the environment can be controlled; outdoors, the artist loses that control, particularly in terms of the alteration of the figure's forms by the changing natural light. He also faces the difficult problem of balancing the figure against the landscape, which has a tendency to dominate, and making the union between the two seem natural.

Many of the reasons, other than the challenge itself, for painting the figure outdoors are traditional ones, although prompted by contemporary impulses. The need remains to give expression to the long-standing theme of the unity of man and nature, of man's dependence on nature for his own real and spiritual welfare. There is also the need to express ecological concerns in a modern context. Obviously, as man has changed in his fundamental relationship to nature, so also has the art that manifests that relationship.

The theme of man and nature finds expression in a wide range of contemporary American realists, some of whom may not value such an interpretation of their work. In Alex Katz's *Good Afternoon #1* (fig. 49), for instance, the figure paddling a canoe across the lake on a peaceful, sunny day is benefiting from the recreational rewards of the outdoors. Man and nature have a sunny-day relationship; it is a world of short sleeves, bathing suits, and dark glasses. Nature is embraced merely for

its commodity value. On the other hand, in works by Andrew Wyeth of the figure outdoors, the relationship of man to nature seems more problematical. While the relationship may be benign, nature is always potentially threatening, a mysterious force never totally grasped by man. In *Distant Thunder* (Pl. 18) the figure lies on the ground enjoying the warmth of the sun, after the pleasures of a day picking berries and watching birds in the company of the family dog. Nature seems benign, offering both physical and spiritual comfort, but as the title *Distant Thunder* suggests, there are ominous, discordant rumblings in the offing that may upset this delicate harmony. Wyeth's figures never enjoy the sun for too long. Nature is more often solemn and brooding, cold and uninviting, vast for Christina Olson but for us also. Nature is not a commodity, but a fragile presence in our lives, and Wyeth uses it to raise fundamental questions about the meaning of life.

The values of farm life and man's direct relationship to the land are recurring themes among realists who paint figures outdoors. Nowhere is this theme more overtly presented than in Jack Beal's *Harvest* (fig. 50), which stands in the long tradition of paintings that give thanks to nature's bounty. Beal lavishes equal affection in *Harvest* on both figures and setting; the painting is conceived as a testament to the harmony that can exist between man and nature and as a metaphor of personal fulfillment. It was painted as an appeal to modern mankind to "return" to nature.

The sense of dislocation, of Americans being lost in their own backyard, that troubles Beal is at the heart of Willard Midgette's series of American Indian paintings. In *Hitchhiker* (fig. 51) the isolation of the figure in the vastness of the landscape suggests the alienation of the Indian — from his world as well as ours. In *Sitting Bull Returns at the Drive-In* (Pl. 16), Midgette portrays the Indian as an image on the movie screen, transformed from a real presence into a Hollywood cliché.

Among those artists who paint the figure outdoors there are those who, either stridently or not, express through their work a sense of impending ecological disaster. It may be too much to interpret Neil Welliver's series from the early 1970s of nude women bathing in natural pools as symbolic cleansing through a return to nature, but there is no doubt

Fig. 49 Alex Katz. *Good Afternoon #1*, 1974. Oil on canvas,
72 x 96 inches. Private collection

Fig. 50 Jack Beal. *Harvest,* 1978–1980. Oil on canvas, 96 x 96
inches. Courtesy of Allan Frumkin Gallery, New York

Fig. 51 Willard Midgette. *Hitchhiker,* 1976. Oil on canvas,
108 x 135 inches. Courtesy of Allan Frumkin Gallery,
New York

88 that Welliver is disturbed by the accelerated ravaging of the natural world, and he has written and spoken of this concern. Milet Andrejevic is another whose painting is largely conditioned by ecological concerns, saying, "impending ecological catastrophe gives our time its unique character."[33] His recurring use of images of Icarus falling to his death over New York's Central Park is intended as a reminder to mankind of his own impending doom if he continues to despoil the natural world. Rackstraw Downes, in paintings like *The Oval Lawn* (fig. 52), paints what is left of nature in New York City surrounded by the works of man. The encroachment of man on nature is even more apparent in Catherine Murphy's *Elena, Harry and Alan in the Backyard* (Pl. 17), where the figures occupy their small piece of ground uneasily, with a view of a parking lot and anonymous buildings marching toward them against the skyline. Martha Mayer Erlebacher's outdoor figures either bask in a fanciful nature reminiscent of a Pre-Raphaelite landscape or despair of a barren nature, as in *In a Garden* (see Pl. 12), where visible signs of natural life are almost totally absent. Edith Neff has painted figures atop a tar-papered roof, an urban equivalent to nature. Neil Welliver is clearly not alone in his concern that Americans have dangerously lost touch with nature.[34]

Fig. 52 Rackstraw Downes. *The Oval Lawn*, 1977. Oil on canvas, 17 x 47 inches. Courtesy of Kornblee Gallery, New York

Chapter Three

Fig. 53 Jack Beal. *Sloth*, 1977–1978. Oil on canvas, 38 x 31¾
inches. Collection of Dr. and Mrs. Wesley Halpert

Narrative Painting
Its Purpose Is to Edify

When Sir Joshua Reynolds admonished the new art students at London's Royal Academy to paint carefully chosen "history" pictures that would serve as moral lessons expressing the highest human ideals, he was reaffirming his strong belief that an artist must exert through his work and by his own example an active moral force in society. Conversely, Reynolds preached, the artist should avoid painting the kind of low, vulgar, and confining genre subjects which he found repellent in the work of his countryman William Hogarth, and which he could not see as exerting that moral force. Since his remarks, artists of each generation in America have aspired in varying degrees to Reynolds's idealism.

In the second half of the eighteenth century when Reynolds spoke, history painting — the depiction of exemplary acts of heroism, sacrifice, and patriotism as recorded in the annals of history, acts that would lend intellectual guidance and emotional support to the lives of mortals — found its principal advocates in America among artists who were anxious to use the events of the young country's history as the raw material for their paintings. Choosing this recent, American history over the distant, often obscure, history of classical times as recommended by Reynolds, who preferred the temporal and geographical remoteness of nontopical heroics, American artists like Benjamin West, John Trumbull, Charles Willson Peale, and Gilbert Stuart found inspiring subjects in their own backyards — in the history of colonization, in the struggle for freedom and the right of self-government, in the deeds of brave leaders who sacrificed their lives in defense of their ideals. Since then, the best American history painting has always been based on American themes.

History painting in the purist sense had a short life in American art. The type of history painting advocated by Reynolds, among others, and practiced by the neoclassicists in the late eighteenth and early nineteenth centuries, was rigidly bound by theory, but by the second quarter of the nineteenth century it had already lost its programmatic discipline both in Europe and in America, where it had been less disciplined to begin with. Its link to stylistic issues and the question of what constituted acceptable subject matter gradually became less significant even as the movement's reformatory zeal cooled. When neoclassical history painting lost its singularity of purpose, its dominance as a style faded suddenly. It was at this point that the idealistic ambitions of history painting in America were subsumed by a narrative art divested of stylistic polemics and predicated simply on the idea that a painting tells a story. The story told might just as well have a "low" subject as a "high" subject; the story could be anecdotal, based on the everyday life of everyday people, or it could be a historical theme with moralizing content. Narrative painting in nineteenth-century America developed these two distinct strains — one, a kind of narrative genre painting, popularized by artists like William Sidney Mount, Eastman Johnson, and George Caleb Bingham; the other, a kind of history painting made by artists like Emanuel Leutze and Peter F. Rothermel, who tried to keep alive the grand manner of eighteenth-century history painting. Both strains lacked dogmatic pictorial conventions, and while the latter was consciously narrative, the former was not.

By the early twentieth century, history painting per se ceased to exist. The popularly based, nondoctrinaire, independent brand of genre painting did find expression in the work of John Sloan, George Bellows, and Reginald Marsh, although it was soon seen as an anachronistic, idiosyncratic presence in the face of modernism. When its advocates did unite for the first time in the 1930s under the banner of

92 Social Realism, they gave the critics a welcome opportunity to attack their work. Art with a narrative content was decried as reactionary, propagandistic, and folksy. The degree of disdain with which Social Realism was regarded in many critical circles at the time is hard for us to imagine today. Subject painting, even more, subject painting with the strong narrative content of Social Realism, has continued since the 1930s to be held in contempt by the avant-garde. Even today in the most informed circles narrative painting is seen as either anachronistic or representative of a new brand of Social Realism.[1]

Contemporary narrative painting lacks the ideological biases that defined and limited American Social Realism of the 1930s. Social Realism self-consciously espoused native subject matter; it rejected anything non-American. It was an affirmation of a way of life with a distinctly rural bias (as in the work of Regionalist painters like Grant Wood or Thomas Hart Benton) and a lesser urban counterpart (as in the work of the 14th Street School or Ben Shahn). It was deeply concerned with causes: where injustices existed, where the rights of individuals were threatened, where economic discrepancies prevailed, Social Realist artists were likely to be found. They loved the downtrodden, the homey farm couple, ethnic minorities. Contemporary narrative painting, to the contrary, is not simply an affirmation of the American way of life; nor is it anti-European. Its subject matter is less parochial and more original. It is not so interested in causes; it attempts to edify and elevate rather than to preach. Nor does it reject modernism's pictorial conventions for purely traditional means; on the other hand, it is not scared off by the past. Sidney Tillim's thoughts on and practice of narrative painting are indicative of its inclusive nature. Interestingly, Tillim states that his predisposition to a narrative art "did not come out of an esthetic limbo. I was predisposed to it by modernist painting," seeing much modernist art as a "metaphor of extreme experiential potency [from which] one could induce a grandeur and quality from which all sorts of ideas could be reified."[2] At the same time, Tillim seems to have taken an antimodernist position in denying the desirability as well as the possibility of originality as a component in contemporary narrative painting. In supporting this position, Tillim says that if narrative painting can be restituted, it "must avoid the *stylish;* that is, it must avoid accommodating a taste."[3]

Originality is a critical requirement for modernist art; a modernist critic would argue that one of the main objectives of a contemporary narrative painting must be the invention of an "original" mode of expression appropriate to its content. Tillim and others, Alfred Leslie, for one, would disagree; *The Killing of Frank O'Hara, 1966,* Leslie's series of seven paintings based on the death of the poet-critic, makes this evident. In composing *#6: Loading Pier* (fig. 54) in the traditional format of a Christian Deposition, Leslie has consciously chosen a format that adds significance to this modern tragedy by the weight of its historical associations (the composition conjures up countless images of Christ being lowered from the cross — for instance, Caravaggio's *Deposizione*) rather than detracts by reason of its lack of originality. And yet it can be argued that Leslie's effective choice of a traditional format has somewhat lessened his own artistic role. Perhaps the reason that narrative painting has limited advocacy today is that artists are unwilling to take the ultimate antimodernist position of allowing content to dominate form, recognizing, moreover, that the success of their narrative works may be heavily dependent on borrowing historical pictorial conventions. If narrative painting is (in Tillim's words) "the end to which real representation strives,"[4] then it is disquieting that so many realist artists, abundantly gifted in painting what they can see, stop at recording with visual accuracy, eschewing the delights and possibilities of a narrative voice.

Contemporary narrative painting falls into two categories: a conscious narrative art, high-minded, public-oriented, moralizing by intent; and an unconscious narrative art in which the message is secondary, existing by implication. By far the largest number of these works (most by artists who may not attach a great deal of significance to the narrative level of their work) falls into the second category. The narrative issues that these paintings raise are determined in large measure by their subject matter. For instance, a landscape subject naturally evokes ecological concerns. In his paintings of the California redwoods, John Button has expressed concern over their dwindling population. Rackstraw Downes has painted pictures about industrial pollution. Idelle Weber's urban trash landscapes speak indirectly to the issue of man's avaricious consumerism and the impermanence of such forms of gratification. Other landscapists prefer to paint natural scenery in a way

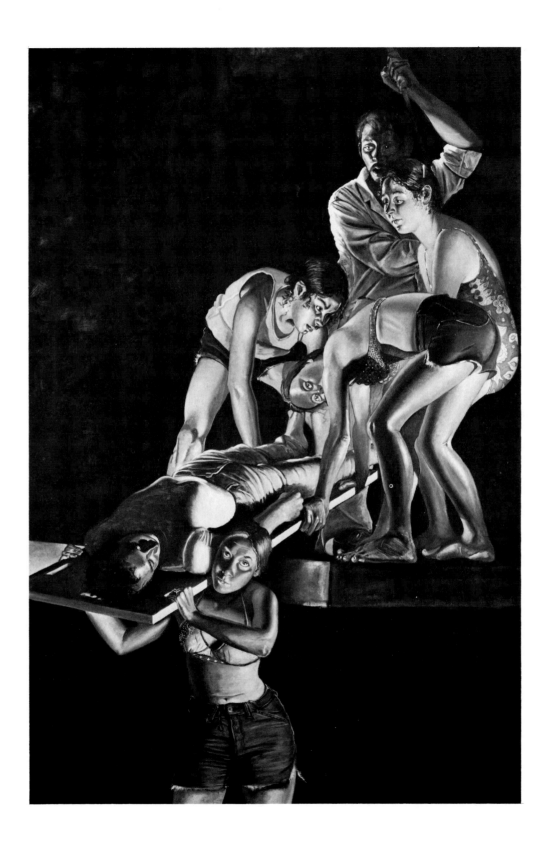

Fig. 54 Alfred Leslie. *The Killing Cycle — #6: Loading Pier,*
1975. Oil on canvas, 108/72 inches. Collection of Mr.
and Mrs. Robert H. Orchard

Fig. 55 Joseph Raffael. *Lily Painting Hilo II*, 1975. Oil on
canvas, 84 x 132 inches © Joseph Raffael. The Oakland
Museum, gift of Collectors Gallery and the National
Endowment for the Arts

that raises fundamental questions about creation, time, and natural processes. Joseph Raffael's phallic water-lily works (*Lily Painting Hilo II,* fig. 55), stand as metaphors of nature's powerful generative forces just as do William Allan's Alaskan mountain landscapes or Diane Burko's towering peaks.

It is fair to say that the level of narrative content is no greater in contemporary American realist landscapes than in contemporary figure or still-life painting, or in sculpture, for that matter. Naturally, the basic narrative issues are different within each genre, even if they are traditional in the historical sense. In the figure, these issues revolve around a series of affirmations and challenges: the principal affirmation is of the value of the individual (the sense of every man's worth) and of human rights and personal freedom (a tenet that has feminist implications). Human foibles are caricatured, man's vulnerability is witnessed, and the fact of mortality is invoked. In the still-life genre, the very meaning of reality itself is challenged by *trompe l'oeil* painting, and doubts about man's life on earth as well as reminders of his ultimate death are raised by *vanitas* still lifes. Still lifes on these themes by artists like Naoto Nakagawa and Audrey Flack are, in spite of their remoteness, as moralizing in intent as the most high-minded narratives of Alfred Leslie or Jack Beal, the two most important narrative painters in America today.

*Alfred Leslie: "The Killing of Frank O'Hara, 1966,"
and Other Narrative Works*

Alfred Leslie, born in 1927 in the Bronx, New York, where he later became a model and student at the Art Students League, worked in an abstract style during his early career. He had early successes as an abstract artist — Clement Greenberg selected his work for a *New Talent* exhibition at the Kootz Gallery in New York in 1950, so it had the stamp of approval; and Fairfield Porter saw in his work a "fresh, romantic, reckless expressionism"[5] — and his reputation as an abstract painter grew. Yet throughout the decade of the 1950s Leslie, like other artists at the Tibor de Nagy Gallery, where he showed, vacillated between abstraction and figurative work. Leslie has said about this period, "We were all in our twenties and the new abstract painting still astonished us, so we kept dragging our feet back and forth between what they did and what we should

do."[6] His first one-man show, at Tibor de Nagy in 1952, included half abstract and half figurative work. His second show there was all abstract, but his third continued "the muddle, with de Kooning-Matisse figures, flower paintings copied from *Woman's Day* magazine, and paintings taken from photos in *Life* magazine."[7]

At the same time that Leslie's painting was in limbo he was actively engaged in making narrative films. The earliest of these, *Directions: A Walk after the War Games* (1946–1949) and *The Eagle and the Foetus* (1945–1947), were begun before Leslie turned twenty; later films included *Pull My Daisy* (1959) and *The Last Clean Shirt* (1963). His involvement with film continued over some twenty years and gave evidence of his long-standing commitment to the possibilities of narration. This interest in narration in combination with an ever-increasing sense that abstract art was "through," at least for him, led to his decision in the early 1960s to become a realist painter.

Leslie's narrative aims initially were fundamental — first to reassert the traditional painting genres, and second, to do so in an aggressive realist format. Leslie accomplished both of his objectives in painting large-scale frontal figures, purged of art, as he liked to think of them — paintings like his own self-portrait (see fig .14) or the portrait *Constance West* (fig. 56); the latter was also intended to establish the validity of drapery painting in the context of twentieth-century art. At this stage in his career, the most aggressive element in his work was expressed in his choice of a realist style; in taking this option he was challenging establishment aesthetics and prodding his colleagues to be more daring and independent in their approach to art.

By the late 1960s Leslie's perception of the narrative ends that could be realized through portraiture had intensified significantly. His first real venture into narrative painting, *Act and Portrait* (figs. 57–59), is a triptych of an evocative but rather ambiguous nature based on three portraits of Constance Leslie, his wife. Its central panel, a 9-by-6-foot canvas entitled *Common Sense*, depicts a seated woman, obviously a "modern" woman in Leslie's mind, with her eyes closed, a shotgun across her lap. It is flanked by two 5-by-4-foot panels. The left panel, entitled *Your Kindness,* shows a seated woman, here a woman obviously perceived in historical

Fig. 56 Alfred Leslie. *Constance West*, 1968–1969. Oil on
canvas, 108 x 72 inches. Collection of Robert C. Scull

19 Alfred Leslie. *A Birthday for Ethel Moore,* 1976. Oil on
canvas, 108 x 132 inches. Collection of Alfred Leslie,
© 1976

20 Jack Beal. *The History of Labor in America,* 1976–1977. Four paintings, each 12 feet 3 inches x 12 feet 6 inches. United States General Services Administration, Dept. of Labor.

Above: *Colonization; Settlement.* Opposite: *Industry; Technology*

21 Alex Katz. *Swamp Maple — 4:30*, 1968. Oil on canvas,
 144 x 93 inches. Collection of the artist

22 Fairfield Porter. *Blue Landscape,* 1974. Oil on canvas, 45½ x 45½ inches. Lent by the Parrish Art Museum, gift of the Estate of Fairfield Porter

23 Jane Freilicher. *Afternoon in October,* 1976. Oil on canvas, 51 x 77 inches. Private collection

24 Neil Welliver. *Moosehorn,* 1978. Oil on canvas, 60 x 72
 inches. Collection of Albert J. Wood

25 William Beckman. *My Father Combining,* 1979. Pastel, 36 x 60 inches. Private collection, Boston

26 Jamie Wyeth. *Bale,* 1972. Oil on canvas, 28½ x 35 inches. Private collection

27 Rackstraw Downes. *Behind the Store at Prospect*, 1979–
1980. Oil on canvas, 18¾ x 46¾ inches. Pennsylvania
Academy of the Fine Arts, Philadelphia

28 Ian Hornak. *Persephone Leaving, Variation II*, 1975. Oil on
canvas, 72 x 48 inches. Collection Citibank, N.A.

29 Milet Andrejevic. *Toward Bethesda Fountain,* 1978. Egg oil
tempera on canvas, 38 x 50 inches. Collection of Lehman
Brothers Kuhn Loeb Inc.

30 Susan Shatter. *Panorama of Machu Picchu, Peru*, 1978.
Acrylic on paper mounted on linen, 48½ x 113½ inches

31 Nickolas Boisvert. *Flameout near the Cockscomb*, 1980.
Acrylic on paper, 29 x 45 inches. Collection of the artist

32 Joseph Raffael. *A Frog in Its Pond, 1977.* Oil on canvas,
78 x 114 inches. Private collection

33 Harold Gregor. *Illinois Corncrib #33*, 1978. Oil and acrylic on canvas, 36 x 51 inches. Private collection

34 Setsko Karasuda. *Summer Day*, 1978. Oil on canvas, 49 x 77 inches. Collection of Western Electric Company

35 John Moore. *South*, 1979. Oil on canvas, 72 x 48 inches.
Private collection

36 Richard Estes. *Ansonia, 1977*. Oil on canvas, 48 x 60 inches.
Collection of the Whitney Museum of American Art, gift
of Sydney and Frances Lewis

37 Don Eddy. *Hosiery, Handbags, and Shoes,* 1974. Acrylic on canvas, 40 x 57 inches. The Ludwig Collection, Aachen

38 Richard Estes. *Helene's Florist,* 1971. Oil on canvas, 48 x 72 inches. The Toledo Museum of Art, gift of **Edward Drummond Libbey**

39 Robert Cottingham. *Lao*, 1978. Oil on canvas, 30 x 30 inches. Private collection

40 Idelle Weber. *Cha-Cha, Brooklyn Terminal Market*, 1979. Oil on linen, 36½ x 73 inches. Private collection

terms, facing toward the central panel, holding a piece of paper on which is written a transcription of the note sent by Charlotte Corday to Jean Paul Marat and recorded by Jacques-Louis David in his *Marat Dying,* 1793. The right panel, entitled *Coming to Term,* depicts a nude, pregnant woman seated facing toward the central panel with meditative eyes cast downward, her form revealed by a bright light source from below.

Act and Portrait can be interpreted on many narrative levels. The left panel is clearly a homage to David and his reformatory spirit, a spirit Leslie closely associates with his own artistic purposes. It contains a specific reference to David in the note, and the painting also owes something to him in the costume, pose, and style in which it is painted. This panel also speaks to Leslie's feelings about the usefulness of the art of the past and of his desire to give modern expression to timeless values. The story of Charlotte Corday's murder of Marat, an event surrounded by ambiguity and controversy, is a narrative subject ripe for reexpression.[8] The French Revolutionary hero Marat, a self-styled "friend of the people," was murdered by the young pro-Royalist Corday in 1793. She, in turn, died on the guillotine. It is said that, although publicly despised for her act, she nonetheless won respect in facing her death with composure and resolution.

Leslie's reexpression of the Marat-Corday story in modern terms is not a political statement in spite of the fact that the story (and David's interpretation of it) clearly was, and remains, one of political consequence. Nothing in the triptych suggests, as one might expect, that Leslie favors one political ideology over another. Rather, *Act and Portrait* raises issues implicit in the original story, issues of life and death. The right panel, *Coming to Term,* forecasts the birth of a child; the central panel, *Common Sense,* includes a blatant reference to death. In fact, *Act and Portrait* can be understood as an allegory on the cycle of life in which Leslie urges the viewer to face life and death with the same courage and resolution exemplified by Charlotte Corday.

Almost all of Leslie's paintings in the 1970s have a narrative level; as Leslie has repeatedly said, he wants his paintings to influence the conduct of people. In works like *Marcelle and Pierre Monnin,* 1975, *A Birthday for Ethel Moore* (Pl. 19), 1976,

and in the monumental *Americans: Youngstown, Ohio,* 1977–1978, Leslie has become the painter-sage of modern America. His paintings of everyday life deal with basic human issues — love, friendship, the dignity of old age, the strength of the family, maternity, the decency of all people. They affirm the ideals of a democracy and the importance of human relationships in an increasingly technological society. In sum, they attempt to validate subjects that have been generally discredited by painters.

The most important of Leslie's narrative works is the cycle of seven paintings entitled *The Killing of Frank O'Hara,* 1966, the most ambitious (along with Jack Beal's *History of American Labor* murals) narrative works yet made by a contemporary American realist. Leslie began the *Killing* cycle shortly after the accidental death of Frank O'Hara, the poet-critic and friend of many New York artists, in the summer of 1966. O'Hara was killed by a beach taxi while standing on the sand on Fire Island late one night. The accident seemed so senseless that it moved Leslie to use it as the subject for an allegory on the stupidity and ineptness of much of contemporary life as well as an affirmation of his own Christian beliefs. The cycle, done over the next fourteen years, was also intended as a memorial to O'Hara and an expression of the personal loss Leslie felt.

Between 1966 and 1970 Leslie recalls making many large paintings (between ten and fifteen) and as many as one hundred drawings and watercolors for the *Killing* cycle.[9] While the drawings, which were made to document the events of the accident, survive, most of the paintings done at this time were destroyed; Leslie kept painting over them. Only within the last year has the final order of the cycle been fixed.

The cycle breaks down into three parts: three introductory paintings; the depiction of the actual accident (see fig. 60) and two paintings of events immediately following; and a final cemetery scene. All of the paintings are based on nature (Leslie spent months collecting information on the accident) and combine a specificity of time and place with a timelessness that allows them to transcend the actuality of the tragedy itself.

Leslie's role as narrator of the cycle is established by the three-quarter-length self-portrait that introduces the cycle. In asserting his own image rather than Frank O'Hara's, which might at first have

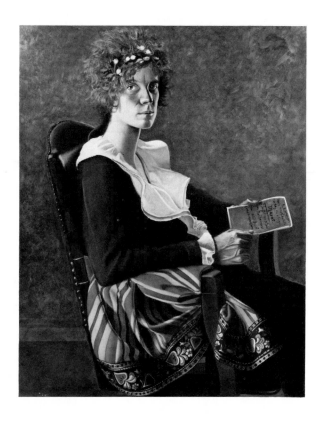

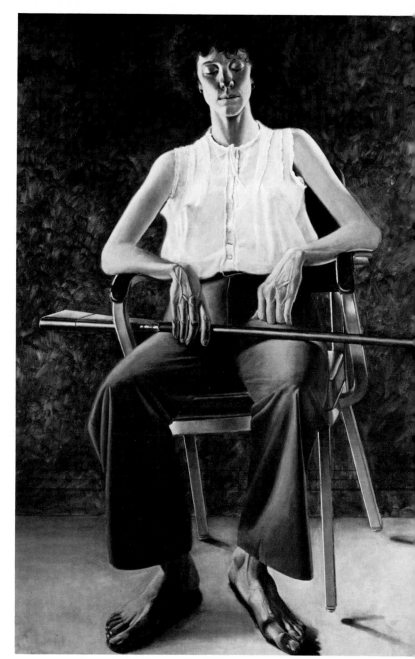

Figs. 57–59 Alfred Leslie. *Act and Portrait*, 1968–1970. Oil on
canvas. The Sydney and Frances Lewis Collection.
Your Kindness, 60 x 48 inches. *Common Sense*,
108 x 72 inches; *Coming to Term*, 60 x 48 inches

seemed more appropriate, Leslie has given the cycle broader implications. He is consciously attempting to legitimize the role of the artist as a moral force in society and to indicate that he wants to be identified with the issues that the cycle raises; not only does he care about O'Hara's death, he cares about people.

From the painter's self-image, the cycle moves to what appears to be a distant image of an island, water in the foreground and low-lying clouds hanging over a spit of land. Leslie says that at an early, documentary stage in the cycle's progress he "stayed for about a month in a house on the ocean and did nothing but sit in front of the window and paint the sky . . . to study the relationship of clouds and the changes in light in order to understand the landscape."[10] Yet the image of Fire Island is deliberately vague and distant; Leslie wanted the image to establish the idea of remoteness. The island symbolizes for him the possibilities for the reunion of man and nature. It is a "paradise" island, but for O'Hara, death comes in the form, ironically, of a taxi, an urban symbol.

By the third painting, the cycle's mood has suddenly changed from serenity, in the island, to one of impending tragedy: seen in pitch-darkness, O'Hara, still oblivious to his fate, is seconds away from being struck down. The two foreground figures watch, as helpless as the viewer to avert the tragedy. The implication, in this the darkest psychological moment of the cycle, is that none of us has control over our lives.

The next three paintings form a trilogy within the cycle — a sort of Crucifixion, Passion, and Deposition mini-cycle. The actual killing painting (fig. 60), in which the figure of O'Hara has been thrown into the air by the impact of the taxi, is nightmarish. The horror of the event is symbolized by fiendish figures out of a Blakean nightmare, shrieking their anguish. Its mood is in striking contrast to the fifth painting, in which O'Hara, who lies in front of the jeep, is comforted by a young girl. The fourth and fifth paintings contrast the horror of the realization of impending death with the repose of death itself; they also juxtapose the wantonness of man and his inherent decency. That decency is given the fullest Christian expression in the sixth painting (see fig. 54), in which O'Hara's limp body is entrusted into the hands of anonymous persons who are

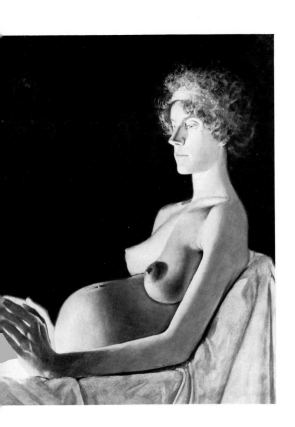

moved by the tragedy. Their support symbolizes to Leslie the ultimate unity of man.

The final painting in the cycle is removed in time and place from the event itself; it is a view of the country cemetery in Easthampton, Long Island, where O'Hara is buried. Of all the paintings in the cycle, it is the most resolute. Questions about life and death have been raised and answered. A mood of consolation and peace now prevails. The cemetery scene stands as a Christian affirmation of life after death as well as a personal statement on the importance of life itself and good works. It is no accident that the cemetery is well cared for. The artist-narrator, who once despaired over O'Hara's death (and every man's life), is now resigned to and sustained by it. Thus, he has accepted the fact of his own life and mortality; he has accepted the meaning of the Resurrection. He hopes the viewer will too.

Jack Beal: "The History of Labor in America," "Virtues and Vices," and Other Narrative Works

Jack Beal is as committed to making narrative paintings as Alfred Leslie. Born in Richmond, Virginia, in 1931, Beal was a student at the Art Institute of Chicago, where he was caught up in the tradition of his hero, Paul Cézanne. He worked for years thereafter seeking something in painting that was meaningful and his own. His principal interests in his paintings of the 1960s were formal problems, even though his imagery was figurative. The work of the late 1960s has loose aesthetic ties to American Precisionism, although the Precisionists, unlike Beal, almost totally avoided the figure. Like Precisionist works, however, Beal's had a precise, detached, synthetic quality. His movement away from this earlier synthetic style began in earnest in the early 1970s. Since then his position as the most vocal antimodernist among contemporary realists has solidified. Believing that modernism has been destructive of both art and life, he has taken the position that "aesthetics isn't everything";[11] art should "point a path toward a better way."[12] Like Leslie, Beal thinks that a responsible contemporary artist must strive to be an important moral force in society:

> I would love to think that painters could change it [what's wrong] all by themselves. I know that is not possible but I think that we can be part of this work to turn it around. And I think that what we have to try to do with our paintings is to make beautiful paintings about life as we live it, by verifying and celebrating the good parts of life as we live it.[13]

Beal now refuses to make paintings of "bad things or ugly things or destructive things."[14]

His earliest narrative paintings are feminist apologias and simple homilies on the virtues of dedication, hard work, and loyalty. His first chance to make large-scale public paintings with distinctly narrative ends came in 1976 when he was awarded the commission through the United States General Services Administration's art-in-architecture program for a series of murals for the new Department of Labor building in Washington, D.C. He chose to paint a four-part series, *The History of Labor in America*. He worked on the project with his wife, Sondra Freckleton, and three other artists — Dana Van Horn, Bob Treloar, and William Eckert — for fifteen months. The four paintings (Pl. 20), each approximately twelve feet square, narrate the struggles and achievements of labor in America during four periods in its history: Colonization, Settlement, Industry, and Technology. Overall, the paintings affirm the value of hard work (of which they are themselves examples) and good works in making the world a better place.

Beal has heightened the dramatic effect and meaning of the murals through an abundance of anecdotal and "period" detail that has an important symbolism. *Colonization* depicts a family gathered around a campfire, joined by a British trader bartering furs with two trappers. The painting is filled with references to time. Images of the past — the Old World, the homeland — are embodied in the distant ship and in the British trader. The ship serves as a metaphor of the past at the same time that it provokes questions. Why did the colonists leave the comfort of their homes? What are the motives of the British trader? Does America signify only the prospect of financial profit? Does the trader, along with the ax-wielding father (the first of many men to "strike a blow" against the wilderness) and the two armed trappers loaded with pelts, symbolize the innocent (or not so innocent) beginnings of nature's destruction in America? Is that great tree being chopped down to be reduced to the tiny seedling in *Technology* centuries later?

Juxtaposed with images of the past, which the family seems consciously to ignore, are the realities of the present — the struggle for land, warmth, and

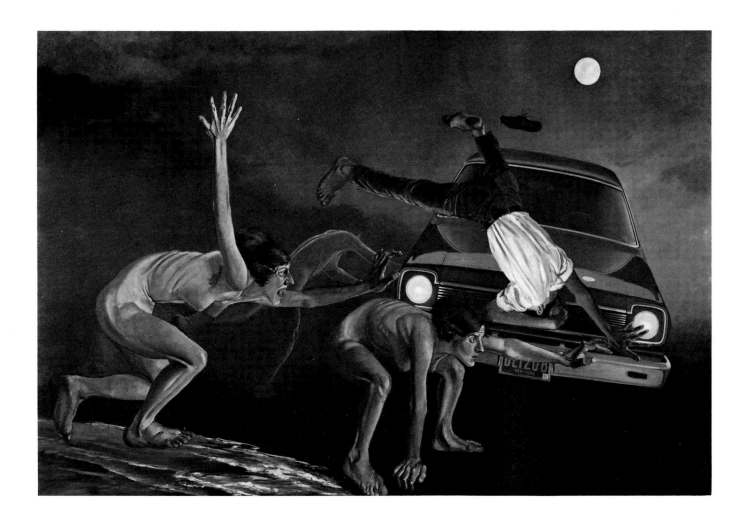

Fig. 60 Alfred Leslie. *The Killing Cycle—#4: Accident,*
 1966–1968. Oil on canvas, 72 x 108 inches. Collection
 of Mr. and Mrs. Robert H. Orchard

other necessities. Every member of the family, young and old, is engaged in the struggle; existence (like the paintings themselves) is predicated upon a group effort, out of which strong ties are forged. Love, friendships, mutual cooperation, labor — these are the bonds that will make America great. *Colonization* is filled with omens of promising things to come, and warnings of possible trouble along the way. The hold on the new land is tenuous; the colonial family is placed precariously near the edge of the shore, seemingly in danger at any moment of sliding into the water. The father, armed only with an ax and his own resources, faces into the wilderness, where unknown dangers that may become tomorrow's reality are lurking. Still, the painting suggests opportunities are there for those who are willing to work for them. A brilliant dawn in the east signals good things to come.

In *Settlement*, great progress has been realized in securing a foothold on the new country. The colonists are now established on dry land, at work building a substantial house. There is a commonality of purpose, for which the sturdy house is the symbol not only for the joint effort, but of the growing permanence. The ranks of the settlers have grown, they have fenced the land, they have greater resources to rely on, not the least of which is one another. The little girl, who in the previous painting tended her own food, is now the guardian of ducks. In herself, she symbolizes what labor can bear; her happy, playful presence would seem to assure a bright future.

In *Industry*, the image shifts dramatically from a rural to an urban context at the same time that the mood of the series shifts from optimism to pessimism. The union between man and nature that had brought the good life no longer prevails. The Industrial Revolution, symbolized by the giant wheels and cables of the cheerless machinery and the distant factory spewing pollution, has now pitted man against machine, and worse, against one another. No longer does the communal ideal prevail; the tycoon exploits both man and nature. Nowhere is nature present in *Industry;* she has been paved over. The act of protest, of striking, has become the reality of labor.

The last painting in the series, *Technology*, is clearly set in modern times. It depicts a group of technicians and scientists in the sterile environs of a modern glass and chrome work space. The ambiguity of the space is heightened by the darkness of the night beyond the glass walls. Literally every bit of light, other than the steely, unnatural fluorescent, has gone out of this world. While a group of technicians in awkward and precarious positions (as precarious in their relationship to nature as that of the family of colonists in *Colonization*) work to straighten out the tangle of wires that symbolizes for Beal the confusion of the modern world, a group of scientists, enclosed within a glass-walled laboratory, examine a sampling of plants. Seen as foreign curiosities rather than as part of the everyday world, examined by sophisticated modern equipment rather than by the natural eye, these plants symbolize all that remains of the natural world. Beal uses the small, potted seedling, which he shows himself holding, as "a symbol of hope living into the next century," [15] believing that the confusion of the twentieth century can be alleviated only by people working together to "resuscitate" nature. Man must reestablish meaningful ties with nature. If *Colonization* is a heroic painting and *Settlement* symbolizes the harmony possible between man and nature and among men, then *Industry* presents the demise of that harmony and *Technology* is a portent of inevitable destruction. Beal is frightened by the world he sees and tries to make the viewer share this fright as the first step toward a saner world.

Shortly after the mural project was realized, Beal began a group of six paintings entitled *Virtues and Vices* (the sixth painting, *Gluttony*, has never been finished). Unlike Leslie's *Killing* cycle, or Beal's own *Labor* murals, *Virtues and Vices* has no ordered sequence, and consequently each painting is not dependent on the previous ones for information. In fact, *Virtues and Vices* differs considerably from both the other narrative series; its themes are more traditional and timeless and the paintings themselves have the feel of studio pictures, a fact that detracts from their narrative effectiveness.

The most successful of the *Virtues and Vices* group are the least ambitious — two smaller, single-figure compositions entitled *Envy* (see fig. 26) and *Sloth* (see fig. 53). Unlike the other paintings in the group, which are intended as moral lessons, if not warnings, this pair performs a separate function within the overall narrative, presenting a subtheme dealing

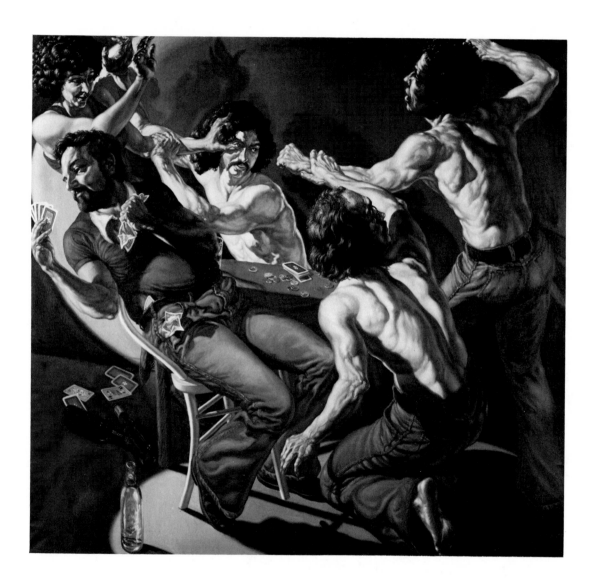

Fig. 61 Jack Beal. *Prudence, Avarice, Lust, Justice, Anger,*
1977–1978. Oil on canvas, 72 x 78 inches. University
of Virginia Art Museum, Charlottesville

Fig. 62 Sidney Tillim. *Count Zinzendorf Spared by the Indians,*
1970–1971. Oil on canvas, 60 x 80 inches. Collection
of the artist

Fig. 63 Paul Georges. *My Kent State,* 1971. Oil on canvas,
92 x 142 inches

with Beal's perceptions of the present conditions and requirements of contemporary American realism. These are serious concerns to Beal, and, like Leslie in the *Killing* cycle, he chooses to identify himself directly with them. *Envy,* a self-portrait, is an expression of the artist's concern that contemporary realists like himself have had to relearn the conventions of realism without having the advantages of a "master" teacher. Contemporary American realism, he feels, has been held back by the lack of "Giorgione-Titian type relationships"; he is envious both of the system that allowed Titian to study with Giorgione and its results.[16] But Beal is always optimistic, and *Sloth* suggests an answer to the problem: the present lack of a "master" can be partially overcome by sheer hard work, the opposite of sloth. Beal portrays a slothful figure against the glories of nature (symbolized by a vine of flowering red roses) and also suggests the challenges and achievements of other realist traditions (the book-cover image is Gustave Courbet's *The Meeting,* 1854), implying that for the contemporary realist to achieve his ambition he must rely on hard work, nature, and the best of previous realist traditions.

Beal's envy is hardly apparent in the remaining three finished paintings in the *Virtues and Vices* group. All of these seem overworked. The most obvious is *Fortitude,* in which the quiet, reflective, if not resigned, determination of a working-class couple underscores Beal's belief that the greatest heroism is the heroism of everyday life. The most ambitious (and the most mannered) of the six is *Prudence, Avarice, Lust, Justice, Anger* (fig. 61), a painting inexplicably built around a card game, which hardly lends credibility to the personifications, except that of Avarice. There is either too much or not enough information to deal with in the painting. The personification of Avarice, for instance, is easily understandable; the figure is intent on his own greed — a warning against a life-style of overconsumption. But Beal has not endowed the other figures in the composition with either a traditional or a new iconography to help clarify their roles. The figure of Justice, for instance, despite its long-standing iconographical traditions in the history of art, here is dependent on a single gesture for its meaning. This is also true of the other three figures in the chain reaction of Justice holding back Anger, who attempts to strike Lust, who is forcing himself upon

Prudence. Similarly, in *Hope, Faith, Charity* (see fig. 13), the figure of Charity, in a token charitable gesture, the giving of money, seems equally superficial and unaware of charity's broader implications. In sum, Beal has denied many of the figures in the *Virtues and Vices* group their full meaning, and therefore a strong narrative presence. In trying to impose heroic gestures on subjects that are not correspondingly heroic, he has actually reduced those gestures to polite, if not trite, clichés.

Sidney Tillim and Paul Georges

As artists, Sidney Tillim and Paul Georges have virtually nothing in common other than the fact that both are narrative painters, although narrative has far less importance for them than for Leslie or Beal. What they do share can only be described as a bizarre choice of subject matter whose narrative content is based more on personal than public concerns.

Tillim, born in Brooklyn in 1925, is well known for his provocative writings on realism. He was an abstract painter through the 1950s (and seems to be returning to abstraction today). He says he first thought of painting a narrative picture in 1963, although it was not until the early 1970s that his narrative efforts reached maturity.

As a narrative artist he has chosen a bewildering range of subjects—kitschy ones like *Rocky's Pyrrhic Victory,* themes based on the drama surrounding the Patty Hearst kidnapping, obscure biblical subjects like *The Syrian Persecution of the Jews by Antiochus Epiphanes IV,* or equally obscure historical events like *Count Zinzendorf Spared by the Indians.* Even in a mature narrative painting like *Count Zinzendorf* (fig. 62), Tillim seems to lack mastery of pictorial conventions to represent his subject. The painting depicts a little-known event that took place in Pennsylvania in 1740, when Zinzendorf, the founder of the Moravian order in Pennsylvania, was spared by a group of superstitious Indians who marveled over his apparent immunity to the deadly bite of a snake. The narrative message is not clear; one is so involved in the obscurity of the subject (even put off by it) that the fact that Tillim intended the painting to epitomize the racial tensions of contemporary American society is lost.

122 While Tillim's narrative paintings suffer from the obscurity of their subjects, Paul Georges's narratives suffer from being too personal and, at times, too trendy. Georges, who was born in Portland, Oregon, in 1923 and studied with both Fernand Léger and Hans Hofmann, has painted a number of large, violent narrative paintings in response to recent public tragedies: the assassinations of John F. Kennedy, Robert Kennedy, and Martin Luther King, and the tragedy at Kent State University. Georges has also based a series of paintings, beginning with *The Mugging of the Muse* and ending with the *Triumphant Muse*, on the demise and revival of figure painting in contemporary American art. Antimodernist statements, these paintings, overly dramatic and heroic, affirm Georges's own values as a painter.

One of the most violent, if not downright strange, of all of Paul Georges's narrative paintings is *My Kent State* (fig. 63). It places the image of a naked woman — a muse — in the context of the shootings at Kent State University in 1970. The meaning of the painting exists on two levels. On one level, it is a statement about prevailing artistic conditions in America; Georges shows himself kneeling at the left center of the canvas, vainly trying to restrain the threatened muse as she flees the violent scene. Her departure is symbolic of the plight of figurative artists in the modern world; with the muse gone, Georges implies, figurative artists are put at the mercy of an unresponsive society, just as the students of Kent State were at the mercy of the soldiers. On a more public level, *My Kent State* is a political painting, a response to and expression of horror at the event (in the tradition of Goya's *The Third of May, 1808* of 1814 and Manet's *The Execution of the Emperor Maximilian,* 1867). Replete with images of death and destruction (its wide red border symbolizes the spilled blood of the Kent State students), the painting is a personal denunciation of the tyranny of American government. Georges clearly lays blame for this tragedy on Richard Nixon, who stands with bloodied hands at the right, next to Spiro Agnew and John Ehrlichmann (ironically, Nixon turns his head away from the event itself, as if to ignore it is to deny its reality). To Georges, these men and their agents personified the malaise of the early 1970s, a malaise that Georges saw as a pervasive presence in his life. *My Kent State,* unlike most narrative paintings of the times, does not find redeeming qualities in contemporary life. It is a painting of singular despair, and as such is an almost unique image in contemporary American narrative painting.

Chapter Four

Fig. 64 Catherine Murphy. *View of World Trade Center from
a Rose Garden*, 1976. Oil on canvas, 37 x 29 inches.
Hirshhorn Museum and Sculpture Garden,
Smithsonian Institution

The New Landscape
Rural and Urban America

With the coming of the industrial and technological revolutions of the nineteenth and twentieth centuries, man's relationship to the land changed, perhaps as radically in the last hundred years as it has during the course of all history. Most Americans are no longer so close to the land in their daily lives as their ancestors were. This fundamental change has increasingly placed new demands on the contemporary landscape painter; it has also caused the artist who paints the land as subject, whether in traditional or innovative ways, to be accused of playing upon the nostalgia inherent in the landscape subject. Critics have tended to associate contemporary landscape, more than other genres, with traditional issues, particularly those issues of importance to landscape painting in the nineteenth century.

Unlike his nineteenth-century counterpart, the landscape painter today is no longer a wilderness painter, lost amid the wonders of a benign God's creation, eager to share its glories with those less adventurous. The market for painting of "natural wonders" no longer exists, just as the wilderness has itself almost disappeared. Wilderness has become rural country, country towns have become suburbs, the strip leading into the city is ubiquitous, and the city itself is more pervasive in our consciousness than ever before. When the poet William Cullen Bryant observed to the young American landscapist Thomas Cole, on the eve of Cole's departure to Europe in 1829, that he would encounter there a very different landscape, touched everywhere — unlike America — by the trace of man, Bryant could not have foreseen how quickly America's own wilderness would itself disappear. Notwithstanding, its topography remains distinctly American, making its painting a unique experience. Today, American landscape painting still has a strong identity and look. It is still as American as the Chevrolet that takes you into the country.

It would be wrong to suggest that as a consequence of the change of man's relation to nature during the last hundred years, contemporary American realists have completely rejected historical attitudes to the land or earlier styles of landscape painting. Here again, realism looks backward at history and tradition in order to go forward. Consequently, any of the classicizing, topographical, phenomenological, allegorical, semireligious, luminist, Barbizon, or Impressionist traditions of landscape painting in nineteenth-century America may not be irrelevant to the realist painter today. This openness to the past, in combination with the expressed desire of making landscape painting relevant to the present, has resulted in a new landscape expression of tremendous vitality.

Whereas landscape painting once flourished in nineteenth-century America (artists like Frederic Church, Albert Bierstadt, and John F. Kensett earned sizable incomes and were popular celebrities to boot), its appeal as a subject for painting gradually diminished in the twentieth century. Like other genres, landscape — as far as the mainstream of American art was concerned — was adapted to the purposes of modernism. According to the tenets of modernism nature was perceived, like all other subject matter, not as an inviolate reality but rather as something that might, or rather must, be manipulated by the artist to suit his own formal requirements. Such manipulation of the subject did not, however, automatically imply that nature was of little importance; it was still widely believed by most of these very modernists that a close study of nature's laws was an essential, never-ending element of an artist's education. Charles Burchfield expressed this:

A picture must have a sound structure, with all parts co-ordinated. This inner structure must be the result of the close study of nature's laws and not of human invention. The artist must come to nature, not with a ready-made formula, but in humble reverence to learn. The work of an artist is superior to the surface appearance of nature, but not its basic laws.[1]

And John Marin advised those who wanted to paint:

Go and look at the way a bird flies, a man walks, the sea moves. There are certain laws, certain formulae. You have to know them. They are nature's laws and you have to follow them just as nature follows them.[2]

Major American painters of the early twentieth century developed an abstract landscape style, departing from nature in varying degrees. For John Marin, regardless of his innate landscape sensibility and deep feeling for the scenery of Maine and New Mexico, nature was the armature on which to construct a cubist painting. Marsden Hartley painted landscapes to experiment with color relationships. Arthur Dove used natural forms, enlarged and reduced in terms of specific information, to create abstract shapes of imaginative color and design. Georgia O'Keeffe, the greatest American landscapist of the twentieth century, imposed her personal sense of order on the land without denying the laws of nature; her semiabstract landscapes are still clearly embedded in the parched hills of New Mexico, capturing the physical and spiritual essence of the place.

Landscape, if it can be called that, became fully abstract in the hands of the New York School, at the same time that the act of painting itself became an increasingly urban phenomenon. As a consequence, the direct experience of landscape became less available. It is not surprising that Willem de Kooning has painted many more landscapes since he moved from New York City to eastern Long Island, or that Andrew Wyeth, who lives in rural Chadds Ford, Pennsylvania, and Maine, has always made landscape an important part of his oeuvre. It is little wonder that mainstream artists directed their energies in the 1940s and 1950s into other channels, or that when they did paint landscapes, it was not out of a phenomenological aesthetic.

It has been argued, notably in the 1976 exhibition *The Natural Paradise: Painting in America 1800–1950* at New York's Museum of Modern Art, that certain Abstract Expressionist work (notably by Barnett Newman, de Kooning, Jackson Pollock, Clyfford Still, Mark Rothko, and Augustus Tack) shares significant characteristics with earlier traditions of American landscape painting. It was thought that if a meaningful link could be established between these painters, traditionally perceived of as dazzlingly new, and earlier American landscapists, it would, first, aid in legitimizing the landscape interests of the Abstract Expressionists; second, place them firmly in the continuum of American art history; and, third, confirm the belief that the American experience had a discernible impact on the look of all American art. The most fertile ground was found in comparing certain mid–nineteenth-century American landscapists with certain Abstract Expressionists. Both groups made heroic works. Both expressed the essential physical qualities of the American land — its expansiveness, openness, and bold topography. Both used a quiet, almost mystical, light to heighten the romanticism inherent in their work. Clyfford Still's "craggy paintscapes" were likened to the sublime mountainscapes of Albert Bierstadt, and the "impalpable luminosity" of a Mark Rothko was interpreted as having its roots in the luminism of a Martin Johnson Heade.

The argument presented by Robert Rosenblum in the catalogue was controversial, but whatever its merits, the very fact that nature — even the landscape image itself, however radically abstracted — was considered a valuable resource to the avant-garde was important to a younger generation of artists who looked there for guidance. Once these younger artists made the decision to paint realistically, the return to landscape was made easier by the abstractionists' acknowledgment of their positive relationship to nature.

The return to the landscape image came initially with the work of a group of gestural realists who painted in a manner influenced by the Abstract Expressionists, but who wanted to retain more of the landscape image in their work. Alex Katz and Fairfield Porter were the most important of these.

Katz's earliest landscapes, which were done directly from nature at the encouragement of his early mentor, Henry Varnum Poor, followed an approach to painting nature that was then generally disapproved of. In combining a strong underlying structure with an overall spontaneity, they show the various influences of Milton Avery (particularly

in a group of collages) and Jackson Pollock, whose work encouraged Katz to paint the "feeling" of nature rather than nature itself. A work like *Winter Scene* (fig. 65) reveals Pollock's influence especially, notably in its use of paint, but it also confirms Katz's desire, at this early stage in his career, to retain some of the image of his subject matter. His landscapes have never reordered nature, and in fact the images have become more realistic and content-oriented. *Luna Park* (fig. 66), easily readable as a moonlit landscape, is typical of Katz's approach in the early sixties. At this point he was abandoning the gesturalism of the Abstract Expressionists for a more finished style, and *Luna Park* is less painterly than earlier works. Reductive in its perception of nature, informed by a deliberate structuralism — in this case imposed like a grid — the painting is predicated upon a basic phenomenological attitude to nature. All of Katz's landscapes, in spite of their reductiveness, are specific in terms of time and place, weather and light; color is natural, distances are real, and the essential components of nature are realized. The title of a large landscape of 1968, *Swamp Maple — 4:30* (Pl. 21), sums up this aspect of Katz's relationship to nature.

Alex Katz's work, however, is essentially figurative, although his figure work is informed by attitudes that he developed early in his career as a landscapist. Fairfield Porter, on the other hand, is known especially for his landscapes. Born in Winnetka, Illinois, in 1907, Porter took his degree in art history at Harvard College in 1928, and then studied figure drawing (not painting) with Thomas Hart Benton and Boardman Robinson at the Art Students League. Neither Benton nor Robinson (whom Porter preferred as a teacher because he treated each student differently, whereas Benton approached teaching systematically) were particularly influential on Porter, and he later criticized Benton's painting for having "no sensuousness as far as the medium is concerned."[3] Porter consistently criticized provincial American painting for its relentless objectivity (in spite of the fact that Porter himself never painted an abstract painting), preferring instead the sensuousness he found in painters like J. M. W. Turner and the French Impressionists. An exhibition of the work of Edouard Vuillard in Chicago in 1938 was a revelation to Porter, prompting him to write years later in reference to Abstract Expressionism:

Fig. 65 Alex Katz. *Winter Scene,* 1951–1952. Oil on board, 24 x 24 inches. Collection of the artist

Fig. 66 Alex Katz. *Luna Park,* 1950. Oil on canvas, 40 x 30 inches. Collection of the artist

There was a return from the objectivity of Post-Impressionism to a non-objectivity like that of Vuillard which derived from the immaterial objectivity of Impressionism. . . . For both Vuillard and the Abstract Expressionists there is no object in the sense of there being no separation of means from ends.[4]

Porter's ideal (as expressed in these words) was embodied among living artists in the painting of de Kooning, whom Porter first met in the early 1940s and who remained a close friend throughout his life. In his own work Porter tried to attain this unity of means and ends.

In 1949 Porter moved to Southampton, where he lived until his death in 1975, spending summers on a family-owned island in Maine. Both eastern Long Island and Maine were to be the principal sources for his landscapes. Porter's approach to landscape painting was empirical, although he was not interested in the phenomenological aspects of nature except in the broadest sense. He wanted to understand nature so that his paintings would be better informed. He was in the habit of making quick pencil or ink drawings, wiry studies of form, as a preliminary means of working out his subject. These drawings were generally followed by a series of oil or watercolor sketches in which the forms were solidly located in space and their color and relative importance determined. Porter's method of fixing on a final composition was deliberate; he even took his own photographs with this end in mind. As a result, his paintings have a presumptive underlying structure even before he starts on the canvas, a fact that allowed him to concentrate during the act of painting on imparting the freshness and surface sensuousness that he so admired. In *April Overcast* (see fig. 1), a sense of rhythmic order is easily achieved through the parallel diagonals of path and road in the foreground supported by a white fence and row of houses in the background, a diagonal rhythm punctuated by the strong, repetitive verticals of the trees. The compositional order of a suburban setting like this, in which the organization of forms has already been articulated, hardly seems a challenge to Porter's keen abilities. It is in work like *Blue Landscape* (Pl. 22), one of many open, airy panoramic compositions painted in Maine, that Porter's sensibility to form, color, and light — the nonobjectivity of the immaterial that he admired so much in Vuillard — reached its apex. Full of delight in the season, firm of foreground and ethereal as the forms recede into space, *Blue Landscape* is true to nature at the same time that it is a triumph of sensitivity to the medium.

There are a number of landscapists, independent of one another, whose attitudes to landscape, like those of Katz and Porter, have been shaped in varying degrees by abstraction, but who will not deny nature its image. Almost all of these artists were influenced by the painterly gesturalism of the Abstract Expressionists (some worked abstractly prior to their commitment to realism) although a few were inspired by the geometry of Piet Mondrian. For some, the color of Hans Hofmann also played an influential role. Porter himself seems to have been an influence on a younger generation of realists; John Gordon's *Street in Iowa City* (fig. 67) is reminiscent, in its handling of paint, its structuralism, and its palette, of Porter's *April Overcast.* Thus these realist landscapists propose various solutions to satisfy the need both to work within the formal structures of abstract art and to work spontaneously from nature. They seek a resolution between dogma and perceptual responses to the real world.

Nell Blaine, Jane Freilicher, Lois Dodd, Wolf Kahn, Paul Resika, James Weeks, Robert Dash, Eugene Leake, and Neil Welliver are among this group. Kahn and Freilicher were students of Hans Hofmann and were deeply influenced by his ideas on color and on the dynamics of positive and negative space. Blaine was also influenced by the geometric structure of Mondrian's late work and by the spontaneity and improvisational quality of jazz music. She became a well-regarded geometric abstractionist in the mid-1940s, early in her career (at one time she was the youngest member of the American Abstract Artists group). Gradually, however, Blaine felt the need to work "more naturally," a need reinforced by her increased admiration for the painterly realism of mid–nineteenth-century landscapes (Courbet's especially) and by the atmospheric light and brilliant local color that she encountered on trips to Mexico and Greece in the late fifties. Since then she has worked directly from nature, painting canvases like *Landscape Near Connecticut River* (fig. 68), in which light and color so dominate the sense of natural form that it is hard sometimes to perceive her work in realistic terms. The landscapes have no sense of place.

Fig. 67 John Gordon. *Street in Iowa City*, 1978. Oil on canvas,
36 x 48 inches. Courtesy of Tatistcheff & Co., New York

130

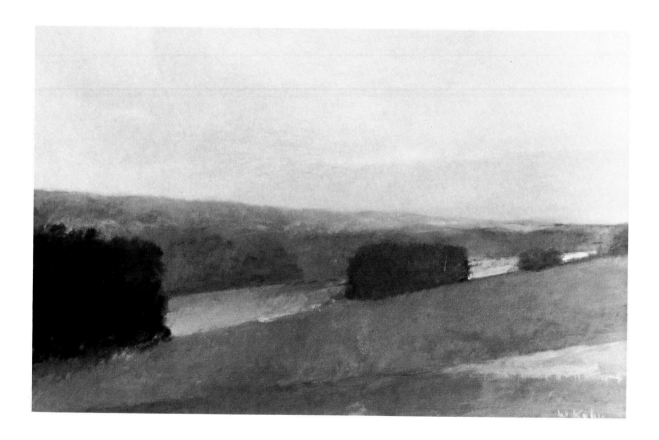

Fig. 68 Nell Blaine. *Landscape near Connecticut River*, 1973. Oil on canvas, 21¼ x 32 inches. Private collection

Fig. 69 Wolf Kahn. *Connecticut River*, 1976–1977. Oil on canvas, 44 x 72 inches. Collection of the Rahr-West Museum, Manitowoc, Wisconsin; gift of Mrs. John D. West

Jane Freilicher's best paintings, like Blaine's, are saturated with brilliant light and fulsome color, although *Afternoon in October* (Pl. 23) reveals the muted tones of a fall landscape. Unlike Blaine's work, however, Freilicher's are geographically specific; they seem rooted in the rural landscape of eastern Long Island.

Wolf Kahn considers his landscapes specific, but in fact they have no more feeling for a sense of place than Blaine's. The large panorama landscape *Connecticut River* (fig. 69) bears no more resemblance to the site than does Blaine's. But Kahn's landscapes do display a distilled order that goes beyond natural order, still farther beyond the disorder of Blaine's. His landscapes have none of the coloristic exuberance of Blaine or Freilicher, but are rather meditative and tonal, revealing a dependence on structure and connections. They contrast openness and density within a luminist haze — Kahn has said that he wants "to paint Rothko over from nature."[5]

Among landscapists who work out of this modernist-painterly aesthetic is Neil Welliver. Born in Millville, Pennsylvania, in 1929 and now a resident of Lincolnville, Maine, Welliver is both the most traditional, in terms of his concerns for landscape content, and the most radical, in his treatment of surface expression. Explaining his position, Welliver has repeatedly said that his relationship to the nineteenth century is not exclusive and that his goal is to make a natural painting as fluid as a de Kooning. Just as Alex Katz wants to be a modernist figurative painter, Welliver wants to be a modernist landscape painter.

Ever since his boyhood days in rural Pennsylvania Welliver has felt close to nature. That feeling now affects the way he has chosen to live. He lives on his Maine farm raising his own food and making his own energy, seeking through his life-style and through his painting a symbiotic relationship to nature. The Maine woods are his home; he regularly makes drawings, watercolors (a particularly important medium for Welliver), and small oil sketches directly from nature (only rarely does he work on a large canvas outdoors), using these studies later as he paints to aid his memory. Even though Welliver works empirically, returning to the woods frequently during the execution of a large canvas to "look

again," he essentially paints from memory and is not averse to altering reality, although he is loath to paint composites. His work has a strong sense of place.

In spite of Welliver's traditional side — his interest in nature's picturesqueness, his sense of nature as a benign therapeutic presence — he clearly predicates his landscapes upon recent modern painting. Welliver calls himself a child of the Abstract Expressionists, greatly admiring the painting of Franz Kline and de Kooning. As a student of Josef Albers and Burgoyne Diller at Yale University during 1953–1954, he was influenced by Albers's color theories, and his own first paintings were color-field abstractions. Around 1965 his painting began to become more directly representational. By the early 1970s, when he moved to Maine, he had established himself as a painter of landscapes, which often included large-scale figures. In Maine he found a subject matter particularly appropriate to his own sensibilities.

Welliver's sensitivity to nature and his interest in abstraction are equally important in the organization of his landscapes. The image of nature is as important to Welliver — it expresses his ideas about inclusiveness, it affirms the significance of place, and it allows for a narrative dialogue — as are the abstract concerns that govern his aesthetic decisions and goals: the attainment of an expressive, fluid paint surface and the creation of a flat, modern image that is at the same time airy and open. He has said that "he wants to put everything in your face."[6] In *Moosehorn* (Pl. 24), a painting in the tradition of interior wooded landscapes by nineteenth-century American artists like Asher B. Durand and Worthington Whittredge, Welliver has bathed the scene in a magical, crystalline light, touched by his personal sense of color (Welliver's color is almost always subjective; he feels no constraint to paint only the colors of nature). The painting provides the viewer with a wealth of visual information and implications about nature, even as it demonstrates the exigencies of being a modernist landscape painter. Solitary forest intimations, distant panoramas, seasonal depictions of nature, studies of native fauna, Welliver's sensuous landscapes are dialogues between reality and its relationship to painting today.

Whereas landscape painting in the hands of artists like Katz, Porter, Freilicher, and Welliver reemerged through the extension and enlargement of Abstract

Fig. 70 Andrew Wyeth. *Public Sale,* 1943. Tempera, 22 x 48
inches. Private collection

Expressionism, it also has survived in more traditional styles. These can be best considered according to subject matter, which includes natural, domesticated, and urban landscapes.

The Natural Landscape

The natural landscape is based on the observation of nature, either directly or through photographs, and its primary intention is to record the information perceived, most often in a landscape format. In such paintings nature is seen both as artifact and process, as an ecosystem in which man's presence (as opposed to a divine presence) is pervasive. The painters of these landscapes, the most traditional of contemporary realist landscapes, strive not to impose art on the subject, but rather to find it in the subject. At its best, the natural landscape is a styleless art, or at least an art whose style is not apparent. Lacking pretension (even its scale is modest), it is an art in which the plain, honest expression is preferred. A local art that is rooted in the topography of the land, it is frequently mimicked; at its worst, it lacks the force of sensation, and it can be boorish and commercial.

Andrew Wyeth, in addition to his prominence as a portraitist, has made landscapes from his earliest days as an apprentice in the studio of his father, N. C. Wyeth, in Chadds Ford, Pennsylvania. The elder Wyeth emphasized the importance of draftsmanship to his precocious son, who early on in his career developed a great facility in recording the visible world and found the infinite variety and moods of rural Pennsylvania and later Maine much to his liking. Wyeth's early watercolor landscapes reveal his passion for Winslow Homer. Curiously, in at least one case his early work shows a connection with the stylized landscapes of the American Regionalists, particularly Thomas Hart Benton; *Public Sale* (fig. 70), 1943, one of the few works painted entirely from memory, without the benefit of prior studies, makes use of that kind of stylized representation. In Wyeth's case it approaches a kind of Magic Realism in which natural objects are filtered through the artist's mind in a metamorphic process. More typical of his mature works are *Teel's Island* (fig. 71), 1954, or *May Day,* 1960, in which both the land and objects are rendered naturalistically. *Teel's Island* records the inevitable passage of time; it is a nostalgic image of a lone, weathered boat, a boat owned by Wyeth's good friend Henry Teel, a lobsterman in Maine, whose protracted illness brought on its abandonment. The intimate watercolor *May Day* acknowledges the many wonders, however small, that can be found in nature. Like John Ruskin's Alpine gentian, the little bank of wildflowers that grows alongside the mill-

Fig. 71 Andrew Wyeth. *Teel's Island*, 1954. Drybrush,
10 x 23 inches. Holly and Arthur Magill Collection

race at Brinton's Mill symbolizes to Wyeth the inherent goodness in nature and the rewards of a life close to it.

Wyeth's approach to nature is shared by others of the Brandywine River school. His work has been influential on artists like Philip Jamison, George Weymouth, John McCoy, and, notably, other members of the Wyeth family, particularly Andrew's son Jamie, born in 1947. Jamie was the student of his father and his aunt, Carolyn Wyeth, and his earliest work (mostly portraits) is unmistakably in the style of his father, with its tight, draftsmanly line searching to define the truth of objects. In the late 1960s, at the time he began to paint more landscapes, his work became more independent; his subject matter became more idiosyncratic, often expressing anomalous relationships in a landscape context; and his technique became more painterly, with a new material richness, an almost viscous surface to the paint. His paintings radiate warmth in marked contrast to the cold, sober moods characteristic of much of his father's work. They continue to display a strong commitment both to place and to nature; in *Bale* (Pl. 26) and *Pumpkins at Sea* (fig. 72), the natural forms are convincingly rendered, but enlarged and isolated in space. These landscapes reveal his interest in pure painting and in the effects of atmospheric condi-

tions on solid forms. While his work may lack the systematic and concentrated involvement that Claude Monet demonstrated in repeatedly examining a haystack under changing atmospheric conditions, and while the central form in a painting like *Bale* may not be denied to the same degree as Monet's haystack, Jamie Wyeth's painting makes it clear that he shares Monet's fascination with the transitory effects of nature.

The Brandywine school has been characterized (and stigmatized) as bent upon the exploitation of tradition; in truth, it is bent more upon an investigation of nature. That approach in itself does not isolate the Wyeths, as critics have tended to do; an increasing number of realist landscape painters have a similar approach. Much of the significance of these landscapists lies in the fundamental importance they attach to painting ordinary reality; they are not only demonstrating the visual variety of nature, but imparting a sense of its excitement and meaning. Within this genre, artists reveal a tremendous diversity of concerns, encompassing topographical as well as specific phenomenological studies — of water, sky, clouds, rocks, mountains, and trees.

Rackstraw Downes and William Beckman work in the most precise style of those landscapists who paint directly from nature. Downes, born in England

Fig. 72 Jamie Wyeth. *Pumpkins at Sea*, 1971. Oil on canvas,
22 x 40 inches. Private collection

in 1939, took a degree in English literature at Cambridge University. As an art student at Yale University in 1963–1964, he was an abstract painter influenced by Al Held. After a period of trying to emulate Held's "heroic geometries," Downes made a dramatic shift in 1965 and began painting realistically. He was at first influenced by Alex Katz and Fairfield Porter and later by Neil Welliver. His earliest paintings from nature, something of clichés, were bucolic landscapes rendered in a painterly style. Since the early 1970s Downes's landscapes have become extremely precise, partially as the result of his exposure to Flemish primitive painting on a trip to Holland and Belgium in 1972. Admiring the "thousand stories in every square inch"[7] that he saw in the work of Pieter Brueghel, Downes (like Gregory Gillespie) set out to make a detailed surface like Brueghel's without allowing the technical handling of materials to "ensnare" the viewer. He also came to admire the honest, documentary quality of American naive painting; it was not marred by what he least admired in modern art, "the insistent *art* component,"[8] and it elevated instead the day-to-day preoccupations of ordinary people to a level of significance he felt appropriate. To Downes, both the Flemish primitives and the American naive painters embraced the reality of the world.

In advocating the position that detail is the natural component, not the enemy, of a sublime reality, Downes has assumed the role of the romantic realist whose work ultimately transcends documentation. Yet without documentary content, art for Downes is all pretension. Interested in vintage panoramic photographs for the amount of unedited visual information they record and for what he has referred to as their calm, neutral attitude to subject matter, Downes has used the panoramic format in his own paintings. All of his works, including the urban landscapes, are first composed in sketchy drawings of superb quality made outdoors. One sheet of paper is added to another as the composition grows, laterally and up and down, until Downes has settled upon the composition's full extension. In the recent landscape *Behind the Store at Prospect* (Pl. 27), this extension is panoramic, although the painting itself is made up of a multitude of intimate vignettes heightened by a crystalline light. The intimacy of the scene is consistent with Downes's preference for a modest format; he has purposely chosen a rural scene in Maine that lacks melodramatic or even picturesque qualities that would require a larger format. In choosing a "plain" scene, painted in a straightforward way, he underscores his contention that beauty resides in conventional, even ordinary, subject matter, be-

lieving as John Constable did that art could be found under every hedge. Landscapist Richard Crozier shares Downes's sentiments. Crozier has cited his preference "to work with the unremarkable, familiar, anonymous landscape that one might see briefly out of the corner of one's eye from a freeway."[9]

Unlike Downes, who paints nothing but landscapes (including urban landscapes), William Beckman paints landscapes as a form of relief from the pressure of figure painting. An integral and important part of his oeuvre, nonetheless, landscapes allow him "to relax and loosen up,"[10] perhaps because he recognizes that he is unable to have the total control over the subject matter that he has over the figure. He also feels that there is an inherent nostalgia in landscape painting that allows him to take a less aggressive stance toward a subject. None of this means that Beckman regards landscape as a lesser subject. He grew up on a farm in Minnesota and that has fostered his respect for and commitment to the land.

Beckman's landscapes, rendered in a precise style, show his acute powers of observation. His best are characterized by a strong sense of place, either rural New York State or the farmlands of Minnesota. He likes to paint farms, with men and machinery at work in the fields, more for the inherent picturesqueness of such scenery than for the symbolism implied by the relationships of the farm worker to his land. To Beckman, the narrative issues of landscape painting are of secondary importance. He seems equally engaged by the delicate, evanescent forms of clouds in the tradition of nineteenth-century painters like Jasper Cropsey and Albert Bierstadt. Beckman's cloud landscapes — for they are not studies for paintings in the sense of John Constable's, for instance — reveal an uncharacteristic romantic sensibility at the same time that they underscore his phenomenological bias. In *My Father Combining* (Pl. 25), a large pastel done with incredible delicacy and control, the horizon line is typically low, much of the force of the work being achieved by the dramatic transition between the land and the sky. Beckman's clouds in *My Father Combining* are not "a little bit of straggling vapor thrown across the sky," as the English critic John Ruskin satirically said of many English cloud paintings of the nineteenth century,[11] but rather, are

closely observed phenomena that reveal a remarkable ability to render the ephemeral bits and passages within a cloud formation; the composition has structure and solidity despite its diaphanous nature. While *My Father Combining* may lack some of the immediacy of smaller cloud studies — for instance, Keith Jacobshagen's *Grain Silo 162 St. & Raymond Road August 4, 1978 4:30–5:45 p.m. 92°* (fig. 73), which is done in the manner of similar quick outdoor studies by Constable — it has none of the pretty agreeableness of cloud paintings by Yvonne Jacquette or the dreamlike theatricality of Ian Hornak's *Persephone Leaving* (Pl. 28). Both Jacquette's and Hornack's clouds drift in an unreal world; in Jacquette's case it is a world dominated by artistic conventions; in Hornak's, a spirit world, with something eerie about it.

Like Downes and Beckman, other realist landscapists prefer subjects close to home, even hackneyed, commercialized subjects, or ones associated with historical landscape traditions. Jack Beal's few landscapes are based on experiences on his own farm in Oneota, New York; Vincent Arcilesi's read like picture postcards; Alfred Leslie conjures up well-known painted landscape images of the past. Other realists find their subjects in distant places, searching out remote, exotic scenery

Fig. 73 Keith Jacobshagen. *Grain Silo 162 St. & Raymond Road Aug. 4, 1978 4:30–5:45 P.M. 92°*, 1978. Oil on canvas, 6¾ x 7 inches. Private collection

Fig. 74 Ben Schonzeit. *Continental Divide*, 1975. Acrylic on
canvas, 84 x 168 inches. Denver Art Museum, gift of
Mr. Robert Mulholland

in the tradition of American nineteenth-century landscapists like Frederic Church and Martin Johnson Heade. Gabriel Laderman's landscapes painted around Kuala Lumpur, Malaysia, are informed by (among other things) his desire to communicate information about the place. Susan Shatter has traveled to Peru, Greece, Canada, and throughout the southwestern United States to find the sort of exotic subjects she prefers. She avoids depicting familiar rolling hills, preferring grander scenery like Machu Picchu or the Grand Canyon, where land and water meet abruptly and where architecture and landscape are compatible, reinforcing each another. Shatter's most moving landscapes are the result of her visit to Machu Picchu. Images of the ancient Inca civilization, whose presence is realized through vestiges of its architectural heritage and by the awesome beauty of its natural setting, inspired works like *Panorama of Machu Picchu, Peru* (Pl. 30), 1978, and other smaller watercolor and crayon drawings of the same subject invested with an appropriate spirituality and romance.

Shatter works *en plein air,* filling sketchbooks with notations of far-from-home subjects later culled to provide information for larger works made in her studio. Many other contemporary painters prefer photographs to record landscape data. Those artists tend to be primarily concerned with perceptual issues, but not to the exclusion of traditional landscape concerns.

It is sometimes difficult to distinguish between these two ideologically different working methods in the resulting paintings, although more often it is obvious. In the case of Pearlstein's *White House Ruin, Canyon de Chelly — Morning* (see fig. 5), a depiction of a prehistoric Pueblo Indian ruin at Canyon de Chelly National Monument, Arizona, painted on-site, and Ben Schonzeit's *Continental Divide* (fig. 74), executed from a photographic source, the distinction is unclear. Pearlstein's *plein-air* vision (compare the painting with Timothy O'Sullivan's 1870s albumen print of the same site, fig. 75), is photographic, whereas Schonzeit's tends to soften the camera's harsh vision, so that one is uncertain about his methods. In other landscapes the perceptual distinction is more obvious. Any of Vincent Arcilesi's or Susan Shatter's landscapes are obviously directly perceived, while those by Johan

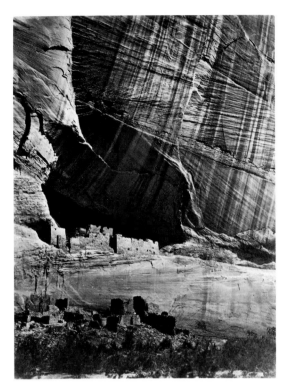

Fig. 75 Timothy O'Sullivan. *Ancient Ruins in the Canyon de Chelle in a niche 50' above present canyon bed,* 1873. Albumen print, 10⅞ x 7⅞ inches. Courtesy of the Library of Congress

Sellenraad, Nickolas Boisvert, Woody Gwyn, Yvonne Jacquette, and Diane Burko are clearly made from photographs (in the case of Jacquette and Burko, often from aerial photographs). Nevertheless, one cannot conclude that photographically derived landscapes are strictly formalistic and directly perceived landscapes are strictly anti-formalistic. Just as Pearlstein's *White House Ruin* is hardly a geological study or a narrative on a lost civilization, neither is Nickolas Boisvert's *Flameout near the Cockscomb* (Pl. 31) merely an exercise in translating photographic information into paint. Boisvert's work reveals a genuine fascination with the geological formations of the American Southwest.

Other contemporary landscapists whose work is derived from photographs are attempting to work in a modernist way (just as Pearlstein and Katz sought to validate the figure and the portrait in the context of modern painting). Joseph Raffael's work is best understood in this context. Raffael's paintings are ultimately worlds apart from the color transparencies from which they begin; in lieu of

138

Fig. 76 Joseph Raffael. *Highland Magic (Black Crag, Scotland),*
1975. Oil on canvas, 96 x 144 inches. Courtesy of Nancy
Hoffman Gallery, New York

Fig. 77 Harold Gregor. *Illinois Landscape #32*, 1979. Oil and
acrylic on canvas, 69 x 84 inches. Collection of
Wayne Andersen

140 making preliminary drawings (he has said that he is unable to draw anything "out of his head"), he takes literally hundreds of transparencies, from which he chooses the subjects he wants to paint. Raffael is fascinated by the photographic image — how and what the camera is able to record — and in a work like *Highland Magic (Black Craig, Scotland)* (fig. 76), he uses the camera to dramatic advantage in monumentalizing (the painting measures 8 feet by 12 feet) a lens-sized image of a pebbly shoreline seen through shallow water from above.

Raffael's commitment to the camera is highly personal, for he is anything but a literal copyist; he is also deeply committed to nature. He speaks often of wanting to express the sense of nature's wholeness, of being "all one" with nature, of "the need within myself to express visually through painting and through color the connection, the powerful connection, I've always felt between what was out in front of my eyes and that which was within me."[12] In *A Frog in Its Pond* (Pl. 32), a work with obvious symbolic overtones (why can't man be at one with nature like the frog in its pond?), Raffael

has rejected the idea of nature as artifact and his own aesthetic as object-oriented, preferring to view nature as a process of elemental forces in harmony with one another. Rejecting critical commentary on his work — he says it "leaves out the mind and soul of the artist"[13] — Raffael (ironically, since he does work from photographs) seems to be relying less and less on sight as the principal perceptually defining sense in his art and more and more on intuition.

Joseph Raffael's paintings deal with fundamental issues about life: generative forces in nature (symbolized by the phallic imagery in numerous water-lily paintings inspired by a trip to Hawaii in 1975), stages of growth and decay. They are loaded with implications, doubts, and affirmations; almost nothing in them is overt. In a more literal way, Harold Gregor's midwestern landscapes are also concerned with nature's cycles of life. They also begin as slides, but unlike Raffael's, they end up looking like projected slides — bright, hard, and lavishly detailed. Whereas Raffael performs a metamorphosis of the photographic image, Gregor is transcriptive. The narrative content of his landscapes is equally

Fig. 78 Vija Celmins. *Untitled (Big Sea #1),* 1969. Graphite on acrylic ground on paper, 34⅛ x 45¼ inches. Chermayeff & Geismar Associates

literal; *Illinois Landscape #32* (fig. 77) is one of a large number of paintings of cornfields that depict stages of growth. From the plowed field, to the seedling crop, to the ripened corn, to its corncrib home (see *Illinois Corncrib #33*, Pl. 33), he documents the natural process at the same time that he involves man in that process.

Gregor's fascination is with cornfields and corncribs; Vija Celmins's, with the ocean, deserts, and galaxies; Bill Richards's, with swamps; William Nichols's, with plant foliage; Robert Birmelin's, with rocks and rocky shorelines; and Setsko Karasuda's, with waves and reflections on water. All these artists share a number of characteristics: all have focused on a relatively restricted subject matter carefully chosen to accommodate their aesthetic concerns; none is object-oriented (Vija Celmins, for instance, is not a painter of oceans); all work from photographs exploring perceptual differences and their various possibilities of translation; and all, as modernist artists, exploit the tactile qualities of their medium, interested in it for its own sake as well as a means to convey illusionistic information.

Vija Celmins, who worked successively in an Abstract Expressionist and Pop style through most of the 1960s, in late 1968 began focusing on lunar and ocean subjects. Working either from clippings or her own photographs, she made graphite drawings on a smooth paper surface. These late 1960s drawings were the first expressions of what is still the meaning of her work: Celmins's drawings are dialogues between the image, which is always remarkable in its heightened illusion, and its physical presence, realized in the medium of graphite. *Untitled (Big Sea #1)* (fig. 78), a graphite drawing, expresses the tension inherent in the accommodation of this dialogue, a dialogue made possible only by the camera. Celmins's imagery is controlled by the camera's ability to locate an entire field of images on a single plane, images that she subsequently reinvents in graphite. Because of her exquisite ability to place "a fine-grained skin of graphite over the surface"[14] of the paper (graphite is her passion), she can emphasize the flatness of the imagery at the same time that she conveys the meaning of that imagery. In the case of the ocean drawings, she gives the ocean that sense of serenity and expansiveness associated with it. In the end, it is her quest for flatness in the context of illusionistic

imagery and her commitment to the medium of graphite that informs her work. As she herself has said:

> I was interested in working with space and flatness. The image has an illusionistic quality that is built into it. The image implies that there is a space, but all the things I do to it have to do with the here and now of the paper, the pencil, and the flat plane.[15]

Bill Richards has committed himself exclusively since about 1970 to the medium of graphite; a laborious worker, he recently has been making small-scale drawings that take from three to five months to complete. Although he works essentially from photographs, he does make sketches and notes of sites he depicts and says that he would "love" to work from nature directly but finds it impractical, if not impossible. Richards's drawings, like Celmins's, reveal a passion for and mastery of the graphite medium. With his control over the pencil, he is able to eliminate almost entirely the sensation of directional pencil marks; the fine particles of graphite seem to float seductively on the paper's surface, both supporting and denying the reality of the image, depending upon the distance at which it is seen. In spite of the artist's seemingly total commitment to the medium, Richards's drawings are informed (to a greater extent than Celmins's) by the artist's close relationship to nature. Of the drawings he has said, "Inspiration is crystallized ultimately by a strong and primary reaction to my subject matter and a natural passion for the medium of graphite on paper."[16]

In his subject matter, Richards looks for three essential qualities: complexity in terms of forms and surface patterns; malleability, so that the parts of the motif are flexible and easily rearranged; and an abstract presence, with movement and rhythm both across the plane of the drawing and in depth. In *Fernswamp (with a Hanging Branch)* (fig. 79) and *Shadow Brook* (fig. 80), he has found subjects in swamps, reeds, grasses, and dense stands of trees that suit his needs.[17]

Questions of perception raised by the drawings of Vija Celmins and Bill Richards are the fundamental issues of the natural landscapes of William Nichols and Setsko Karasuda. Nichols paints dense screens of plant foliage, and his images read as fields of colored washes on the painting's surface, abstractly patterned when seen from close up, sharpening

142

Fig. 79 Bill Richards. *Fernswamp (with a Hanging Branch)*, 1975. Pencil on paper, 18 x 22 inches. Collection of the Chase Manhattan Bank

Fig. 80 Bill Richards. *Shadow Brook*, 1977–1978. Graphite on paper, 18¼ x 22½ inches. Collection of Mrs. Glenn C. Janss

Fig. 81 William Nichols. *Day Lilies*, 1978–1979. Acrylic on
canvas, 64 x 92½ inches. Collection of Security Pacific
National Bank

144 into focus at a distance. In natural landscapes like *Day Lilies* (fig. 81), the thin, semitransparent washes of color, in a stunning range of green hues, give the natural forms hardly any solidity at all, even when the forms are in focus.

Setsko Karasuda's seascapes are more traditionally composed, although like Nichols's landscapes, they are essentially abstract. Like the horizontal bands of color in a Kenneth Noland painting, the ocean in *Summer Day* (Pl. 34) is perceived as varying bands of color on a flat surface. Karasuda's interest in reflective surfaces is essential, and strong light endows her seascapes with familiar reality. Nonetheless, in both Nichols's and Karasuda's works, the natural scene as a phenomenological presence has been reduced to a pretty and convenient imagery. The work of both these artists relies exclusively on the camera's vision as the perceptually defining sense.

The Urban Landscape

The natural landscape is in part a response (and some would say a nostalgic response) to the rapidly disintegrating phenomenon of nature in our lives. The urban landscape represents the artist's appraisal of man's self-created environment. It is both a celebration and a condemnation of the modern urban complex, and one of the most conspicuous contributions of contemporary realism. The new urban landscape encompasses images of garish commercialism expressed in the tacky architecture of the strip, gaudy storefront window displays, neon signs, streets blighted by refuse, anonymous urban sprawl, but also the energy and bustle of the contemporary city, historic landmarks as well as exciting new corporate towers. Almost never in the history of art have images of the city been so multifaceted.

The megalopolis holds the ultimate fascination for the urban landscapist (even Philip Pearlstein has

Fig. 82 George Nick. *Mother's Day, Newburyport*, 1977.
Oil on canvas, 35 x 48 inches. Institute of
Contemporary Art, Boston

145

Fig. 83 Ralph Goings. *McDonald's Pick-up*, 1970. Oil on canvas, 41 x 41 inches. Collection of Mr. and Mrs. Ivan Karp

Fig. 84 John Baeder. *Silver Top Diner*, 1974. Oil on canvas, 30 x 48 inches. Collection of Arthur and Jeanne Cohen

not been able to resist the subject), which is not to say that it is the only urban subject; small-town America and the suburbs (what might be called domesticated landscapes) are recurrent themes in contemporary American realism. Main Street, wherever it is found, the great American backyard, the local McDonald's, the sleek, often idiosyncratic diner, the corner gas station, are all familiar images that have found their way into art. George Nick's *Mother's Day, Newburyport* (fig. 82), with the washline hung out in the backyard, Ralph Goings's *McDonald's Pick-up* (fig. 83), and John Baeder's *Silver Top Diner* (fig. 84), images of middle America, exemplify the democratization of American art. Prosaic images belonging to the everyday world, they attest to realism's open-minded attitude to the most banal subject matter.

The credit for first establishing the contemporary possibilities of the urban landscape may best be given to the English-born artist Malcolm Morley in such a painting as *S.S. United States with New York Skyline* (fig. 85), 1965. Morley was obviously fasci-

nated by the overpowering presence of the city. But the quintessential urban landscape painter is Richard Estes, and it is Estes who has since instilled the urban image with its broadest implications. Estes was born in Kewanee, Illinois, in 1936 and studied at the Art Institute of Chicago from 1952 to 1956. He worked only sporadically as an artist until 1966, when he began painting full-time. He was making traditional figure paintings and charcoal drawings from the model and was undoubtedly unaffected by Morley's urban landscapes at the time — he maintains that he "was really only interested in very old-fashioned traditional painting."[18] Estes began painting urban landscapes in the late 1960s; ever since he has intentionally limited his subject matter, saying, "What's wrong with doing the same thing over and over again?"[19] During the past few years, his work has become the sine qua non of the urban genre.

Estes works from photographs (the only artist interested in precise execution who paints urban landscapes *not* based on photographs is, to my

Fig. 85 Malcolm Morley. *S.S. United States with New York Skyline*, 1965. Liquitex on canvas, 45½ x 59½ inches. Morton Neumann Family Collection

knowledge, Rackstraw Downes); generally he has no preconceived subject matter, but selects from among the thousands of contact-sheet images that he shoots randomly throughout the city. Unlike other photo-realists, Estes does not project a photographic image onto a canvas. His images are reborn on the canvas during the process of selecting information from the multiple photographic images that he has taken. The method is best explained in his own words:

> I can select what to do or not to do from what's in the photograph. I can add or subtract from it. . . .
> So what I'm trying to paint is not something different, but something more like the place I've photographed. Somehow the paint and the intensity of color emphasize the light and do things to build up form that a photograph does not do. . . . The reason I take a lot of photographs is to make up for the fact that one photograph really doesn't give me all the information I need.[20]

In the urban landscapes of the early 1970s Estes opted for a frontal image, usually shallow-spaced and confined to a narrow range. *Helene's Florist* (Pl. 38) is typical of these early images, although it is a more "beautiful" subject than most (Estes made the curious remark that his "paintings of ugly things are more successful than of beautiful things"[21]). In *Helene's Florist* richness and variety of visual detail, staggering in its profusion, would otherwise be overwhelming were it not for Estes's enormous talent in imposing a calm, classical order on his painted world. In spite of its obviously contemporary imagery, a timelessness pervades the scene, and a sense of an ordered perfection, revealed in a preternatural light, prevails. Estes, who now lives in Maine, says that he dislikes the environments that he paints; in fact, the viewer is given the image of an immaculate (even the few bits of litter seem clean), rational world in *Helene's Florist* that in the final analysis has little to do with reality.

In Estes's more recent paintings, such as *Ansonia* (Pl. 36), depth perception has been increased without sacrificing the intimacy of a focused reality, and without losing the opportunity for the incredibly tactile vignettes of reflections characteristic of his work. The drama of the reflected image in the glass panel on the wall diagonally receding in the right foreground is heightened by our own need to compare it with its original and by the spatial ambiguity the reflection creates. Ultimately, that ambiguity dissipates as one "reads" the painting more carefully, and what remains is a diptych-like,

classically composed composition in which our relationship to reality is clarified.

Estes's vision, at once urban and abstract, finds parallels in the work of other contemporary American realists, notably Davis Cone, Don Eddy, and Noel Mahaffey, although none of these has narrowed the parameters of his subject matter to the extent that Estes has. *Greenwich Theater* (fig. 86), by the young Georgian artist Davis Cone, reveals the same assertiveness of visual information, and the tension such information creates, that inform Estes's work; both artists are involved in the process of translating a lot of very small pieces of information into multifocused paintings, paintings that make it difficult for the eye to fix on any one object (which is one of the reasons why both tend to eliminate figures in their work). Cone's choice of subject matter, however, minimizes the visual ambiguity that is so essential to the drama of Estes's works and that allows Estes ultimately to give the viewer greater amounts of visual information than he is used to receiving.

Fig. 86 Davis Cone. *Greenwich Theater,* 1979. Acrylic on canvas, 41 x 36 inches. Private collection

148

Fig. 87 Noel Mahaffey. *St. Louis, Missouri*, 1971. Acrylic on
canvas, 60 x 72 inches. Private collection

The play on opposing realities, realities that coexist uneasily, makes Don Eddy an aesthetic ally of Estes. In storefront-window subjects like *Silverware V for S* (see fig. 12), Eddy has created a similar world of ambiguous and opposing realities. In *Hosiery, Handbags, and Shoes* (Pl. 37) a pane of window glass, itself a real presence, mirrors what is in front of it and allows what is behind to be seen, establishing three spatial planes, but so flattening these planes onto one that reality exists as a multitude of uncertain relationships.

In the end, since it is impossible for the human eye to focus on all three planes at once (it is even difficult to read the reflected images when they are flattened out on one plane), Eddy's paintings negate reality. They are primarily about the reality of painting.

Noel Mahaffey's panoramic views of American cities, done in the early 1970s, have little concern for the opposing realities that Estes and Eddy deal with. In the long tradition of topographical views of American scenery, they read like *National Geographic* photographs intent on broad, descriptive narration. But in Mahaffey's works, the narration is noncelebratory and nonpreferential — an attitude of "one city is just as good as another." *St. Louis, Missouri* (fig. 87) is one of many views in which the city is treated as a standardized object. While the famous arch does identify the city, one senses that Mahaffey has chosen the scenery, otherwise undistinguished, for the very fact of its anonymity. An even greater sense of anonymity informs John Moore's *South* (Pl. 35), a panoramic view of center-city Philadelphia in which Moore's interest is more in painting the volumes, color, and light of urban buildings than in identifying their specific location.

The same neutrality exists in similar panoramic urban views by Philip Pearlstein, Catherine Murphy, Yvonne Jacquette, and Richard Haas, each of whom has painted the city as an amalgam of geometric still-life shapes in space. Nonetheless, these same artists are capable of revealing their fascination with the modern urban phenomenon. Richard Haas, who worked nonobjectively through most of the 1960s,

Fig. 88 Richard Haas. *View of Manhattan, Brooklyn Bridge,* 1979. Watercolor, 27½ x 42½ inches. Collection of Jalane and Richard Davidson

honors the technology that made the modern city a possibility and the diversity that characterizes it in his *View of Manhattan, Brooklyn Bridge* (fig. 88). Interestingly, Haas has added to the visual diversity of his work through the monumental paintings he has executed on the exterior walls of buildings (the earliest of these dates from 1974). Recently he proposed a series of shadow murals, murals to be painted on blank exterior walls that would depict the shadows of razed buildings that once stood in the neighborhood. The possibility is unrealized to date, but it is one that would allow for a provocative dialogue between past and present architecture.

Other realists find inspiration in the drama of buildings. Catherine Murphy's *View of World Trade Center from a Rose Garden* (see fig. 64) objectifies the towering presence of modern skyscrapers; Murphy is attached to urban subjects that allow her to remain a neutral observer. Altoon Sultan prefers the eclectic forms of older architecture, latent with romantic overtones. Many realists (Hugh Kepets, John Button, Robert Bidner) paint fragments of buildings or signs, seeing in such subjects opportunities to explore their interest in abstraction. Robert Cottingham refers to these paintings as signscapes. While such works may not seem initially to be urban landscapes, they do explore the topography of a building's surface.

Robert Cottingham, born in Brooklyn, New York, in 1935, came to painting through a career as a graphic design director in advertising. He remains the most interesting of these artists. Cottingham has acknowledged the influence of Edward Hopper and Piet Mondrian on his work, but especially of Roy Lichtenstein (and one would think of Robert Indiana). Subjects that establish a strong tension between visual elements perceived photographically are of particular interest to him; he says his painting has improved since his own photographic ability and equipment have become more sophisticated. The subjects, which he describes as the "fragments, details of our environment, letter forms, words, textures, the man-made things that say more about man's condition,"[22] are all seen from close up, being radically cropped (he makes photographically derived drawings that are cropped even more). "The subject," he says, "must be honed to its most telling elements, all extraneous matter stripped away,

the end result being a detached, unsentimental observation of a piece of our world — a heightened reality carried to a level akin to surrealism."[23]

In spite of his strong photographic dependence, he recognizes the limitation of the camera, saying that the artist must instill in painting information that the photograph could never supply. A successful painting, he believes, should be well designed, but also be humorous, ominous, emotional, and aloof.

In *Lao* (Pl. 39), Cottingham achieves a dramatic image through the use of close-up forms and a spatial complexity in which lettering plays a dominant role. Like Robert Indiana, Cottingham is fascinated by the assertive presence of letters, although, unlike Indiana, he does not become involved with words for their symbolic or social meaning. He seems more interested in the form than in the message of his painted words. Like other photorealists, he has remained neutral about much that informs his art; in his reliance on banal, commercial subject matter, in his making of an art about signs (but not sign systems), and in his neutral position as an "anti-ego" painter, Cottingham shows his indebtedness to Pop Art.

Idelle Weber's landscapes of garbage or refuse are also informed by a Pop Art attitude to subject matter, although she employs a photo-realist's working method. Born in Chicago in 1932, Weber began painting figuratively in the 1950s, but by the early 1960s she was making works closely associated with Pop Art. In the late 1960s she began painting more literal urban landscapes of vegetable stands. Since the mid-1970s her work has been devoted to landscapes of refuse, works that might be considered the ultimate urban landscapes as well as allegories on the fall of man. Somehow, however, almost magically, Weber is able to instill a sense of dignity, even beauty, in such seemingly blighted subject matter. In works like *Cha-Cha: Brooklyn Terminal Market* (Pl. 40), the precise manner of Weber's style, her obvious delight in rendering forms (the light bulbs, for instance, are a tour de force), and her innate respect for the objects invest an otherwise alien scene with a poetic presence. Weber, like other urban landscapists, understands the world as a man-centered phenomenon in which there are few, if any, direct visual references to nature.

Chapter Five

Fig. 89 Paul Wonner. *Dutch Still Life with Pot of Chrysan-*
themums, 1978. Acrylic on canvas, 70 x 48 inches.
Courtesy of John Berggruen Gallery, San Francisco

Still Life
Objects That Delight the Eye

Contemporary American realists, for a variety of reasons, have delighted in the description of things and in giving the viewer a lot to look at. Nowhere is this more evident than in still-life painting, where a pleasure in objects themselves and their description informs much of the best work. In earlier traditions the subject matter of still life, whether flower, fruit, fish, game, breakfast, or banquet pieces, followed established patterns often predicated on iconography; almost never was a still life composed of objects chosen randomly, without consideration of their meaning. Iconographic significance, however, is no longer an essential component of most still-life painting, and by and large, contemporary painters choose to paint objects because they are convenient, because they pose descriptive challenges, or simply because they delight the eye. Contemporary realist still-life painters are challenged by two imperatives: a passion for forms, perceived either factually or essentially, and their ordering in space. No matter how untraditional its subjects may be, the still-life genre in America today embodies a sort of classicistic revival based on *nature.*

American still-life painting had modest beginnings in the early nineteenth century, but by the third quarter its scope had increased to encompass a full range of subjects — conventional tabletop still lifes with fruits, flowers, vegetables, or dead game; rare porcelains and glass; ordinary crockery and old books; *trompe l'oeil;* and still lifes of objects chosen principally for iconographical reasons. There were also a small number of studies of living things — plants growing outdoors or fruits on a branch — a type advocated by John Ruskin, whose writings on art were influential in America in the mid–nineteenth century. Except for these nature studies, still-life painting meant *nature morte.* It was a representation of objects that lacked the ability to move.

The categories of contemporary American still life follow earlier patterns, although there has also been a significant development in terms of new imagery. The "Big Machine" paintings of photo-realists Tom Blackwell, Ron Kleemann, David Parrish, and James Torlakson, for instance, are, in my opinion, best considered as still life. Since these subjects have the ability to move, works of this kind, and others, such as animal paintings, are not still lifes in the strict sense of the term. However, the imagery is almost always treated in a still-life sense; that is, the objects are presented as a myriad of shapes ordered in a well-defined, often enclosed or shallow space that enhances the viewer's ability to examine them closely. Ron Kleemann painted *Big Foot Cross* (fig. 90), as both a visual icon of contemporary America and as a form with a seemingly infinite variety of intricate shapes, colors, and reflections. His attitude to the imagery, then, is no different from that of a traditional flower painter. While Kleemann's subject has literally come down off the ledge (the ground now serves the function of the ledge in traditional still life), it remains the single object on which our attention is focused. And yet its greater meaning is not lost by the fact of its total objectivity.

Much of the best contemporary still-life painting lives in limbo between the artist's need to describe forms objectively and, at the same time, to transcend description. Janet Fish has said that she is interested in the literalness of specific forms so that they "read right"[1] (she admires the precision and tangibility of Dutch seventeenth-century still-life painting), but she seeks simultaneously to divest her paintings of their explicit reality. William Bailey wants his shapes to have "the credibility of real objects — or real place" so that there is "always that tension between the clarity of the object — the reality — and the artifice that's employed,"[2] a credi-

Fig. 90 Ron Kleemann. *Big Foot Cross*, 1977–1978. Acrylic on
 canvas, 54½ x 78 inches. The Solomon R. Guggenheim
 Museum, New York

bility enhanced by the deliberate ordering of forms seen frontally. And yet Bailey, who paints from memory, endows his forms with a mysterious, even supernatural, quality that transcends literalness. Other artists take different ways to transcend description: Louisa Matthiasdottir describes forms in terms of an expressionistic paint surface, while Nell Blaine and Jane Freilicher see objects in terms of color — both approaches that minimize illusionism in favor of "essential" description. Stephen Posen's works were once predicated on a highly illusionistic surface (see *Variations on a Millstone*, Pl. 2, painted from an enlarged photograph with pieces of colored cloth stapled to it). He now believes that such extreme illusionism is contrary to his purpose of expressing the essences and natural unity of objects. Thus he now draws and paints directly from the objects (see fig. 110), which are largely chosen for convenience; this process is more conducive to eliminating the details of reality in order to come to terms with the exclusive nature of the subject. Like other realists, Posen understands the different, but noncontradictory, levels at which reality can be encountered and remain perceptually meaningful.

Tabletop Still Lifes

The tabletop composition has been the most traditional still-life format in American art, with objects set up as if on display in a shallow space that confines the viewer's attention to a narrow focus. In the hands of contemporary realists, it reflects basic attitudes to the essential idea of still life, sometimes making reference to historical still-life conventions, more often enlarging upon those attitudes to give new meaning to the form. Like his realist peers in other genres, the still-life artist is free to renegotiate the relationship of what he sees to how he chooses to paint it.

The most traditional tabletop still lifes are ones that unabashedly borrow earlier conventions at the same time that they seem to deny recent developments in modern art. To paint objects for their own intrinsic beauty, to convey pleasure in their color, texture, and form, is largely the motivation of John Stuart Ingle's still lifes. *Still Life XXX* (Pl. 41) unmistakably bears the look of earlier still lifes without appearing to be wholly anachronistic. It employs age-old compositional conventions — a knife pointing diagonally into the composition, a tablecloth breaking the

plane of the table's side, peeled fruit — and juxtaposes objects of pleasure in the manner of seventeenth-century Dutch still life. In spite of its strong affinity to the Dutch tradition, however, it is made modern by its ability to overcome, yet at the same time retain, its literalness within the context of modern pictorial strategies. The objects exist less as ornaments than as space-fillers; Ingle is as interested in an overall surface patterning and in the richness of the medium as he is in the objects per se.

The tradition of Dutch seventeenth-century still-life painting also informs the still lifes of James Valerio. *Still Life #2* (Pl. 42) is painted on a monumental scale (it measures almost 8 feet by 10 feet) that far exceeds the physical ambitions of the earlier Dutch painters. Nonetheless, in the obvious passion for form and the objective, detailed rendering, *Still Life #2* reflects the phenomenological approach of the Dutch tradition. Valerio's allegiance to descriptive drawing — he has a clear drawing bias, as evidenced in his still-life paintings as well as in exquisitely finished drawings (see fig. 91) — is at the root of his painting aesthetic. His reluctance to make the slightest concessions in descriptive detail for the sake of a greater pictorial unity causes one to "read" his paintings rather than to "feel" them.

Michael Webb, a young artist who lives in Philadelphia, also works from studio setups (rather than from photographs or memory) and is like Valerio, too, in his almost fanatical insistence on description. He makes equally precise drawings, like *The Studio #2* (fig. 92), in which each object encountered in the long process of looking is a tour de force in terms of craftsmanship, but seemingly devoid of a higher meaning. Other contemporary still-life artists are involved less with description than with enhancing the interest of their subjects, whether formal or iconographical. Paul Georges's *Still Life with Rembrandt* (Pl. 43) is as conventional compositionally as Ingle's *Still Life XXX* (see Pl. 41), in spite of its apparent casualness, but a greater unity is achieved, an effect that necessarily involves some loss of objective realism in the description of the individual objects. A balanced whole is realized through a greater fluidity in the medium, yet the integrity of each form is retained. As in Manet's still lifes, the viewer is treated in Georges's painting to forms that are understood first in terms

156

Fig. 91 James Valerio. *Still Life*, 1979. Charcoal and pencil
 on paper, 48 x 85 inches. Prudential Insurance
 Company of America

Fig. 92 Michael Webb. *The Studio #2*, 1978. Pencil and white
conté crayon on paper, 48 x 84 inches. Collection of
the artist

158 of paint and second in terms of their objectness. Similarly, in paintings like *Still Life with Eggplant* (fig. 93) by Louisa Matthiasdottir (an artist whose purely painterly sensibility gives her works a heightened lyricism) or in Robert Kulicke's *Gardenias in a Bottle* (Pl. 45), the robust texture of the paint is as dominant as the forms themselves.

Other contemporary tabletop still lifes are more obviously touched by modernism—by the influences of artists like Cézanne, Giorgio de Chirico, or Giorgio Morandi, and by the gesturalism of Abstract Expressionism. Lennart Anderson's *Still Life with White Pitcher* (fig. 94) reflects Cézanne's influence. Like Cézanne, Anderson initially reduces forms to elements of pure volume and space, then reconstructs them in his mind and brings them back into the concrete world of things, not by giving them back their specificity, but by endowing them with a new expressive presence. Anderson does not reject the integrity of objects, but allows them to retain an abstract quality. This duality is evident in *Still Life with Kettle* (Pl. 44), in which he has purposely combined objects of distinct shape, color, transparency, and surface texture, creating an essentially abstract composition without sacrificing the reality of what he sees.

Anderson, like William Bailey and Stephen Posen, gives objects a certain level of credibility within a distinctly abstract framework. Realist artists like Martha Mayer Erlebacher, Elsie Manville, and John Moore, on the other hand, make still lifes in which objects exist in a limbo between tangibility and a metaphysical presence. Even Gabriel Laderman's still lifes, which seem on the surface to reflect a stridently academic approach (Laderman has been called a "fanatical traditionalist"[3]) to questions of form, balance, and the placement of forms within a classical structure, are touched by the Magical Realism, even surrealism, of artists like de Chirico. In *Still Life #5* (fig. 95), Laderman disdains the use of pleasurable still-life objects for conventional ones with basic geometric shapes, conventionally arranged. The result is almost like a student's exercise in giving shapes solidity in space, but the artist realizes a transcendence of forms into almost surreal presences through the use of a magical light that heightens the reality of the visible world.

Of all the modernist contemporary realists interested in painting traditional still lifes, William

Fig. 93 Louisa Matthiasdottir. *Still Life with Eggplant*, 1976. Oil on canvas, 15 x 21 inches. Private collection, Darien, Connecticut

Bailey has most successfully resisted classification. Bailey, who was born in Council Bluffs, Iowa, in 1930, and holds bachelor's and master's degrees in painting from Yale University, has repeatedly said that he doesn't like being labeled a realist. A romantic by nature, he has an intensely personal vision, and his work reveals strong affinities to classicizing traditions at the same time that it acknowledges the work of Morandi, the color theories of his Yale mentor Josef Albers, and the tension of Mondrian's geometricism.

His artistic ambition is to impose a sensuous order on nature, reducing its multitude of facts without eliminating its essence. Bailey, who worked as an Abstract Expressionist until the early 1960s, considers his paintings as falling "between factual and actual";[4] his goal is not to reproduce what he sees, but what he knows.

Since the late 1960s Bailey, who also makes figure paintings, has confined his subject matter to tabletop still lifes, painting the apparently humble shapes of bowls, crocks, pitchers, cups, pots, and eggs. Variations on a theme rather than serial, works like *Still Life—Table with Ochre Wall* (fig. 97) explore formal concerns—the location of volumes in space, balance, and the juxtaposition of shapes against one another and against a stark background. In his work of the early 1970s, Bailey preferred regular shapes

Fig. 94 Lennart Anderson. *Still Life with White Pitcher*,
1956–1958. Oil on canvas, 26 x 34 inches. Private
collection

Fig. 95 Gabriel Laderman. *Still Life #5,* 1976. Oil on canvas, 30 x 36 inches. Private collection

Fig. 96 Elizabeth Osborne. *Still Life with Red Bowl,* 1979. Watercolor, 30 x 40 inches. Collection of Arlene and Avrom Doft, New York

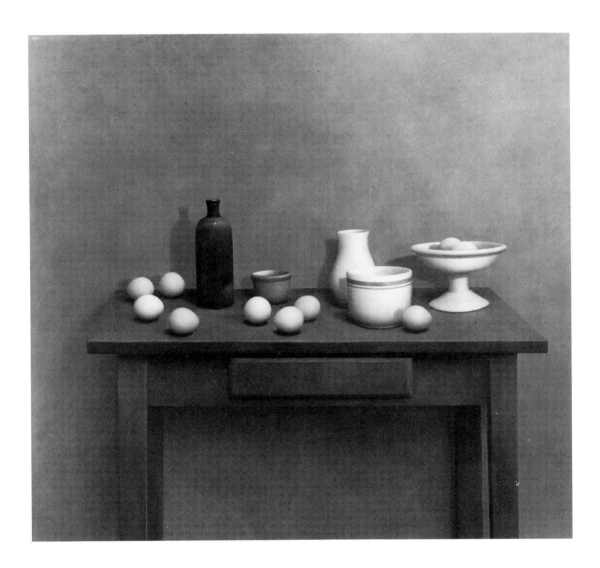

Fig. 97 William Bailey. *Still Life — Table with Ochre Wall,*
 1972. Oil on canvas, 47¾ x 53¾ inches. Yale
 University Art Gallery, purchased with the aid of funds
 from the National Endowment for the Arts and the
 Susan Morse Hilles Matching Fund

162 with even surfaces, hard, smooth, sensuous contours, and soft color; he used a diffused general light that minimized sharp contrasts. In more recent works like *Monte Migiana Still Life* (see Pl. 3), the shapes have become stronger and more eclectic, patterning is more pronounced, and color is more descriptive. Illumination is stronger and the objects have greater individual presence without ceasing to exist in that remarkable realm created by Bailey's genius, entrancing, serene, remote, mysterious. Both that presence and the mood of serenity are the result of his ability to re-create his "memory" of the objects viewed against a pervasive ground. Not surprisingly, Bailey is challenged as much if not more in painting the backgrounds as in painting the objects themselves:

> The backgrounds of the still lifes are the hard parts. That's where I get back to the mere synthetic ideas about painting, and it doesn't have anything to do with realism at all. What I want there is a tension between that expanse of substantial plane and a light-giving, color-giving modifier for the objects.[5]

William Bailey's commitment to abstract principles and to the retention of objective imagery is shared by a relatively large group of painters who work within the parameters of tabletop still life. Wayne Thiebaud's *Buffet* (Pl. 46) may ackowledge the idea of a ceremonial banquet, but its feeling for food is less central to its purpose than the artist's interest in establishing a harmonious rhythm through the placement of shapes on a horizontal plane and in instilling those shapes with a sensuous paint surface and a rich, personal sense of color. Thiebaud's concerns are principally formal and not subject-oriented. Similarly, Paul Wonner's *Dutch Still Life with Pot of Chrysanthemums* (see fig. 89) is a work that celebrates a visual order carefully rationalized by the artist. Lacking (unlike Thiebaud) a sincere feeling for the objects themselves, Wonner reduces each to a miniature scale, making *Dutch Still Life* a modernist's interpretation, and parody, of the spatially defining conventions of seventeenth-century Dutch still-life painting.

The spaces in Wonner's works are distinctly abstract. Elizabeth Osborne prefers spaces that appear more naturalistic even though in the final analysis they are also carefully formalized. Osborne, whose stained landscapes appear to be influenced by Helen Frankenthaler, and whose natural artistic leaning seems to be toward a simplification of

Fig. 98 Janet Fish. *Tanqueray Bottles*, 1973. Oil on canvas, 40 x 40 inches. Private collection

nature that approaches abstraction, explores these possibilities in the watercolor *Still Life with Red Bowl* (fig. 96). Her still lifes, in which the forms may appear to be randomly disposed, are really essays on the tension created between colors, a tension defined in the context of semiabstract forms within an abstracted space.

Nell Blaine and Jane Freilicher paint tabletop still lifes that allow them to unleash their passion for brilliant color and gestural paint surfaces. However, of all the gestural still-life painters, Janet Fish has shown the greatest consistency in uniting the study of the form of the object, its location in space, its color and light, with an expressionistic painting style. Fish, who worked in an Abstract Expressionist style prior to the early 1960s, has since then preferred a gestural style, more recently in combination with recognizable images. Initially, these images were of ordinary, supermarket-variety packaged goods. She has subsequently become interested in the evanescent, evocative qualities of light and its effects on glass, and has chosen glass containers and drinking vessels as the vehicle to express this fascination. Not interested in glass objects as tokens of conviviality or icons of rarity, Fish prefers to paint what she has called "bland forms"[6] rather than seductive forms; her enthusiasm for glass is "materialistic," exploring its transparent, reflective, and prismatic qualities. In works of the early 1970s, like *Tanqueray Bottles* (fig. 98), her glass forms never give up their tangibility or specificity. To this end, clearly the bottles' labels detract from the potentially evocative quality of the glass itself. In later paintings (and in pastels, an important medium for her and one that has helped her evolution as a painter) the solidity of the glass forms gives way to an energized surface of light and color. In *F.W.F.* (Pl. 47), Abstract Expressionist gesture has become one of the principal elements in the painting; as much attention is focused on the negative space and on reflective patterns of color and light as on the description of the glass forms themselves. The glasses, once the subject of Fish's paintings, have become the anti-subjects.

Carolyn Brady, a photo-realist watercolorist, is also concerned with the materialistic, particularly the decorative surface patterns of rugs, furniture coverings, tablecloths, as well as flower arrangements and the reflections of patterns in transparent

Fig. 99 Carolyn Brady. *White Wicker Chair,* 1977. Watercolor on paper, 44 x 35½ inches. Courtesy of Nancy Hoffman Gallery, New York

Fig. 100 Naoto Nakagawa. *Flight,* 1978. Acrylic on canvas,
 46 x 54 inches. Private collection

Fig. 101 Audrey Flack. *Wheel of Fortune*, 1977–1978. Oil and acrylic on canvas, 96 x 96 inches. H.H.K. Foundation for Contemporary Art, Inc., Milwaukee, Wisconsin

surfaces. In *White Wicker Chair* (fig. 99), the interplay of patterns is almost excessive; the eye is not able to settle on any part of the composition for long. In *White Tulip, I* (Pl. 48), the decorative rhythms are even more baroque, the spatial illusion more complex, and the amount of visual information more demanding. Bold in design, exuberant in color, in the end Brady's work succeeds on the strength of its truth to the medium of watercolor, whose inherent fluidity she understands.

Carolyn Brady's watercolors speak of a familiar world, a world close to home, a world the viewer feels comfortable in. In the tabletop still lifes of Naoto Nakagawa and Audrey Flack the viewer feels threatened, challenged, puzzled, or repelled by imagery almost always too personal to share. Of those who work in the tabletop format, only Nakagawa and Flack consistently load their still lifes with symbols; their paintings are on one level conceived as self-conscious narratives. Nakagawa often deals with universal issues of life and death in his still lifes. In *Flight* (fig. 100), he combines objects, eccentric as a group, in a highly idiosyncratic fashion, creating a work open to various interpretations. The images relate to three distinct, but narratively allied, issues: the human senses and life's riches (a bouquet of red roses, a box of watercolors, a classical bust, a strand of pearls); destruction and death (a horse's skull, a dead game bird held in the teeth of a fox, the potentially destructive teeth of a power saw, and a stuffed Canada goose); and man's accumulated knowledge and means of guidance through the world (a globe, a lantern, a radio, a tape measure). Nakagawa challenges the viewer to consider these images (and issues) in personal terms, leaving him in the end without an obvious message.

The omission of the traditional *vanitas* warning distinguishes Nakagawa's still lifes from those of Audrey Flack, which also deal with issues of life and death. Paintings like Flack's *Wheel of Fortune* (fig. 101) or *Queen* (fig. 102) are modern expressions of traditional *vanitas* themes, using the imagery historically associated with the theme in combination with symbols of a highly personal nature. *Wheel of Fortune* imposes its message on the viewer emphatically. Replete with traditional *memento mori* images (a human skull, a burning candle, a calendar) opposed to images of vanity (mirrors, lipstick, jewelry—glittering objects of worldliness), the painting reminds the viewer—even by its

title—that luck may soon run out. Ultimately we humans have no more control over our own lives than the spinner of the wheel. *Wheel of Fortune* is a clear reminder of our own mortality, a visual *vanitas* admonition to turn our attention to higher purposes in the service of God.

Interiors

The depiction of interiors—in the still-life sense, rooms without figures—has a long history, although the type of interiors chosen by contemporary realists is a new departure. There are only a few contemporary realists, notably Paul Wiesenfeld, Jack Mendenhall, Douglas Bond, Sylvia Mangold, and Walter Hatke, who concentrate on this genre, although there are many realists who use an interior setting as the background for figurative work.

The object richness of the interior still life is exemplified by works like Rebecca Davenport's *Opal Interior* (fig. 103), a work that embodies the eclectic, if not curious, sensibility of artists who seem to be obsessed by and delighted with the challenge of description. In *Opal Interior* the human presence is everywhere implied by visually appealing and provocative vignettes that define the personality of the room's inhabitants. In this sense still-life objects become surrogates for more traditional means of portraiture.

Spatial complexity is added to a comparable optical richness in Jack Mendenhall's *Dressing Room with Chandelier* (Pl. 50), a depiction of a bathroom filled with mirrors and other reflective surfaces. Mendenhall's interests are diametrically opposed to Davenport's, nonetheless, although both works engage the viewer by dint of the incredible amount of visual information they offer. Davenport's interest is clearly object-oriented and her perception of space three-dimensional, whereas Mendenhall, a photo-realist, is interested in surface effects and flatness. His choice of a mirrored room where reflected images collide with reality—where what is real and what is an illusion of an illusion are sometimes difficult to determine—allows for a spatial complexity at the same time that it reduces the three-dimensionality of the images to abstract patterns existing as flat shapes on the plane of the canvas. *Dressing Room with Chandelier* is a masterful expression of modern formalistic painting concerns perceived under the rubric of realism.

Fig. 102 Audrey Flack. *Queen*, 1976. Oil on canvas, 80 x 80
inches. Private collection

Fig. 103 Rebecca Davenport. *Opal Interior*, 1978. Oil on
canvas, 72 x 90 inches. Collection of the artist

Space itself—either perceived of in terms of reality, like the Davenport, or in flat and abstract modernist pictorial terms, like the Mendenhall—more than what occupies space has been the major concern of realists who have concentrated on this genre. Paul Wiesenfeld, who was born in Los Angeles in 1942, has devoted much of his activity as a painter since the mid-1960s to interior still lifes. His earliest attempts generally included nude female figures in rather old-fashioned, intimate settings obviously arranged for pictorial purposes, although inhabitable as living space. Those works expressed a genuine commitment to accurate description and an obvious fascination with different period styles of furniture placed within a tightly focused space. In more recent works, from which such idealized figures and vaguely anecdotal vignettes have been deleted, Wiesenfeld has centered on the location of forms in a restricted interior setting. In *Interior with Apples* (fig. 104), forms are selected and arranged for purely pictorial ends; the space is no longer comfortable as living space. Wiesenfeld's interests in such a painting are primarily formal—in creating a staccato rhythm of forms in space and in giving those forms volume and surface tension in the context of an objective realism. Concerned at once with the abstract and the real, Paul Wiesenfeld, like many contemporary American realists, does not perceive these poles as mutually exclusive.

Other realists like Walter Hatke (whose work has parallels with Jack Beal's pre-1970s "synthetic" interiors), Douglas Bond, and Sylvia Mangold (in her floor pieces) have painted interiors as overt explorations of spatial questions; such works are far less object-oriented than even Paul Wiesenfeld's interiors. In Walter Hatke's *Front Room* (fig. 105), the apparently random placement of the objects, themselves conceived of in a cold, synthetic manner heightened by the artificiality of the light, is, in fact, calculated to allow the exploration of abstract ideas. Douglas Bond's interests are equally synthetic, although in *Al Jolson's Revenge at Superstition Mountain* (fig. 106), the random placement of forms of the Hatke *Front Room* becomes a tidy, calculated order. Nothing seems out of place; one can hardly imagine what the intrusion of a human presence might mean to the space, which is antiseptic and uninviting. So anonymous and antimaterialistic is it that one ultimately confronts

Fig. 104 Paul Wiesenfeld. *Interior with Apples*, 1975. Oil on canvas, 43½ x 38 inches. Permanent collection, Delaware Art Museum

Fig. 105 Walter Hatke. *Front Room,* 1974–1976. Oil on canvas, 48 x 60 inches. Collection of the artist

Fig. 106 Douglas Bond. *Al Jolson's Revenge at Superstition Mountain,* 1976. Acrylic on canvas, 60 x 55 inches. Morton Neumann Family Collection

Fig. 107 Sylvia Mangold. *Opposite Corners #23*, 1973.
Acrylic on canvas, 78 x 63¾ inches. Yale University
Art Gallery, Susan Morse Hilles Fund

Fig. 108 John Clem Clarke. *Plywood with Three White Sections,*
1974. Oil on canvas, 90 x 48 inches. Collection of
James Havard

Al Jolson's Revenge as one might a flat, geometric abstraction. It is both related to, and at the same time a subversion of, American abstract art of the 1960s.

The same may be said of Sylvia Mangold's paintings and drawings of floors. The most minimal in terms of subject matter of those artists who have painted interiors, Mangold's floor paintings of the mid-1960s to the mid-1970s are often completely devoid of volumetric forms. In works like the 1973 *Opposite Corners #23* (fig. 107), space is defined by floors and walls, and by a mirror that creates an illusion of space in front of the picture plane. The space may not be objective, but Mangold's description of it is; with exacting detail she has painted its specific reality. In the end, Mangold's floor pieces are examples of two opposing tendencies—the imposition of a subjective presence on reality to satisfy her abstract sensibilities, and a strong phenomenological bias, which informs even her recent abstract landscapes.

Trompe l'Oeil Still Lifes

Whether referred to as deception pieces, fool-the-eye illusions, or simply *trompe l'oeil,* this sort of painting has been known since the time of the Greek painters Parrhasios and Zeuxis in the fifth century B C. American *trompe l'oeil* realized its heyday in the last quarter of the nineteenth century in the work of artists like William Michael Harnett and John Frederick Peto. Harnett and Peto composed with the intention to deceive, following the accepted *trompe l'oeil* format: objects, many of them chosen for their flatness and depicted with fidelity, were painted against a shallow space. Both artists were committed to an exaggerated form of illusionism, an illusionism that initially would trick the viewer into believing that what he was looking at was real. In America such art had popular appeal, although it was often denigrated by critics because of its inherent gimmickry.

Since then, *trompe l'oeil* still-life painting has had few followers; the traditional formats—the rack, the after-the-hunt, and the cupboard paintings—appear anachronistic in the context of twentieth-century modernism (witness, for instance, the traditional *trompe l'oeil* of Kenneth Davies). More important, even those artists who do make highly illusionistic images of nontraditional subjects deny the *trompe l'oeil* intention—the intention to deceive. Among contemporary American realists from Stephen Posen to Duane Hanson the importance of facsimile illusionism as a goal is denied. Remarkably, Duane Hanson even denies seeing facsimile illusionism as a factor in his work: "Perhaps I am so close to my work that I don't see the illusion. If there is one, it is a by-product for me. It is not my goal."[7]

For contemporary American realism, *trompe l'oeil* still-life painting is best understood in terms of abstraction; in fact, artists like John Clem Clarke, Paul Sarkisian, and Stephen Posen may be considered abstract illusionists rather than painters of *trompe l'oeil*. Clarke's art has strong conceptual links with Pop Art, particularly with the work of Roy Lichtenstein. Using photographs as the basic structure for his abstract concerns, he has chosen to paint an eclectic, even bizarre, range of images only because he is basically not interested in their content; like other photo-realists, he has always been more interested in the way images are transmitted than in their meaning. Nor is he at all interested in the photographic quality of the image that he works from. In Clarke's Old Master series of the late 1960s the character of the forms reflects not only the distortions inherent in the commercial reproductions that he works from, but equally his working method. In his Plywood series of the mid-1970s the image has become more illusionistic, so that initially the viewer is deceived into believing the painted surface is the real object. In spite of the heightened illusionism of *Plywood with Three White Sections* (fig. 108), for example, Clarke is not principally interested in replication but in the process of transposing reality onto a two-dimensional surface. Additionally, in creating an object so close in appearance to its original, Clarke raises basic questions about the meaning and identity of reality.

Paul Sarkisian also wants his paintings to be indistinguishable from the objects he paints. His most recent works read like modern expressions of John Frederick Peto's rack-type *trompe l'oeils* and simulated collage (simulated because they are painted) constructions. At once highly composed but with the feeling, nonetheless, that the forms floating in space against a pristine white background are randomly placed, Sarkisian's works combine tangible imagery both shaped and arranged in abstract configurations. In *Untitled* (fig. 109) one is forced to try

Fig. 109 Paul Sarkisian. *Untitled*, 1979. Acrylic on canvas,
78 x 108 inches. Courtesy of Nancy Hoffman Gallery,
New York

to read the images, images that exist in such a disjunctive context that ultimately such a reading proves meaningless. In the end, Sarkisian's paintings function as geometric abstractions that deny the incredible illusionism of each part of the painting. The lasting effect of his recent works, which are becoming more overtly abstract, is one of ambivalence. What is one to make of them?

Of contemporary *trompe l'oeil* paintings, those of Stephen Posen (who would strenuously object to his works being so categorized) are at once the most intellectualized and keenly felt. Posen, who was born in St. Louis in 1939, paints dialogues on the meaning of reality and the processes of its perception; until recently he worked within the constraints of a realistic style. In spite of the strong illusionism of his pre-1978 work, he has never considered himself a realist (he does not make paintings in terms of style). Rather, his goal has been to achieve in his paintings a quality of contemplation based on his own understanding of reality that transcends the requirements of style. Equally committed to and challenged by the dogma of modern painting, Posen has made highly illusionistic works as another way of getting at the "truth about the medium itself, which is its flatness."[8] At the same time, he covers every inch of his paintings with a rich, expressive, surface, a legacy of his Abstract Expressionist days as Jack Tworkov's student at the Yale School of Art.

Posen's work since the early 1970s has dealt increasingly with the kinds of visual relationships that result from an exploration of various processes of perception. Initially, this exploration was based on three-dimensional models that he constructed. His working method soon involved the use of models that combined enlarged photographs, which served as shallow background space, and superimposed colored cloths. The cloth either hung in strips on the surface of the photograph or covered objects on top of it, a process that helped him locate the picture plane and thus the space behind and in front of it. Having carefully constructed the model, Posen was challenged to paint it so as to integrate its various elements — without compromising their identities—so that they read both as individual parts and as elements in a homogeneous whole. In *Variations on a Millstone* (see Pl. 2), Posen manages to achieve this homogeneity through his ability to hold in rhythmic equilibrium the vast number of direc-

tional movements in the canvas, while the colored cloth and black-and-white photographic background still exist as separate visual parts. Claiming now that "the cloth got in the way,"[9] Posen experimented with combining colored photographs *and* colored cloth in the same composition, and then recently directed his attention to a new subject matter, still-life setups, perceived directly. In these, he has found subject matter that he can manipulate to fit his inherently abstract sensibility, and that he can use to express his understanding about individual objects, not solely in isolation, but in a relational sense (he wants to express the basic homogeneity of the substantive world). His 1978 flower paintings are principally conceived as "vehicles of expression for perceptions which seem to cut across rigid boundaries of vision, thought, feeling, and involve experiences which in ordinary everyday terms are contradictions."[10] In *Flowers I* (fig. 110), the varying degrees of fragility in a bouquet of spring flowers are conveyed through semitransparent colored washes. One understands immediately that the colors are not those of actual flowers; rather they are correlatives to reality, but correlatives that, nonetheless, endow the flowers with their natural essence — alive, fresh, fragile. That essence is also expressed in the colors of the surrounding ground, which, in turn, both reinforce the meaning of the flowers and give the canvas an overall unity. In the end, the perception of the flowers is antimaterialistic, although what we learn about them is still crucial to our understanding of their meaning. In effect, Posen has managed to heighten our awareness of reality without directly invoking it.

Animals

The inclusion of animal painting within the still-life genre may seem inappropriate in view of still life's traditional definition — the painting of inanimate objects — particularly since paintings of dead game have not been part of the contemporary animal painter's repertoire. And yet many of those realists who do paint living animals must be considered still-life painters by reason of their attitudes to their subject matter; some realists like Don Nice and Richard McLean have acknowledged their painting activity as still life. McLean, for example, paints horses from photographs (the visual source is as inanimate as a dead stag), repeatedly affirming that he is not interested in the pictorial possibilities of

Fig. 110 Stephen Posen. *Flowers I*, 1978. Oil on canvas,
 50 x 40 inches. Private collection

41 John Stuart Ingle. *Still Life XXX*, 1980. Watercolor, 30 x 42½ inches. Collection of Philip Morris Inc., New York

42 James Valerio. *Still Life #2*, 1978. Oil on canvas, 93½ x
116 inches. Collection of Graham Gund

43 Paul Georges. *Still Life with Rembrandt,* 1975. Oil on
canvas, 41 x 53. Collection of Dr. Michel Amzallag

44 Lennart Anderson. *Still Life with Kettle,* 1977. Oil on
canvas, 46 x 38⅛ inches. Cleveland Museum of Art,
Wishing Well Fund

45 Robert Kulicke. *Gardenias in a Bottle*, 1975. Oil on board, 9¾ x 7⅝ inches. Collection of Jean Reist Stark D'Andrea

46 Wayne Thiebaud. *Buffet*, 1972–1975. Oil on canvas, 48 x 60 inches. Collection of the artist

47 Janet Fish. *F.W.F.*, 1976. Oil on canvas, 72 x 56 inches.
 Courtesy of Kornblee Gallery, New York

48 Carolyn Brady. *White Tulip, I,* 1980. Watercolor on paper,
 31½ x 44 inches. Private collection

49 Don Nice. *Peaceable Kingdom,* 1978. Acrylic on linen/
watercolor on paper, triptych, 9 x 36 feet. Courtesy of
Nancy Hoffman Gallery, New York

50 Jack Mendenhall. *Dressing Room with Chandelier*, 1978.
 Oil on canvas, 71 x 68½ inches. Private collection, England

51 David Parrish. *Yamaha,* 1978. Oil on canvas, 78 x 77 inches.
Wadsworth Atheneum, Hartford; Ella Gallup Sumner and
Mary Catlin Sumner Collection

52 George Segal. *The Butcher Shop*, 1965. Plaster, wood,
vinyl, metal, Plexiglas, 94 x 99¼ x 49 inches. Art Gallery of
Ontario, Toronto, gift from the Women's Committee Fund,
1966

53 Duane Hanson. *Couple with Shopping Bags*, 1976. Cast
vinyl, polychromed in oil, life-size. Private collection

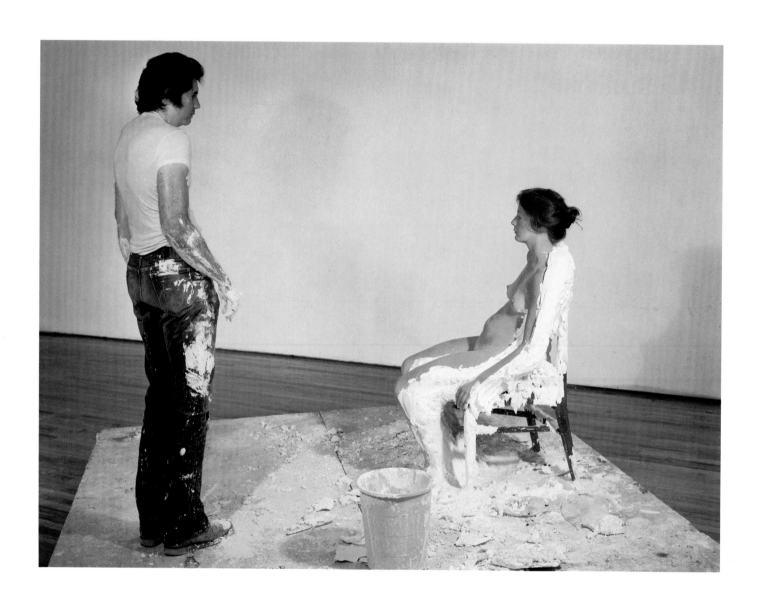

54 John DeAndrea. *Clothed Artist and Model*, 1976. Construc-
 tion of wood, plaster, vinyl, plastic, 77 x 96 x 96 inches.
 Private collection

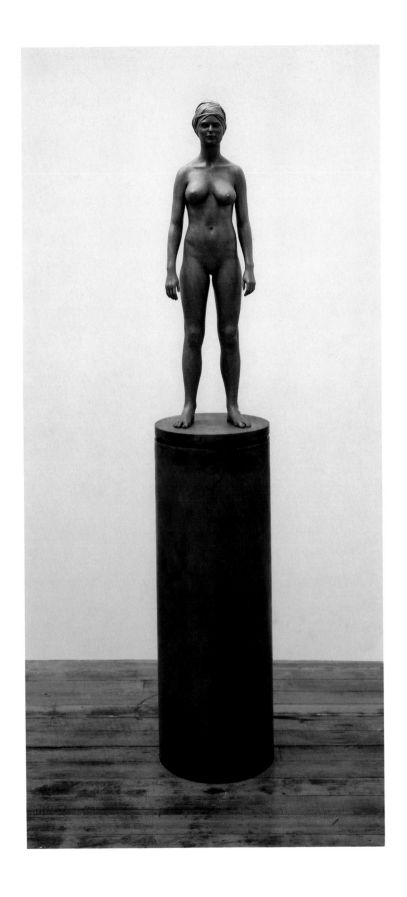

55 Robert Graham. *Heather,* 1979. Bronze, 69½ x 12 x 12
inches. Collection of the artist

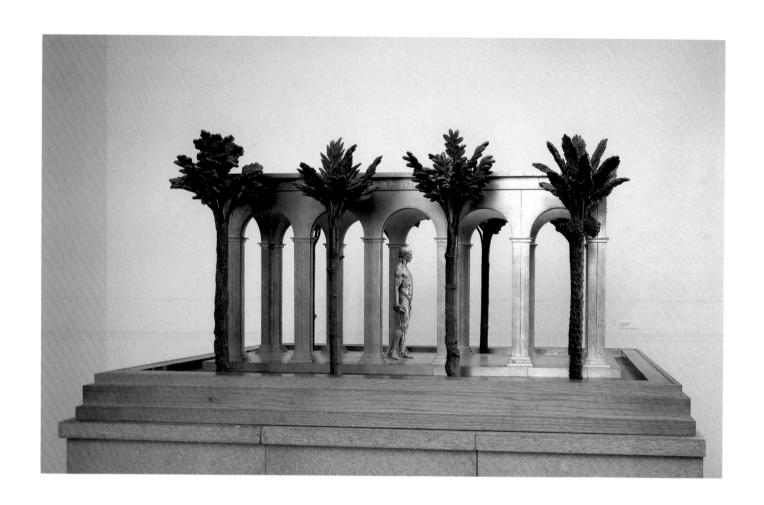

56 Walter Erlebacher. *The Death of Apollo,* 1975. Lead alloy
and oak, 22¼ x 29 x 46⅝ inches. Collection of the artist

movement. Other realist animal painters approach their subjects with similar attitudes. William Allan, who makes brilliant watercolors of dead fish, treats his subjects as natural specimens portrayed against the blank whiteness of the sheet. Tommy Dale Palmore, who has specialized in painting cats, exotic fish, and birds, but particularly apes, is interested in the infinite variety of still-life detail that reveals the characteristics of an animal.

Only a few contemporary American realists regularly make animal paintings, a fact that may reflect not only on the urbanization of modern America, but also on the relative insignificance of animals in our lives; even those artists who do make animal paintings find their inspirations in zoos or in commercial reproductions. The artist-naturalist in the tradition of Mark Catesby, Alexander Wilson, or John James Audubon is not found among contemporary American realists, with the notable exception of William Allan (although Don Nice has also worked from live animals and has been known to visit the Museum of Natural History in New York to corroborate his animal drawings against stuffed originals).

Images of animals do appear, albeit infrequently, as the subjects of paintings by Alex Katz, Michael Mazur, and Wayne Thiebaud, and they often appear as supporting detail in the work of Fairfield Porter, William Beckman, and Rackstraw Downes; as anecdotal vignettes in the narratives of Alfred Leslie and Jack Beal; or as reflections of the natural order of the universe in the landscapes of Joseph Raffael (see *A Frog in Its Pond,* Pl. 32). Jamie Wyeth has focused on painting pigs *(Portrait of Pig,* fig. 112), which he perceives in terms of portraiture, exploring their personalities as if he were painting humans. In the same vein, Manon Cleary has painted larger-than-life images of rats and Michael Mazur caged monkeys.

Tommy Dale Palmore's interest in the personality of gorillas is analogous to Wyeth's interest in the personality of pigs. Palmore has observed gorilla behavior in general as well as come to know the unique traits of several individuals. In *Reclining Nude* (fig. 113), the close-up image of the gorilla is forced upon the viewer, who, if he is to be engaged at all by the painting, must read it in terms of the specific information about the gorilla's body. And yet Palmore does not rely solely on that information

to convey the individual spirit of the beast. Rather, through the pose, with its myriad art-historical associations of nude female figures reclining on sofas as images of lust, in combination with the humor of the title, Palmore expresses in human terms the gentle, passive personality of his gorilla friend.

William Allan's attitude to his subject matter is more that of the traditional artist-naturalist; his striking watercolor images of fish, like mounted trophies over a fireplace, are both clinically objective and replete with romantic associations. Allan is fascinated by the natural variables he observes in fish native both to the waters of the American Northwest—trout, salmon, and steelheads—and to more southern climes. In *Brook Trout* (fig. 111) and similar works, Allan celebrates their individual presences, which he obviously understands in a larger context as a wilderness fisherman. In that sense his fish are loaded images, for they symbolize a way of life close to nature that he values. A sense of fierce independence and fitness is captured in these fish watercolors, just as Allan's landscapes of Alaska evoke the spirit of a natural paradise.

Don Nice's images of animals are far more eclectic than Allan's. Nice wants his work to celebrate the grandeur of the animal kingdom. A tireless sketcher, he translates the information into large watercolors and oils, with the animals usually seen in profile against a neutral background. Interested in the animal's specific information, Nice has adapted altarpiece and predella formats to enlarge upon the meaning and context of his animals. In *Montana Totem* (fig. 114), composed in a four-part format, he combines natural and supermarket images—cognitive and popular—chosen for their symbolism. The painting is full of masculine symbols—from the sturdy badger (said to be pound-for-pound the fiercest of all animals), to the rugged Montana landscape, to vignettes of nonfiltered cigarettes, chewing tobacco, beer, and work gloves—each of which supports and enlarges upon the meaning of the others, in particular of the badger. In placing the badger in this sort of popular context, Nice makes its meaning more comprehensible.

In choosing the altarpiece and predella formats, pictorial structures that have a long history in religious art, Nice elevates the subjects of his paintings, forcing the viewer to reconsider the

194

Fig. 111 William Allan. *Brook Trout,* 1976. Watercolor, 20 x 27 inches. Collection of the artist

Fig. 112 Jamie Wyeth. *Portrait of Pig,* 1970. Oil on canvas, 48 x 84 inches

Fig. 113 Tommy Dale Palmore. *Reclining Nude*, 1976.
Acrylic on canvas, 56 x 84 inches. Philadelphia
Museum of Art; funds given by Marion B. Stroud
and the Adele Haas Turner and Beatrice Pastorius
Turner Fund

Fig. 114 Don Nice. *Montana Totem*, 1978. Acrylic on canvas,
82½ x 48 inches. Courtesy of Nancy Hoffman
Gallery, New York

Fig. 115 Richard McLean. *The Boilermaker,* 1977. Oil on
canvas, 56½ x 69 inches. Private collection

Fig. 116 Ralph Goings. *Country Chevrolets*, 1978. Oil on canvas, 26 x 36 inches. Richard Brown Baker Collection

images in and of themselves rather than as nature subjects or slickly packaged goods. In a recent monumental work entitled *Peaceable Kingdom* (36 feet wide; Pl. 49), Nice alludes to a divine creation in juxtaposing many different species within a single format. While the viewer reads the animal figures in the painting singly, and basically non-hierarchically, the overriding sense of a natural order is implied. In *Peaceable Kingdom,* a modern expression in the tradition of Edward Hicks, Nice seeks the meaning of his own life through multiple images of God's creation.

Whereas William Allan and Don Nice are intellectually and emotionally committed to their subject matter, Richard McLean, who has devoted most of his career to painting horses (and their surroundings), is not. He admits that he doesn't particularly like horses, nor does he identify with people of the horse world. A photo-realist who worked abstractly as a student of Richard Diebenkorn and was also influenced by Pop Art's legacy, McLean recognized in the horse "a cultural image all tied up in romance, terribly fraught with implications." McLean's intention has been "to divest it of all that, to paint the horse as an object—like Johns painted the American flag . . . to cool it off"[11] as a subject.

As a result of his working method, McLean's images read as horse portraits, although he maintains that portraiture is not a real concern. He alters the photograph wherever necessary in order to accommodate his sense of abstract design. Since 1973 he has worked from his own photographs, preferring to paint from snapshots. In *The Boilermaker* (fig. 115), McLean achieves his formal objectives, in spite of the horse's very real presence, in both his use of a motionless, profile pose and his matter-of-fact style of painting, which, in not accenting any one element, places emphasis on visual rather than subject values. For McLean, the pleasure of painting comes from the mechanical crafting of the illusion of the subject rather than from any particular fondness for it.

"Modern Machine" Still Lifes

Just as John Marin, Joseph Stella, and Charles Sheeler found inspiration in the visible (and what came to be symbolic) manifestations of the technological revolution in early twentieth-century America, so have many contemporary realists turned to subjects that are obviously expressive of contemporary America—cars, trucks, trailers,

Fig. 117 Robert Bechtle. *'58 Rambler*, 1967. Oil on canvas,
30 x 32 inches. Sloan Collection, Valparaiso
University; gift of Mrs. McCauley Conner in memory
of her father, Barklie McK. Henry

Fig. 118 John Salt. *Silver Plymouth in Woods,* 1979. Oil on
canvas, 41¾ x 63½ inches. Richard Brown Baker
Collection

Fig. 119 James Torlakson. *South City Diamond T,* 1976.
Watercolor, 13½ x 18½ inches. The Fine Arts
Museums of San Francisco, Achenbach Foundation
for Graphic Arts, gift of Mr. and Mrs. George Hopper
Fitch, 1977

oceanliners, airplanes, and motorcycles—subjects that say something indirectly about the culture that made them even if the artist who painted them has no narrative intention. English-born artist John Salt actually suggests these subjects imposed themselves: "Choice of subject matter was so obvious when I came here. The automobile was very obvious, so ugly and useless and so big, and I just got interested in it. I would never have done cars in England. It's just not that important over there."[12] Or as David Parrish has said, he paints motorcycles because a lot of people have them.

Malcolm Morley, in his paintings of luxury liners (see fig. 85) in the mid-1960s, was one of the first realists to focus on symbols of modern transportation. At a slightly later date realists like Robert Bechtle, Don Eddy, Ralph Goings, and John Salt began concentrating on painting cars and trucks, each developing a clearly identifiable personal subject matter in a photo-realist style. Each was attracted to this subject matter by a combination of reasons: the challenge of making a high art form out of nonart objects that were free of art-historical precedents; the fact that cars gave artists "very middle class (and thus anti-heroic) subjects to paint";[13] their convenience, coupled with their familiarity as objects. Robert Bechtle considers his paintings of cars as formalist still lifes: "I chose cars to paint the same way Cézanne chose a bowl of fruit."[14]

Bechtle's paintings of cars are derived from photographs. (He considers that a "really convincing painting of an automobile is next to impossible without photographs, short of parking the car in the studio."[15]) No matter how neutral the artist was at the time of their painting, no matter how formal his painterly concerns, Bechtle's car paintings have become nostalgic images. In works like '58 Rambler (fig. 117), the viewer is immediately struck by the now-obsolete styling of the car; indeed, the model was out-of-date even when it was painted. This fact alone places Bechtle's paintings of cars within a period time frame, replete with other associations that define an age. '58 Rambler, like a "golden oldie," reminds us of our past.

Somewhat the same associations pertain to the paintings of Ralph Goings and of John Salt. Goings, whose art is identified with images of pickup trucks,

says that he is more interested in the process of painting them than in their significance ("I like to render, I like to copy—I do a lot of copying—I like tracing"[16]). But he is not able to divest them of their inherent associations. In Country Chevrolets (fig. 116), the pickup truck exists as a symbol of a way of life, an image that labors under a set of values, whether real or mythical, that transcends its own utility. The same narrative component exists in the battered-car paintings of John Salt. Like allegorical images of old age or tainted fruit, Salt's works, like Silver Plymouth in Woods (fig. 118), are bound up with a narrative they are unable to relate, but about which the viewer must speculate.

Other contemporary American realists who paint "modern machine" still lifes emphasize the bigness and power inherent in these forms as well as the beauty of purely functional designs. James Torlakson's South City Diamond T (fig. 119) and Ron Kleemann's Big Foot Cross (see fig. 90) may be paintings about photographic perception, but they also deal with subjects that exist as cultural icons. Gaudy, garish, represented on a large scale (in the case of the Kleemann) to allow for a greater definition of detail, these images are important as descriptions of the look of contemporary America. It is that sensibility that also informs the work of Tom Blackwell and David Parrish, both photo-realists who paint motorcycles. Blackwell, who has said, "what interests me as a painter and as a person is the look and ambience of the modern world, synthetic plastic junk and all,"[17] has chosen the motorcycle as the ultimate modern American icon. Blackwell's Triumph Trumpet (fig. 120), a painting involved with reflections and the superimposition of one reality over another, focuses, like so much other photo-realist painting, on what people look at but do not see. David Parrish's Yamaha (Pl. 51) is even more precisely demanding. Described as "sections of machinery larger than life-size that imply continuance beyond the arbitrary limits of the canvas,"[18] Parrish's motorcycles cannot be ridden; their existence as three-dimensional objects in space seems to have been purposely denied. Fractured, abstracted images, they do have a basis in reality, but they are really about its perception. Like the best contemporary still-life painting, Parrish's work raises questions (and insecurities) about our own ability to perceive what reality is.

Fig. 120 Tom Blackwell. *Triumph Trumpet,* 1977. Oil on
canvas, 71 x 71 inches. Collection of Louis and
Susan Meisel

Chapter Six

Fig. 121 Robert Graham. *Lise Dance Figure I*, 1979. Painted
bronze, 93 x 11 x 7 inches. Collection of the artist

The Realist Alternative in American Sculpture

The dominant style of American sculpture in the twentieth century has remained abstract. Nonetheless, the figurative tradition has been kept alive both outside vanguard circles, by an entrenched band of academics working in traditional ways, and within, by avant-garde sculptors who work in the figurative tradition. The latter do not constitute a group — they include sculptors as diverse as direct carvers like William Zorach and Leonard Baskin, expressionists like Theodore Roszak, and stone carvers like José deCreeft. However, neither of these tendencies has had significant influence on the two principal realist sculptural alliances today — the so-called postmodern realist sculptors and the neo-academics. In fact, postmodern realist sculptors, few in number and anything but a coherent group, have taken their aesthetic cues from painting. As for neo-academic realist sculptors, the best of these have demonstrated new attitudes, perfected new working methods, and employed new materials in a tradition that remains essentially conservative.

The impact of modernism, or, more specifically, of the ideological positions of modernism as they relate to painting, on contemporary American realist sculpture has been twofold: it has made it even more difficult for many postmodern sculptors to work figuratively, and it has reestablished the importance of antipictorial issues in the conception of a postmodern figurative tradition. Realist sculptors, working in an inherently three-dimensional format, face special difficulties, since they do not share with painters (notably the photo-realists) the possibility of combining illusionistic imagery in the context of overall flatness. Sculptors can use the photograph — and they do — to assemble visual data to inform the subject, but unlike painters, they cannot use it as material for the exploration of perceptual questions in the context of modern-

ism. The difficulty of working in a postmodern figurative way as a sculptor may explain why there are so few contemporary realist sculptors. At the same time, modernism's impact has resulted in the contemporary figurative sculptors' expansion of their goals. Many of the best postmodern sculptors came to reject the limitations of nonobjective art while first working as painters; George Segal, for example, turned from Abstract Expressionism to figurative sculptures in the late 1950s in order to enlarge upon and increase the resources immediately available to his art.

It is perhaps not altogether surprising that many of the best realist sculptors in America today came to sculpture after initial careers as painters or turned to sculpture as a logical extension of painting, which still remained their primary activity. George Segal was influenced by Henri Matisse and Pierre Bonnard as well as by Hans Hofmann in the 1950s; his ambition then was "to be a great French painter."[1] Around 1958 he first realized the possibilities of sculpture, prompted by his "dissatisfaction with all the modes of painting that I had been taught that couldn't express the quality of my own experience."[2] He first showed sculpture in combination with paintings at the Hansa Gallery in 1958, saying the figures "looked to me as if they stepped out of my paintings."[3] Clearly, Segal's earliest attempts at sculpture, highly expressionistic conceptions of the figure, were greatly influenced by his Abstract Expressionist style of painting.

Similarly, Alex Katz's cutout figures were also closely related to his paintings, but whereas Segal's sculpture has evolved away from his early painting, Katz's remains an extension of his. He made his first cutouts in the late 1950s, when, dissatisfied with the way a painting was progressing but liking its figures, he cut them out and later mounted them on

Fig. 122 Alex Katz. *Sanford Schwartz*, 1978 (back and front views). Oil on aluminum, 71 x 10 inches. Private collection

plywood forms and gave them bases.[4] The cutouts are neither sculptures nor paintings, although it is perhaps best to think of them as paintings liberated from walls. Thereafter, when Katz made sculpture, he painted directly onto a metal surface, which he would in turn cut out to make freestanding figures. Consequently, the illusion of a Katz cutout figure in space—thin, compressed, flat, even if it is painted on both sides (some are left blank on the back)—is just that—a painted illusion. Regardless of the fact that with pieces like *Sanford Schwartz* (fig. 122) or *Red Band* (fig. 123), the viewer spends time trying to justify the front and back of the figures, they never take on the weight of sculptural forms.

Other contemporary American realist sculptors value their early experience as painters or designers for practical reasons, being dependent on the technical knowledge they acquired as painters to achieve their objectives as sculptors. John DeAndrea, who says that he is "painting oriented" and "admires painters, not sculptors,"[5] made both paintings and sculpture during his student years at the University of Colorado and the University of Mexico. The experience of painting proved to be invaluable, not only for the practical skills he acquired, but also because his impatience with the emotionalism and subjectivity of Abstract Expressionism helped condition his objective stance as an artist. Interestingly, the sculptor Duane Hanson, with whom DeAndrea is almost always associated, says he never painted in his life,[6] and indeed the painted surfaces in Hanson's earlier works were not particularly veristic. His lack of experience as a painter undoubtedly has affected his approach to sculpture—his decision to make clothed figures, for example, meant that he did not have to paint as much of the body itself. Other sculptors who have never painted recognize that this has had an effect on their own work. Richard McDermott Miller places great value on the fact that he has always been *only* a sculptor, believing that he is able to treat the figure as an object in space rather than an illusion because he has never painted.

Undoubtedly, the sculptor's relationship—or lack of it—to modern painting has had an important influence on contemporary realist sculpture. Modernism has also played a role in realist sculpture through its experimental bias, which has encouraged technological developments in the use of materials and

Fig. 123 Alex Katz. *Red Band,* 1978 (front view). Oil on
aluminum, 18 x 47¼ inches. Private collection

the fabrication methods of sculpture, and through
an attitude to subject matter that has permitted a
broad range of uses of these technological develop-
ments. For instance, while casting directly from life
was a common practice in nineteenth-century
academic sculpture circles (even Auguste Rodin is
known to have employed this method), in the hands
of Duane Hanson and John DeAndrea this direct
practice has taken on new meaning. Their use of
modern plastics (fiberglass and vinyl instead of
bronze or other traditional metals) has allowed for
finished castings that are incredibly realistic replica-
tions. Both sculptors have perfected the use of
these materials to attain maximized fidelity to the
original; and for both the materials themselves have
largely conditioned their attitudes to their subjects.
DeAndrea says that he wants his figures "to
breathe";[7] his objective is to make a figure as phys-
ically real as possible, and he always strives for the
maximum technical finish. Acknowledging that "the
work is not about me,"[8] he has sublimated his
presence in it, a situation made all the more possible
by the nature and use of the materials he prefers.

Jud Nelson is another who exploits new materials;
he makes objects from Styrofoam as well as white
Carrara marble. He is also enthusiastic about using
contemporary technology: in his investigation of

objects (he says he wants to see "every molecule,
every atom of an object"[9]), he has stated his inten-
tion of using laser light for optimum illumination.
Similarly, Robert Graham's sculpture is partially
predicated on new materials and technological
innovations. Graham acknowledges the importance
of developing industrial techniques in his work;
since 1978 he has used a video cassette system as
an aid to his perception to record the movement of
his models. The video system, which allows Graham
to freeze an image on a screen, also enables him to
study and select poses on the basis of recorded
rather than directly observed information.

Realist sculptors have also adopted a more open
attitude to subject matter. Certainly nontraditional
subject matter was made acceptable through the
traditions of Pop Art, most notably in the marvel-
ously personal and eclectic works of Jasper Johns
and Claes Oldenburg. Jud Nelson's preference for
banal subjects—teabags, sunglasses, mousetraps, or
Popsicles—clearly reflects Pop Art's decision to
elevate ordinary objects to an artistic level. Fumio
Yoshimura's carved wooden images of typewriters,
electric fans, sewing machines, and other commer-
cial objects; and Marilyn Levine's choice of leather
goods—handbags, shoes, boots, gloves, and coats
—reflect this same mentality. Nevertheless, the

208 figure still remains at the center of the contemporary American realist sculptor's experience. It has been the principal reason for sculpture, expressing both human and formal concerns.

More than any realist sculpture today, the work of George Segal encompasses the broadest interpretation of the figure. Born in New York in 1924, Segal found his early commitment to Abstract Expressionism (which he has called "a splinter of human experience") did not allow him to express his deep feelings about people. At first he made sculptures of imaginary figures and then in the early 1960s shifted to direct castings of real individuals. He prefers now to make sculptures of people well known to him in the circumstances he has known them—seeking to express the relationship that exists, as he understands it, between himself and his subjects. His work has none of the cold, even sarcastic, sensibility of Pop Art, to which he has often erroneously been linked, partly because he emerged at the same time as Pop in the early 1960s. He is close to his subjects, physically as well as emotionally, casting from the body in hydrostone, a type of plaster more resilient than plaster of paris, and using the positive rather than the negative casts. Segal's sculpture, in the manner of Alfred Leslie's portrait and narrative paintings, seeks to express the dignity and humanity of all people through simple, human gestures made by people in everyday environments—restaurants, diners, gas stations, butcher shops, the front porch, or the bedroom.

Segal is a master at the creation of typal figures expressive of human conditions and psychological states. The figures themselves are enhanced by the fundamental quality of his portraiture, which expresses through generalized gesture and meaningfully arranged tableaux of found objects what is not suggested by specific detail ("If you don't get involved with their specifics," he has observed, "you are murdered when you try to approach generalities"[10]).

Although viewers tend to focus on the figures, Segal's environments create multiple levels of meaning. He places equal emphasis on the formal structure of his work. *The Butcher Shop* (Pl. 52) is typical of his broad concerns. Conceived as a tribute to his father, who had died six months before the work was begun, *The Butcher Shop* depicts his mother

Fig. 124 George Segal. *The Tightrope Walker,* 1969. Plaster, metal, and rope, 6 feet 16 inches x 17 feet 5 inches. Museum of Art, Carnegie Institute, Pittsburgh (National Endowment for the Arts Matching Grant and Fellows of the Museum of Art Fund)

wielding a knife in the small family butcher shop in the Bronx where Segal helped out as a child. The work captures with a warm affection and humility the meaning of the family experience. It stands as a son's requiem for his father and an oath of love and respect to his mother. A private and deeply felt subject for the artist, it nonetheless exists for Everyman's consideration.

Segal's narrative ambitions, often spawned by private remembrances, but not unresponsive to public events, are sometimes overt but more often than not couched in the ambiguity that Segal sees around him and that he likes to instill in his work. These are balanced in *The Butcher Shop* by an overriding formal structure that is forcefully imposed on the tableau. Segal has placed a grid (seen from the front) over it and framing it on all four sides. The work reflects in its austerity Segal's admiration of the formal severity of a Mondrian painting. A classicist by nature, he sees in everyday life an order imposed on mankind that helps to define his behavior. He is interested in the way people do and do not relate to

space and to other shapes in that space, and his best works are those in which architectural structures organize the plurality of facts and meanings of an environment—as they do in *The Butcher Shop.* Even a freer and more open work like *The Tightrope Walker* (fig. 124) is orderly, for Segal has chosen a subject that organizes itself through its own actions without the imposition of an overlay. All of Segal's figures, no matter how naturalistic or accidental they may initially appear, are informed by his need to order the air around them.

In addition to his more ambitious environments and single-figure compositions, Segal has been engaged since the early 1970s in making figural wall pieces, bas-reliefs, and fragments, figures attesting to his fundamental fascination with the way three-dimensional forms occupy space. They seem naturalistic, in spite of the fact that these figures are generally radically cropped and allowed to emerge only partially from the plaster (like Rodin's figures that remain half-hidden in the stone). In *Girl Holding Her Left Arm* (fig. 125), the figure is given a

Fig. 125 George Segal. *Girl Holding Her Left Arm,* 1973. Plaster, 31 x 28 x 7 inches. Courtesy of Sidney Janis Gallery, New York

Fig. 126 George Segal. *Girl in Robe VI,* 1974. Plaster, 25¾ x 16 x 7 inches. Courtesy of Sidney Janis Gallery, New York

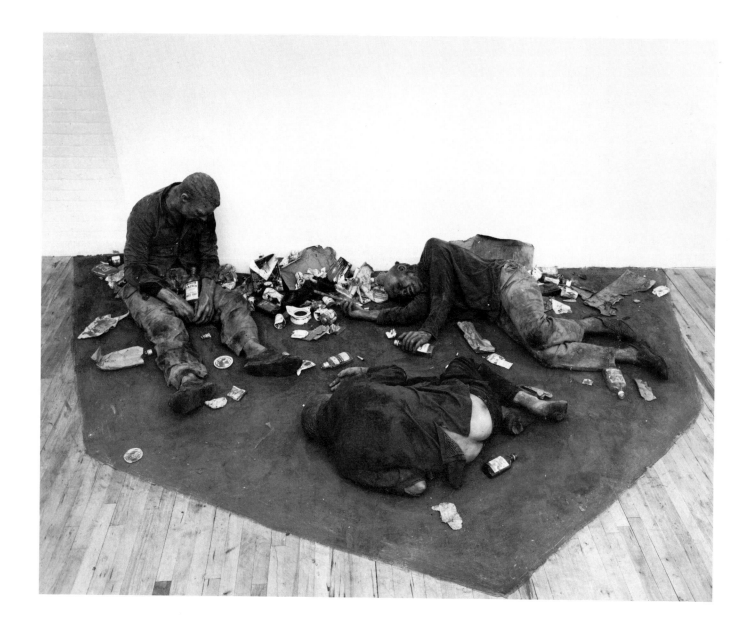

Fig. 127 Duane Hanson. *Bowery Derelicts*, 1969-1970.
Polyester and fiberglass, polychromed, life-size.
Collection Neue Galerie, Aachen, Germany

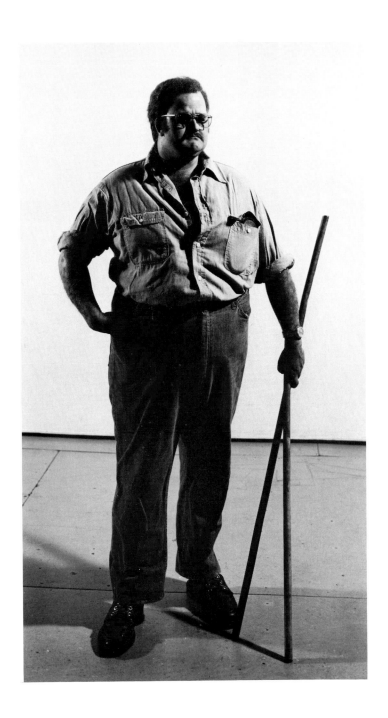

Fig. 128 Duane Hanson. *Ryan the Plumber*, 1977. Cast vinyl,
polychromed in oil, life-size. Courtesy of O. K. Harris
Works of Art, New York

212 voluptuous fullness, while in *Girl in Robe VI* (fig. 126) — a figure with its hands clasped and with a quiet, contemplative mien — the form is hardly allowed to emerge from the plaster. Both figures, however reduced, capture the spirit of the subject and speak to Segal's fascination for life and art.

Segal's figures mimic life; they do not reproduce it. There are distancing factors in his work that remove it from reality — into the realm of art, as Jan van der Marck has written.[11] The rough, expressionistic plaster surface, its overall whiteness (Segal has used color, but abstractly), the muteness of the figures, and the viewer's difficulty in entering and occupying their space separate them from life. Nonetheless, Segal's attitude to his subjects is always compassionate, without the condescension and sarcasm one associates with Pop Art culture, and his environments are based on routine, everyday happenings. At the same time, he does not aim for the reproductive verisimilitude of the direct-cast figures by Duane Hanson and John DeAndrea, whose work is literally worlds apart from Segal's white mummies.

Duane Hanson's and John DeAndrea's figures do reproduce reality; both employ a direct-casting technique using materials that permit them to create images with an incredible *trompe l'oeil* effect, one that shocks the viewer and focuses undue attention on technique. Both artists have been very clear about the value they place on their technique, seeing it only as a means to an end, an end each feels could be achieved (though with greater difficulty) by employing traditional modeling techniques. Unfortunately, the extraordinary illusionism of figures by both these artists has led to a tendency to lump their work together, obscuring their fundamentally different attitudes to the figure. Both respect the figure, DeAndrea more for its inherent beauty, Hanson for its narrative potential, and both use it to arouse the viewer's consciousness on many levels, but DeAndrea is more interested in the individuality of his subject, while Hanson, who denies the portrait equivalency of his work, wants his figures to function as generic types.

Duane Hanson, who was born in Alexandria, Virginia, in 1925, has been working as a realist sculptor only since the late 1960s. Before that time, his work

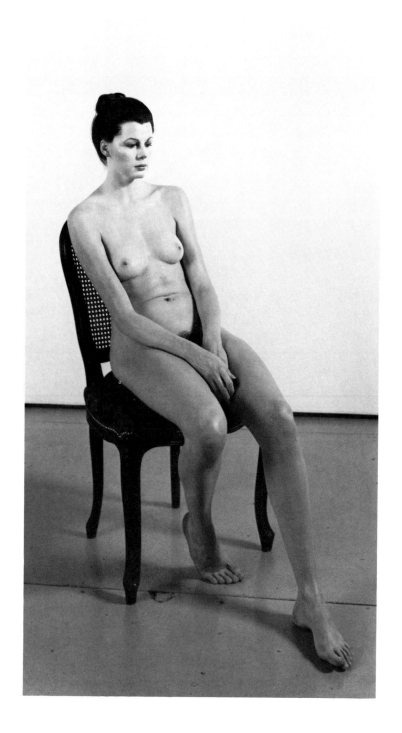

Fig. 129 John DeAndrea. *Seated Woman,* 1977. Vinyl, polychromed in oil, life-size. Private collection, New York

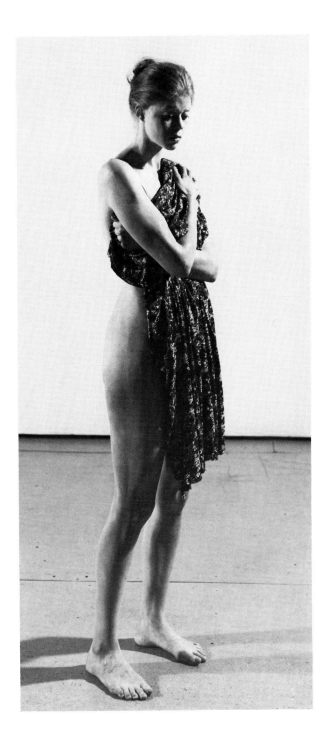

Fig. 130 John DeAndrea. *Blond Woman Holding Dress,* 1977.
Cast vinyl, polychromed in oil, life-size. Courtesy of
O. K. Harris Works of Art, New York

(which he has destroyed) was mostly "abstract and 213
decorative."[12] He recalls that he was unfocused:

> I did all kinds of things. I did a little clay modelling, carved
> wood, cast in bronze and a little welding in steel. I got to the
> point where I said to myself, so what? They were pretty
> statements that didn't amount to much. It was all too
> concerned with esthetics. There was no attempt to
> communicate any deep feeling or to say anything about
> how I felt.[13]

In 1967 Hanson made his first figure, a polyester
resin and fiberglass cast made from a clay model.
Subsequently, he decided to forgo modeling in clay,
taking a plaster impression directly from the live
model and coating the outside of the mold, rather
than the inside as he does now, with a fiberglass
surface, which he then filed down to achieve a fin-
ished surface. The results pleased Hanson, the
rough, expressionistic surfaces of his figures
supporting the violence and brutality of his sub-
jects, for his work of the late 1960s was stridently
political. His subjects ranged from violent race-riot
tableaux, to grisly depictions of dead and dying
soldiers (in protest of the Vietnam War) and motor
accidents, to works like *Bowery Derelicts* (fig. 127),
which expressed Hanson's concern about the prob-
lems of alcoholism and social injustice that he saw
around him. Like Millet and Daumier, both of whom
Hanson deeply respects, he used his sculpture to
express social comment and to force it on the viewer.

Since these early figure pieces Hanson's work has
become less stridently political, less anti-Establish-
ment, although it still reveals a sensitive social con-
science. His recent subjects have been blue-collar
laborers — waitresses, plumbers *(Ryan the Plumber,*
fig. 128), painters, electricians, janitors, repairmen —
and the elderly. All of his figures have a particularly
American quality; he is a master of social cues, of
selecting telling poses and choosing commercially
made props — clothing, jewelry, or trade tools. His
figures are representative of entire categories of
people, and are intended to thrust consciousness of
these people on the viewer. While his attitude to the
subjects is generally sympathetic — he feels the
boredom and fatigue of the laborer, the loneliness
and frailty of the aged — his works are also critical
of human foibles. Many of his "types" represent
aspects of modern American life displeasing to
Hanson: overconsumption, narrow-mindedness,
tastelessness, and lethargy. In *Couple with Shop-*
ping Bags (Pl. 53), Hanson satirizes greed, particu-

214

larly through the more dominant woman, who, by her obesity and by the large shopping bag she carries, symbolizes the excessive thirst for material goods in contemporary American life.

Hanson is almost unique among contemporary realist sculptors in the sense that his subjects stand as metaphors of contemporary American life. But if subject matter and its narrative potential are paramount, they do not preempt formal concerns. Hanson realizes that the narrative success of his sculptures is directly proportionate to his ability to achieve them as works of art. As he says, they have to be "right," and by this he means that the composition, form, and painted surface of the figure must support its narrative ends. Compositions are arrived at empirically and the realization of the form itself is a laborious process that almost always involves "doctoring it up" once the positive castings have been made. The final application of a painted surface is equally crucial to the success of the illusion (Hanson says, "For me it's all surface" [14]). Like any realist portrait painter he has to achieve the correct value and tone in his flesh colors in order to give the underlying form a sense of life.

While Hanson's figures should be thought of as distillations, John DeAndrea's work exists conceptually within the traditions of portraiture. He is interested in the specific information of the individual's body, seeing it as a way to understand the whole person. For that reason, he prefers not to clothe his figures. Nakedness forces DeAndrea to paint the entire figure, and unlike Hanson, he does this directly from the model so as to attain as accurate, specific a verisimilitude as possible. He says that his activity as a painter is the essential reason why his figures have a strong, individual presence.

DeAndrea has chosen, for the most part, to make life-size portraits of young women, choosing a model because he likes her rather than on the basis of preconceived ideas of beauty. In staying within a narrower range of subjects than Hanson, he believes he can give his work a greater intensity. He feels uncomfortable with the "Hanson approach" to subject matter, wanting to avoid any potentially critical or narrative stance in his work. DeAndrea's is a strictly phenomenological realism.

His almost total preoccupation with the subject of naked young women (he has made a few naked

Fig. 131 John DeAndrea. *Woman Facing Wall,* 1978. Vinyl, polychromed in oil, and wood, life-size. Sydney and Frances Lewis Foundation

Fig. 132 Richard McDermott Miller. *Sandy in Defined Space,*
1967. Bronze, 75 x 37½ x 46 inches. Collection of
the artist

male figures as well as self-portraits in tableaux) unfortunately has produced a general misconception about the intention of his work. It has all too often been misinterpreted in terms of erotic intentions, in spite of the fact that he has repeatedly denied the importance of eroticism in his work. While it is true that there is a built-in eroticism in the naked body, with few exceptions (a number of early 1970s pieces), DeAndrea has not exploited the erotic potential. In a work like *Seated Woman* (fig. 129) the restraint and introspective mood of the subject deny, if anything, the inherent eroticism of the body. Many of his figures embody a classical severity that heightens their humanness and at the same time downplays the sexuality of the body forms. In the last five years DeAndrea has made a number of important standing female figures; although not conceived of as a group, they are perhaps more revealing collectively than singly in that each emphasizes the individuality of the others, an essential fact for the artist. In *Blond Woman Holding Dress* (fig. 130), a very modest pose, DeAndrea forces the viewer to focus on the figure and the figure only, as he does in each of these recent works. These figures are self-contained objects, in most cases without any additive props and stripped of any supporting environment, and thus forced into environments outside of the artist's control; single, isolated, extreme in their vulnerability to the outside world, these figures are monuments to DeAndrea's commitment to his model.

Not all of his figures exist without context nor is he fixed on making *trompe l'oeil* figures exclusively. Many of his figures incorporate commercially made objects—chairs, beds, stools—that allow his models greater variety of poses without adding a significant environmental context. In *Clothed Artist and Model* (Pl. 54), the best of several tableaux that celebrate the artistic process, the dramatic presence of the studio environment with the artist at work gives the piece its meaning. The viewer is invited into the studio to participate in a momentary exchange between the model and the artist as the work progresses, although it is, of course, a finished sculpture. Other recent figures, for instance *Woman Facing Wall* (fig. 131), are predicated to a lesser degree on heightened illusionism than were earlier works. In this work, DeAndrea departs from a naturalistic flesh tone to a surface whose color ranges from black through gray to white. Such

recent figures have their own built-in painted light, they lack the "curiosity" quotient of earlier works, and they seem in the end to relate to photographic images of the figure; thus they present DeAndrea with the challenge of resolving perceptual and photographic vision within the context of directly cast three-dimensional forms.

Duane Hanson and John DeAndrea are the principal contemporary American realist sculptors who cast life-size figures in fiberglass or vinyl, although other figural artists have worked in this manner. Frank Gallo and Paul Anthony Greenwood use similar material in a pseudo-realist way. Arlene Love, who pioneered in the medium of polyester resin and fiberglass in 1956, has occasionally made realist portraits, although essentially her figural work is transmogrifying and surreal. Jann Haworth works in a pseudo-Pop manner, and Edward Kienholz and Red Grooms are best understood as Pop artists. The work of sculptors like José deCreeft and Leonard Baskin, who employ the technique of direct carving, is so deeply rooted in earlier twentieth-century sculpture traditions that it is probably best not considered in a contemporary context. This is not to say that traditional sculptural concerns are outside the parameters of contemporary realist sculpture, except, of course, when the treatment of those concerns is so obviously anachronistic. The distinction may be a fine one, but there are important traditionalist sculptors today who should be thought of as contemporary realists even though their work might seem to fit a neo-academic category.

Richard McDermott Miller, who was born in New Philadelphia, Ohio, in 1922, has expressed the sentiments of many of his more traditional peers: "I am conditioned by the present yet nourished by the past."[15] He feels a kinship to earlier sculptural traditions, all bound by their ties to nature. In fact his strong admiration for historical styles seems almost nondiscriminatory — he has said that he likes "the sculpture of the Greeks, the Romans, the Renaissance, the 17th, 18th, and 19th centuries."[16]

As a sculptor who has never been a painter, he has taken a decidedly antimodern position in attempting to liberate sculpture from the pictorial domain into which it has been gradually assimilated in the twentieth century. This attitude does not preclude a level of abstract concern; Miller is clearly less

Fig. 133 Richard McDermott Miller. *Stout Woman II*, 1971.
Bronze, 11½ x 18½ x 13 inches. Collection of
the artist

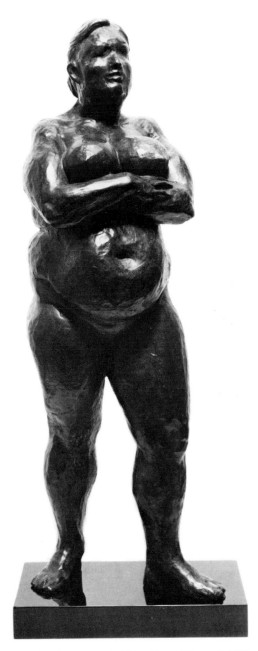

Fig. 134 Richard McDermott Miller. *Stout Woman III*, 1971.
Bronze, 11 x 19 x 11 inches. Collection of the artist

Fig. 135 Richard McDermott Miller. *Stout Woman I*, 1971.
Bronze, 16¾ x 6 x 4¾ inches. Collection of the artist

218

antiabstract than he is antipictorial (Tillim has even suggested that his work has links to the "sensibility of non-image sculpture"[17]). He works directly from nature, although he does photograph his models first in order to study the information of their bodies, making traditional images that he wants divested of the rhetoric that accompanies the statue format. He wants his figures to read as volumes rather than as illusions of something or somebody.

Miller's figures seem drained of the emotional presence one might expect in figurative sculpture. In *Sandy in Defined Space* (fig. 132), the forms of the figure read like volumes in a space defined by an enclosure rather than as signs revealing the individuality of that figure. In other words, the forms themselves are left unprovoked, even untouched, by emotions that might disturb the classical ideal. Miller's work, however, is not completely devoid of emotion; the wonderfully expressionionistic figures of *Stout Woman I–III* (figs. 133–135), like Gaston Lachaise's female figures in their exaggerated abundance, capture the personality of the sitter's forms. But typically, in such works as *Diving, Plummeting, Leveling-Off* (fig. 136), the sculptor's interest returns to the investigation of the formal operation of volumes in space.

With a few exceptions, Miller's figures, and contemporary realist sculpture as a whole, are based on a perceptual rather than a rationalizing method; even the *Diving, Plummeting, Leveling-Off* assemblage of figures is not made up entirely out of the artist's head. However, even the rationalizing method — in which an image is generated by an idea rather than by a specific reality — is strongly based in phenomenological aesthetics. The "made-up" figure, in other words, always has behind it some reality — it may be influenced by a certain body type, constructed as a composite from various figures, or based on a study of anatomy.

Isabel McIlvain's female figures, cast in hydrocal with a lustrous, highly polished white surface, are also based on both photographic and direct perception. They are intimate in scale, quiet, feminine works in which a serenity of mood is achieved through passive gestures. McIlvain, who studied anatomy with Robert Beverly Hale, is committed to replicating the forms of the human body with accuracy. In all of her figural works, for instance,

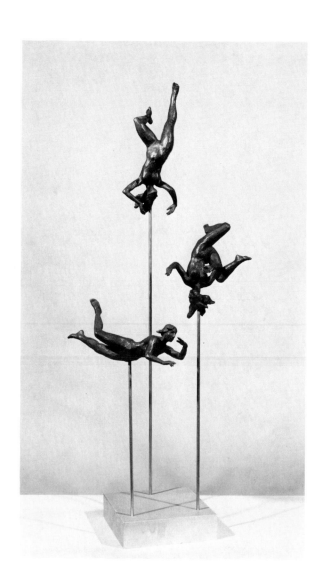

Fig. 136 Richard McDermott Miller. *Diving, Plummeting, Leveling-Off*, 1977. Bronze, 11 inches high. Collection of the artist

Seated Figure (fig. 137), anatomical accuracy under- lies her intentions although its presence is never obtrusive.

The sculpture of Robert Graham embodies the same requirement of anatomical accuracy and the same *intimiste* qualities as McIlvain's figures; his work of the mid-1960s was in fact miniature figures, often in erotic positions, seen under domed, Plexiglas cases. In recent works like *Lise Dance Figure I* (see fig. 121), the figure is elevated, like a Giacometti, and has the grace of a Degas bronze dancer. In *Heather* (Pl. 55) the figure's symmetry and precise finish force the eye to examine the surface for flaws. As in McIlvain's figures, the anatomy is accurate but not obtrusive.

The anatomical presence is more insistent in Harvey Citron's *Study for Full Figure*, reminiscent in its pose of Auguste Rodin's *Walking Man*, in which the sculpture is read more as an anatomical lesson than as the figure of a real person. Citron, who studied sculpture at the Accademia di Belli Arti da Roma, approaches his work in a highly tra- ditional manner. His most successful works to date are smaller pieces like *Female Figure Standing* (fig. 138), in which bodily forms are less rigidly anatomical and in which the underlying drama of the movement is realized through the fluency of line that invests the figure with a lyrical unity.

A similar lyricism, touched with nostalgia, informs the bas-relief *Portrait of Ann Jay* (fig. 139) by Robert White. White, who was born in New York City in 1921 and studied at the Rhode Island School of Design and at the American Academy in Rome, captures in this intimate portrait of youth the essence of a quiet moment with sensitivity, compassion, and timelessness.

Of the traditional sculptors among contemporary American realists, Walter Erlebacher is one of the most gifted; his work is certainly the most theo- retical and it is valued for both its learnedness and its contemporaneity. Erlebacher, who was born in Frankfurt am Main, Germany, in 1933, came to New York with his family in 1940; in 1951 he en- rolled at Pratt Institute, where he later received degrees in industrial design. During his years at Pratt (interrupted by a stint in the United States Army), Erlebacher spent an increasing amount of time making sculpture, which in those days was constructed abstract metal forms. In the early 1960s,

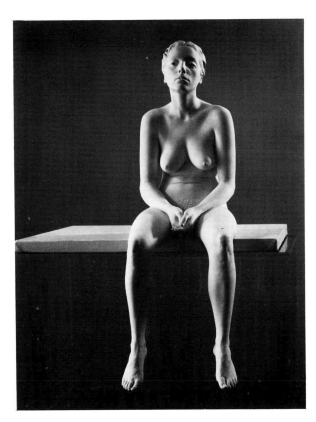

Fig. 137 Isabel McIlvain. *Seated Figure,* 1979. Hydrocal, 23 x 10 x 7½ inches. Courtesy of Robert Schoelkopf Gallery, New York

already working in clay (and subsequently plaster) from the model, Erlebacher began to sculpt small, amorphous forms, with a porcelainlike surface, that became increasingly anthropomorphic. As these forms increased in size they conveyed the energy and movement of the human body without specific references to it. Faithful to the modernist idea of emphasizing materials, Erlebacher found in the human figure the natural form that suited the materials he chose to work in.

In 1964–1965, after years of resisting his inclinations for natural forms and dissatisfaction with the amorphous quality of his figures, Erlebacher com- mitted himself to realist representation. His under- standing of the human figures is based on a thorough study of human anatomy, which he taught himself; this study still preoccupies him and remains crucial to his work. Erlebacher's post-1965 figures, fabri- cated in a lead alloy, are based on this knowledge and a conceptualized system of proportions, rather than on specific models. The subjects derive from his interest in classical mythology, which he turned

220

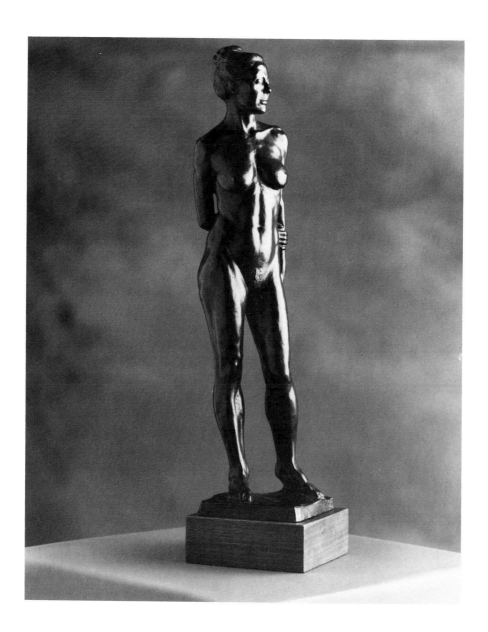

Fig. 138 Harvey Citron. *Female Figure Standing*, 1976.
Bronze, 18 x 4 x 4 inches. Collection of the artist

to not for its own sake but as the basis for a narrative art. Rather than reiterating historical myths, he, like the painter Milet Andrejevic, chose to update them to give them a modern relevancy.

Since the early 1970s Erlebacher's rationalizing method has increasingly given way to a more perceptual method. His ambition now is to combine in a figure the specific information of an invididual and an idealized, typal characterization for narrative ends. Erlebacher has said he wants to "force real figures into rationalized conventions."[18]

The Death of Apollo (Pl. 56) is a clear departure from earlier figurative works in which figures were based on an ideal system of proportions, although it is transitional in terms of his more recent work. Narrative, but intentionally not totally accessible, *The Death of Apollo* is predicated upon the inherent dichotomy between rational thinking and nature that Erlebacher posits, a theme of particular relevancy to contemporary life since it implies the alternatives (to the sculptor, at least) of destruction ("rationalization may lead to the end of the world," Erlebacher says) and permanency (nature). Apollo,

the most revered and influential of the Hellenic gods, whose presence traditionally made men aware of their own guilt and purified them of it, walks boldly through an edifice symbolic of civilization (a product of man's rational thinking), which is surrounded by various tree species as signs of nature. In a significant departure, Erlebacher has based the figure of Apollo not on a conceptual system of proportions based on rational thinking, but on a body type, specifically on the memory of a well-muscled older man whom he once observed at work. In his choice of Apollo as a symbol and in his treatment of him in the context of an enclosing edifice, Erlebacher seems to imply that the future of mankind depends on compromising the very dichotomy that he posits.

In more recent work, the figures are based on composites of different prototypes, although in some, as in *Jesus Breaking Bread* (fig. 140), parts of the figure (the face of Jesus, for example) are totally made up. His most recent commission, entitled *Bishop John Neumann Greeting the Citizens of Philadelphia* (fig. 141), not yet completed (and

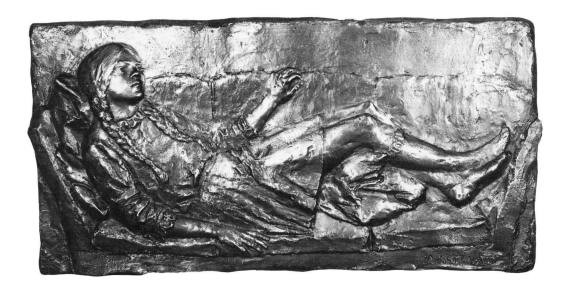

Fig. 139 Robert White. *Portrait of Ann Jay,* 1974. Bronze, 11 x 22 inches. Collection of Mr. and Mrs. Robert Dean Jay

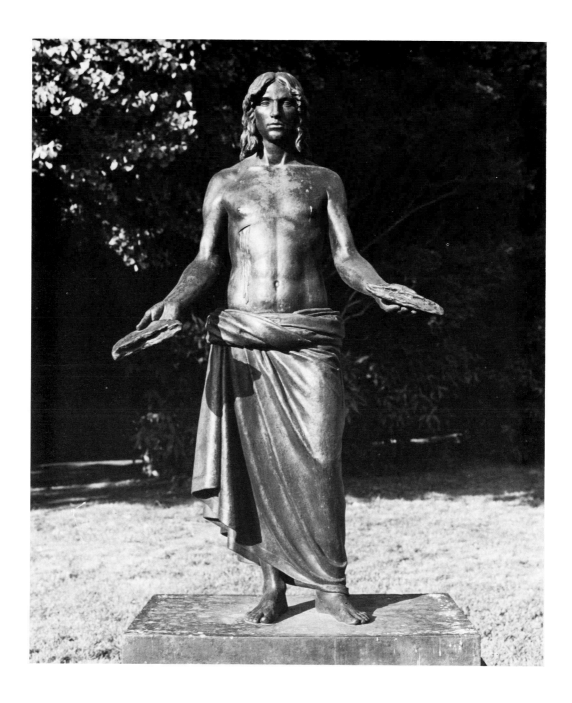

Fig. 140 Walter Erlebacher. *Jesus Breaking Bread*, 1975–1976.
Bronze, 6 feet high. Archdiocese of Philadelphia

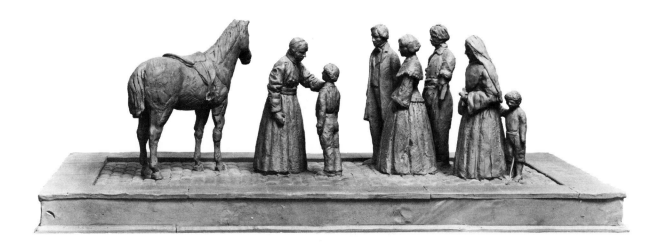

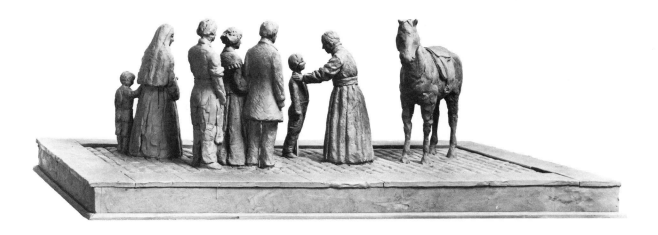

Fig. 141 Walter Erlebacher. *Bishop John Neumann Greeting
the Citizens of Philadelphia*, 1979. Maquette:
plastelene, 9⅞ x 28½ x 15½ inches. Collection of
the artist

reproduced here as a clay maquette that has already undergone programmatic changes), is a public monument to commemorate the life of Neumann, a Catholic bishop living in Philadelphia in the nineteenth century who has recently been canonized, a person widely known for his selflessness, humility, charity, and good works. In honoring John Neumann in a simple genre scene, a scene that must have taken place many times but that has no visual record, Erlebacher has proposed a fitting memorial that has both a specific reference and a timeless narrative.

The sculptor (and his wife, Martha Mayer Erlebacher) carefully researched the circumstances of John Neumann's life. All the figures are based on real personages; the monument incorporates a mixture of portraits of historical and contemporary figures as appropriate to both the piece's historical reference and its timeless quality. They are shown in accurate period clothing, the horse's saddle is of the time, and the figures are placed on a footing of red brick, a material used to pave the streets of Philadelphia during Neumann's life. The figures represent a variety of types — a young boy, perhaps from the country; a professional man escorting a lady; a municipal laborer; a nun, and an orphan — all of whom would have been touched by Neumann. Compositionally, the figures support the meaning of the bishop's life. Dressed in his bishop's robes, he is portrayed dismounted next to his horse, with his hand placed on the young boy's shoulder, a gesture symbolic of his good works. The horse itself is a reference to Neumann's missionary work and service throughout the city, and his dismounting is a traditional symbol of humility. The simple gesture of the hand placed sympathetically on the young boy's shoulder points to his concern for the welfare of children and symbolizes his commitment to exercise his responsibility to transmit moral values. Neumann's example serves as the model to other citizens of Philadelphia. Erlebacher, himself moved by the example of the great bishop's passionate life, hopes others will benefit in the same way that he has.

While the figure in all its manifestations, both ideationally and materialistically, has always been the principal image for sculpture, and remains so among realist sculptors, the perception of the guises sculpture may take has been radically altered in the twentieth century.[19] The aesthetics of modernism have had a profound effect on both nonobjective and objective sculpture. One effect has been to liberalize the range of acceptable subject matter, a liberalization capitalized on by Pop sculptors, who, in turn, have influenced several contemporary realist sculptors.

The subject matter of Pop Art (and Pop Sculpture) was based on familiar materials — brand-name goods and other ordinary images taken from popular culture — that had a precoded information level. As Lawrence Alloway said, it was an art about signs and sign systems. Contemporary realist sculptors who use images from everyday life as their subject matter share this with Pop sculptors, but their work differs in three important ways. First, their art is not based upon the desire to borrow "signs." Indeed, they have chosen as their subject nonprecoded images, not limited by a priori ideas. Second, their attitude to subject matter is less satirical and caustic; it is more affirmative in its genuine appreciation of the beauty inherent in the most ordinary objects. Third, realist sculpture is not so much predicated upon an objectmaking mentality — although realist sculptors do make real-looking objects — as it is upon the perception of those objects. As Jud Nelson, who makes meticulously detailed styrofoam as well as marble sculptures, has said, "If there is one activity that takes place in my studio, it is learning how to see."[20]

Jud Nelson, who was born in Portland, Oregon, in 1943, is the most precise of the small group of post-Pop realist sculptors. His subjects — sunglasses, slices of bread, teabags, Popsicles, mousetraps, and the like, seen in multiples of six — are records of Nelson's perceptual acumen, of his need to detail the slightest features of an object with the utmost fidelity, as well as records of his own working processes. Described as an "intimiste,"[21] he admires Chardin's ability to instill magic in ordinary objects, but at the same time he is influenced by holograms. His life-size objects are derived from real objects and not photographs of them, and are not about the objects themselves but about the act of perception. Working in the series format (he refers to the "Holos Series," for example, as in Holos Series 7, Nos. 1 — 6 [Wonder bread], fig. 142), Nelson believes that one's perception of objects is increased if one sees them individually and compara-

Fig. 142 Jud Nelson. *HOLOS / series 7, nos. 1-6 (Wonder bread)*,
1979. Carved Italian statuary marble, 4 x 4 x ½
inches. Nos. 1, 2, 6, courtesy of Carol Taylor Art,
Dallas; Nos. 3, 4, 5, collection of the artist

Fig. 143 Marilyn Levine. *Judy's Hiking Boots,* 1974. Ceramic, 5½ x 4½ x 11 inches each. Collection of Bruce and Barbara Berger

Fig. 144 Fumio Yoshimura. *Bicycle with Parking Meter,* 1978. Linden wood, 68 x 53½ x 16½ inches. Courtesy of Nancy Hoffman Gallery, New York

tively so that the nuances of each state become clearer while the observer decides whether to regard objects as six exact duplicates or six unique objects. Presenting the objects like specimens in a case, Nelson achieves these nuances through a painstakingly meticulous process, carving Styrofoam and marble under intense illumination (he wants to employ laser light) with precisionist skill. He takes months to complete a single object, and the end results are monuments both to technology and to his ability to see almost atomically.

The *trompe l'oeil* effect of Jud Nelson's sculpture is matched by Marilyn Levine's worker's boots, handbags, gloves, jackets, and golf bags modeled freehand in clay to simulate the look and feel of leather objects. Levine's work challenges our perceptual abilities while it reflects upon the fact of human existence. She has purposely chosen to replicate the look of leather since it (better than any other material, perhaps) reflects the aging process that is so much a part of the content of her work. In *Judy's Hiking Boots* (fig. 143) the aging process largely determines the form and sets up a narrative dialogue. Her works take on personalities of their own, expressing, like portraits, moods of optimism, thoughtfulness, despair, and resolution. They become icons of the human condition.

Fumio Yoshimura's carved wooden works share little of this sense of the passage of time, nor are they invested with human personalities. Yoshimura, born in 1926 in Kamakura, Japan, makes objects of a wide assortment in exquisitely carved wood. Not working directly from photographs, he studies his subjects at length, making copious realistic drawings and measurements as well as studying accurate mechanical drawings and specifications, and making illustrations of professional quality before beginning work. Whereas likeness is important, particularly at the outset, Yoshimura is ultimately more interested in an object's essence than in its likeness. He talks about his pieces being "poems" of reality in wood. Yoshimura is a master of wood carving, and in such a work as *Bicycle with Parking Meter* (fig. 144), his love for wood is obvious. However, in the best traditions of the contemporary American realist, his work never departs from the object. What is perceived lies at the heart of the artistic experience.

Conclusion

American artists and their patrons have demonstrated a long-standing commitment to realism as an artistic mode; if anything, until the early years of the twentieth century there existed a discernible prejudice against work that wandered from the realist path. Instances of this prejudice were frequent in the nineteenth century — in the urging of landscapists to paint real scenes rather than ideal or imaginary ones; in the public rejection of many of America's best visionary artists; and in the aesthetic writings of the time. Deep in the American mind was a pragmatic sensibility that valued the look of things.

This realist bias came apart during the first sixty years of the twentieth century. Its initial putdown came from European modernism, which was new and exciting and allowed for an entirely different set of behavorial attitudes to the making of art. In the face of these avant-garde expressions, realism seemed rooted in conservative traditions that no longer appeared so relevant. Later, in the 1940s, realism as an artistic mode became the prey of modernist ideologists. These critics argued, for instance, that there was no validity in painting figuratively since figure painting no longer offered the possibility for artistic originality. They also promoted the idea that painting, being a unique art form, should reveal its uniqueness in dealing only with those issues — flatness and the properties of the medium — that it shared with no other art form. Such an attitude made illusionistic art retarditaire; America was gripped by the cult of the avant-garde.

Pop Art reintroduced imagery into mainstream American art, although the Pop aesthetic shares little with the tenets of contemporary realism. Nonetheless, it pointed in a new direction; without that direction contemporary American realism might not have developed as we know it today.

Realism has emerged in the last twenty years as a viable alternative to, and an extension of, modernism. As we have seen, it is not an art movement per se, but a pluralistic expression shaped by its unique relationship to the past and present. The critic must consider it in human and formal terms. Neither approach is inappropriate; neither should be exercised exclusively.

As would be expected from its pluralistic nature, contemporary realism does not impose a dialectical, stylistic, or historical imperative on the artist. It leaves the painter or sculptor free to follow his individual vision, allowing a multitude of personal choices. This explains its heterogeneous look, and also the divergent attitudes realist artists show to the past — to earlier realist traditions — and to modernism. It is at once a reaction to the exclusiveness of modernism and an extension of the tenets of modernism into an illusionistic art. Made possible by modernism, it takes what it needs from both the old and the new to make something itself new in the tradition of realism. In other words, it allows the artist to take an "inclusivist" position: those who wish to express traditional concerns can do so in a contemporary syntax; those with abstract concerns can work illusionistically. Through such a strategy, realism has broken out of the corner it had painted itself into in the earlier twentieth century.

No matter what their bias, formal or phenomenological, contemporary realists share a basic concern for visual perception. They like to give the viewer a lot to look at. They like to test their own ability to see at the same time that they challenge ours. They are not satisfied with the knowledge of what they *think* they know about something — like true empiricists, they are always gathering more data. Those data are the basis of pictorial structure, serving a multitude of purposes. In the long tradition of realism, American realism of the past two decades is an important new episode. Contemporary life finds expression in contemporary art, which becomes an expression of our modern world.

Introduction

1 Neil Welliver, "Inclusive Painting," *America 1976*, A Bicentennial Exhibition sponsored by the U.S. Department of the Interior, 1976 (1978), p. 4.

2 Interview by Nancy Foote with Stephen Posen, in Linda Chase et al., "The Photo-Realists: 12 Interviews," *Art in America* 60, no. 6 (November — December 1972): 85.

3 Interview by Brian O'Doherty with Ralph Goings, ibid., p. 88.

4 Hilton Kramer, "The Return of Realism," *The New York Times*, March 12, 1978, Section 2, p. 1.

5 Frank H. Goodyear, Jr., *8 Contemporary American Realists* (Philadelphia: Pennsylvania Academy of the Fine Arts, 1977), p. 20.

6 Ibid., p. 50.

7 Hermann Kern, *Chuck Close* (Munich: Kunstraum München, 1979), p. 11.

8 Goodyear, *8 Contemporary American Realists*, p. 15.

9 Interview by Rose Hartman with Don Eddy, in Hartman, "Don Eddy," *Current* 1, no. 6 (February–March–April 1976): 40.

10 Alex Katz, "Is there a new Academy? Part II," *Art News* 58 (September 1959): 39.

11 Hilton Kramer, "Why Figurative Art Confounds Our Museums," *The New York Times*, January 2, 1977, Section D, p. 19.

12 Rackstraw Downes, "What the Sixties Meant to Me," *Art Journal* 34, no. 2 (Winter 1974–1975): 129.

Chapter One
Contemporary American Realism

1 Dorothy C. Miller, Alfred H. Barr, Jr., and Lincoln Kirstein, *American Realists and Magic Realists* (New York: The Museum of Modern Art, 1943), p. 5.

2 Ibid.

3 Ibid., p. 8.

4 *Art Digest* (June 1943).

5 Statement, *Reality: A Journal of Artists' Opinions* 1, no. 1 (Spring 1953): 1.

6 Ibid.

7 Statement by Edward Hopper, *Reality* 1, p. 8.

8 Editorial, "To Continue," *Reality* 3 (Summer 1955): 2.

9 The thesis of the exhibition *New Images of Man* (New York: The Museum of Modern Art, 1959), was predicated on an art that combined real images, however modified or distorted, in overall abstract compositions.

10 Fairfield Porter, "Recent American Figure Painting," in *Fairfield Porter: Art in Its Own Terms, Selected Criticism, 1935 — 1975*, ed. and with an introduction by Rackstraw Downes (New York: Taplinger, 1979), pp. 69 — 73.

11 *New Realists*, essay by John Ashbery (New York: Sidney Janis Gallery, 1962), unpaged.

12 E. C. Goossen, *The Art of the REAL USA 1948–1968* (New York: The Museum of Modern Art, 1968), p. 7.

13 See Linda Nochlin, *Realism Now* (Poughkeepsie, N.Y.: Vassar College Art Gallery, 1968); Sidney Tillim and William S. Wilson, *Directions 2: Aspects of a New Realism* (Milwaukee: Milwaukee Art Center and two other museums, 1969); James K. Monte, *22 Realists* (New York: Whitney Museum of American Art, 1970).

14 It seems very unlikely that such a lack of unanimity would appear in similar group shows on Abstract Expressionism or Pop Art, for instance.

15 In my opinion, the exhibition *New/PhotoRealism Painting & Sculpture of the 1970s*, organized by Jack Cowart for the Wadsworth Atheneum, Hartford, in 1974, has been the clearest in its presentation of a realist strategy. However, since it dealt only with photo-realism, it avoided the larger issues of defining contemporary realism's full scope.

16 *Prospectus & Benefit Exhibition* (New York: Artists' Choice Museum, 1979).

17 For an excellent discussion on this, see Barbara Novak, *American Painting of the Nineteenth Century: Realism, Idealism and the American Experience* (New York: Praeger, 1969), pp. 61–79.

18 Linda Nochlin, *Realism Now*, p. 7.

19 Hilton Kramer, "A Refuge from the Vexing 70s," *The New York Times*, March 25, 1979, Section D, p. 31.

20 Clement Greenberg, "Abstract, Representational, and so forth," *Art and Culture* (Boston: Beacon Press, 1961), p. 133.

230

21 Clement Greenberg, "Modernist Painting," *The New Art: A Critical Anthology*, ed. Gregory Battcock (New York: E. P. Dutton, 1973), pp. 66–67.

22 Devonna Pieszak, "Interview with Jack Beal," *New Art Examiner 7*, no. 2 (November 1979): 6.

23 These have been brilliantly put forth in Linda Nochlin's *Realism* (Baltimore: Penguin Books, 1971).

24 Linda Nochlin has developed these ideas in her article "The Realist Criminal and the Abstract Law," *Art in America 61*, no. 5 (September–October 1973): 54–61.

25 For a brilliant account of the story of the artist's struggle against "schemata," see E. H. Gombrich, *Art and Illusion*, Bollingen Series XXV, no. 5 (Princeton: Princeton University Press, 1961), p. 4.

26 Justin Schorr, "Destination: Realism," *Art in America 52*, no. 1 (June 1964): 117.

27 Monte, *22 Realists*, p. 9.

28 Sidney Tillim, "Figurative Art 1969: Aspects and Prospect," *Directions 2: Aspects of a New Realism*, p. 2.

29 Nochlin, *Realism*, p. 13.

30 Gabriel Laderman, "Problems of Criticism, VII," *Artforum 9*, no. 1 (September 1970): 59.

31 *Gustave Courbet 1819–1877* (Paris: Galeries nationales d'exposition du Grand Palais, and London, The Royal Academy of Arts, 1978–1979), p. 77.

32 Neil Welliver, "Inclusive Painting," *American 1976, A Bicentennial Exhibition* sponsored by the U.S. Department of the Interior, 1976 (1978), p. 14.

33 Rackstraw Downes, "What the Sixties Meant to Me," *Art Journal 34*, no. 2 (Winter—1974–1975): 127.

34 Robert Venturi, *Complexity and Contradiction in Architecture* (New York: The Museum of Modern Art, 1966), pp. 22–23.

35 Downes, "What the Sixties Meant to Me," p. 127.

36 Interview by Brian O'Doherty with Robert Bechtle, in Linda Chase, et al., "The Photo-Realists: 12 Interviews," *Art in America 60*, no. 6 (November–December 1972): 73.

37 Welliver, "Inclusive Painting," p. 14.

38 Jack Beal has maintained that contemporary realism must cleanse itself of modern aesthetics before it can sincerely address itself to the humanistic issues of painting.

39 Frank H. Goodyear, Jr., *8 Contemporary American Realists* (Philadelphia: Pennsylvania Academy of the Fine Arts, 1977), p.44.

40 Interview by Linda Chase and Ted McBurnett with Tom Blackwell, in "The Photo-Realists: 12 Interviews," p. 76.

41 Ibid., p. 87.

42 John H. Neff, "Painting and Perception: Don Eddy," *Arts Magazine 54* no. 4. (December 1979): 99.

43 Interview by Linda Chase and Ted McBurnett with Chuck Close, in "The Photo-Realists: 12 Interviews," p. 76.

44 Hermann Kern, *Chuck Close* (Munich: Kunstraum München, 1979), p. 13. The essay "Photography and Picture Language" in this catalogue is an excellent exposition of Close's ideas about the relationship of photography and painting.

45 Lawrence Alloway, "Notes on Realism," *Arts Magazine 44*, no. 6 (April 1970): 26.

46 Interview by Linda Chase and Ted McBurnett with Robert Cottingham, in "The Photo-Realists: 12 Interviews," p. 78.

47 Goodyear, *8 Contemporary American Realists*, p. 20.

48 Ibid., p. 26.

49 Ibid.

50 John Gruen, "William Bailey: Mystery and Mastery," *Art News 78*, no. 9 (November 1979): 145.

51 Neff, "Painting and Perception: Don Eddy," p. 102.

52 Statement by Alfred Leslie in *Alfred Leslie* (New York: Allan Frumkin Gallery, n.d.)

53 For instance, Rackstraw Downes, Theophil Groell, Catherine Murphy, and Gregory Gillespie paint on a small scale, and others, like William Beckman, regularly paint small pictures as well as large ones.

54 Tillim, "Figurative Art 1969," p. 6.

55 Nochlin, *Realism Now*, p. 9.

56 Courbet's remark, "I cannot paint an angel because I have never seen one," is cited in Nochlin, *Realism*, p. 82.

57 Interview with Alex Katz by the author, November 10, 1979, New York

Chapter Two
Portraits, Nudes, and the Figure Outdoors

1 Peter Selz expresses his thoughts in *New Images of Man* (New York: The Museum of Modern Art, 1959), pp. 11–12.

2 W. J. Kelly, "Figure/Studio," in *The Figure in Recent American Painting* (New Wilmington, Pa.: Westminster College, 1974), p. 10.

3 Paul Tillich, "A Prefatory Note," in *New Images of Man*, p. 9.

4 Ibid., pp. 9–10.

5 Selz, "Introduction," *New Images of Man*. p. 12.

6 Fairfield Porter, "Recent American Figure Painting," in *Fairfield Porter: Art in Its Own Terms, Selected Criticism, 1935-1975*, ed. and with an introduction by Rackstraw Downes (New York: Taplinger, 1979), p. 72.

7 Ibid.

8 Ibid., pp. 72–73.

9 Alfred H. Barr, Jr., "Introduction," in *Recent Painting USA: The Figure* (New York: The Museum of Modern Art, 1962), unpaged.

10 Ibid.

11 Philip Pearlstein, "Figure Paintings Today Are Not Made in Heaven," *Art News* 61, no. 3 (Summer 1962): 39.

12 Larry Day, "Notes on Figurative Art," in *The Figure in Recent American Painting*, p. 4.

13 Pearlstein, "Figure Paintings," p. 51.

14 W. J. Kelly, "Figure/Studio," p. 10.

15 Porter, "Recent American Figure Painting," p. 70.

16 Pearlstein, "The Process is My Goal," in "The Art of Portraiture, in the Words of Four New York Artists," *The New York Times*, October 31, 1976, Section D, p. 29.

17 Ann C. Van Devanter and Alfred V. Frankenstein, *American Self-Portraits, 1670–1973*, an exhibition organized and circulated by the International Exhibitions Foundation (Washington, D.C., 1974), p. 218.

18 Ibid., p. 230.

19 Abram Lerner and Howard Fox, "An Interview with Gregory Gillespie," in *Gregory Gillespie* (Washington, D.C.: Hirshhorn Museum and Sculpture Garden, 1977), p. 28.

20 Ibid., p. 29.

21 Gerrit Henry, "The Artist and the Face: A Modern American Sampling," *Art in America* 63, no. 1 (January – February 1975): 34.

22 Ibid.

23 Pearlstein, *"Figure Paintings,"* p. 39.

24 Statement by Alex Katz, in "Ten Portraitists: Interviews/ Statements," *Art in America* 63, no. 1 (January – February 1975): 36.

25 Ibid.

26 Statement by Chuck Close, "Ten Portraits: Interviews/ Statements," p. 41.

27 Close, "I Translate from a Photo," in "The Art of Portraiture, in the Words of Four New York Artists," p. 29.

28 Hayden Herrera, "Pearlstein's Portraits at Face Value," *Art in America* 63, no. 1 (January–February 1975): 46.

29 Statement by Alfred Leslie in *Alfred Leslie* (New York: Allan Frumkin Gallery, 1976).

30 Interview by the author with Alfred Leslie, July 14, 1976, South Amherst, Massachusetts.

31 Quoted in Linda Nochlin, "The Art of Philip Pearlstein: Realism is Alive and Well in Georgia, Kansas, and Poughkeepsie," in *Philip Pearlstein* (Athens, Ga.: Georgia Museum of Art, 1970), unpaged.

32 Pearlstein, "The Process is My Goal," p. 29.

33 Statement provided by Milet Andrejevic to the author, New York, January 23, 1980.

34 Neil Welliver, "Inclusive Painting," *America 1976*, A Bicentennial Exhibition sponsored by the U.S. Department of the Interior, 1976 (1978), p. 13.

Chapter Three
Narrative Painting

1 See, for instance, Hilton Kramer, "Jack Beal's Unabashed Social Realism," *The New York Times,* February 10, 1980, Section 2, p. 29.

2 Sidney Tillim, "Notes on Narrative and History Painting," *Artforum* 15, no. 9 (May 1977): 41.

3 Ibid., p. 43.

4 Ibid., p. 41.

5 Fairfield Porter, "Leslie Ferrer, Schueler," *Fairfield Porter: Art in Its Own Terms, Selected Criticism, 1935 – 1975*, ed. and with an introduction by Rackstraw Downes (New York: Taplinger, 1979), p. 181.

6 Quoted from a letter by Alfred Leslie to John Arthur, April 12, 1976, printed in *Alfred Leslie* (Boston: Museum of Fine Arts, 1976).

7 Ibid.

8 The account of this event and and its artistic tradition is well told in Michael Marrinan, "Images and Ideas of Charlotte Corday: Texts and Contexts of an Assassination," *Arts* 54, no. 8 (April 1980): 158 – 176.

9 "Alfred Leslie Talks with John Arthur," *Drawing* 1, no. 4 (November–December 1979): 82.

10 Ibid.

11 Devonna Pieszak, "Interview with Jack Beal," *New Art Examiner* 7, no. 2 (November 1979): 3.

12 Interview by the author with Jack Beal, December 15, 1978, on the New Jersey Turnpike.

13 Pieszak, "Interview with Jack Beal," p. 3.

14 Ibid., p. 6.

15 Quoted from GSA News Release, no. 6739, February 25, 1977.

16 Beal discusses the advantages of such a system in his interview with Devonna Pieszak.

Chapter Four
The New Landscape

1 "Toward the Abstract Sublime: A Selection of Twentieth Century Artists' Texts," in Kynaston McShine, ed., *The Natural Paradise: Painting in America 1800 – 1950* (New York: The Museum of Modern Art, 1976), p. 109.

2 Ibid., p. 110.

3 Rackstraw Downes, "Introduction," in *Fairfield Porter: Art in Its Own Terms, Selected Criticism, 1935 – 1975* (New York: Taplinger, 1979), p. 26.

4 Fairfield Porter, "Abstract Expressionism and Landscape," in *Fairfield Porter: Art in Its Own Terms*, p. 111.

5 Wolf Kahn, "What is a Painter's Subject?" in *Wolf Kahn* (New York: Borgenicht Gallery, 1974).

232 6 Interview by the author with Neil Welliver, July 15, 1976, Lincolnville, Maine.

7 Rackstraw Downes, "What the Sixties Meant to Me." *Art Journal* 34, no. 2 (Winter 1974–1975): 131.

8 Ibid., p. 130.

9 Statement by Richard Crozier, in *New York Realists 1980* (Sparkhill, N.Y.: Thorpe Intermedia Gallery, 1980), p. 14.

10 Interview by the author with William Beckman, September 21, 1978, Amenia, New York.

11 Quoted in Jasper F. Cropsey, "Up Among the Clouds," *The Crayon* (New York, August 8, 1855), p. 80.

12 Letter to the author from Joseph Raffael, September 3, 1976.

13 Quoted in Jan Butterfield, " 'I have Always Copied': An Interview with Joseph Raffael," *Arts Magazine* 51, no. 2 (October 1976): 124.

14 Susan C. Larsen, *Vija Celmins* (Newport Beach, Calif.: Newport Harbor Art Museum, 1979–1980), p. 26.

15 Ibid.

16 Taken from "Bill Richards: Q. & A.," in *Drawings* (New York: Nancy Hoffman Gallery, 1976).

17 See "Bill Richards: Q. & A." for an excellent discussion on what Richards requires of subject matter.

18 John Arthur, "A Conversation with Richard Estes," in *Richard Estes: The Urban Landscape* (Boston: Museum of Fine Arts, 1978), p. 18.

19 Ibid., p. 22.

20 Ibid., p. 27.

21 Ibid., p. 43.

22 Manuscript notes provided by Robert Cottingham to the author, July 31, 1979, Newtown, Connecticut.

23 Ibid.

Chapter Five
Still Life

1 Quoted in Frank H. Goodyear, Jr., *8 Contemporary American Realists* (Philadelphia: Pennsylvania Academy of the Fine Arts, 1977), p. 38.

2 John Gruen, "William Bailey: Mystery and Mastery," *Art News* 78, no. 9 (November 1979): 145.

3 Jed Perl, "Gabriel Laderman," *Arts Magazine* 51, no. 9 (May 1977): 5.

4 Gruen, "William Bailey," p. 142.

5 Ibid., p. 145.

6 Quoted in Goodyear, *8 Contemporary American Realists*, p. 41.

7 Quoted, ibid., p. 56.

8 Ibid., p. 30.

9 Interview with Stephen Posen by the author, New York, June 6, 1980.

10 Alwynne Mackie, "Dialectic in Modernism: The Paintings of Stephen Posen," *Art International* 23, no. 8 (December 1979): 61.

11 Interview with Richard McLean by the author, Oakland, California, February 9, 1979.

12 Interview by Linda Chase and Ted McBurnett with John Salt, in Chase, et al., "The Photo-Realists: 12 Interviews," *Art in America* 60. no. 6 (November-December 1972): 88.

13 Interview by the author with Robert Bechtle, Berkeley, California, February 9, 1979.

14 Ibid.

15 Robert Bechtle, "Artist's Statement" in *Robert Bechtle: Retrospective* (Sacramento: E. B. Crocker Art Gallery, 1973).

16 Interview by Brian O'Doherty with Ralph Goings, in "The Photo-Realists: 12 Interviews," p. 87.

17 Statement by the artist, in *Tom Blackwell* (New York: Louis K. Meisel Gallery, 1977).

18 Letter from David Parrish to the author, November 6, 1979.

Chapter Six
The Realist Alternative in American Sculpture

1 Robert Pincus-Witten, "George Segal as Realist," *Artforum* 5, no. 10 (Summer 1967): 84.

2 Henry Geldzahler, "An Interview with George Segal," *Artforum* 3, no. 2 (November 1964): 26.

3 Ibid.

4 The most complete discussion of Katz's cutout sculpture is in Carter Ratcliff, *Alex Katz's Cutouts* (New York: Robert Miller Gallery, 1979).

5 Interview with John DeAndrea by the author, August 5, 1978, Lakewood, California.

6 Interview by Linda Chase and Ted McBurnett with Duane Hanson in Joseph Masheck, "Verist Sculpture: Hanson and DeAndrea," *Art in America* 60, no. 6 (November-December 1972): 99.

7 Interview by Duncan Pollock with John DeAndrea in Masheck, "Verist Sculpture: Hanson and DeAndrea," p. 98.

8 Quoted in Frank H. Goodyear, Jr., *Seven on the Figure* (Philadelphia: Pennsylvania Academy of the Fine Arts, 1979), p. 38.

9 Lisa Lyons, "Jud Nelson," in *Eight Artists: The Elusive Image* (Minneapolis: Walker Art Center, 1979), p. 47.

10 Quoted in Jan van der Marck, *George Segal* (New York: Harry Abrams, 1975), notes accompanying plate 49.

11 I feel van der Marck's view (ibid., p. 30) is erroneous.

12 Ellen Edwards, "Duane Hanson's blue collar society," *Art News* 77, no. 4 (April 1978): 57.

13 Ibid., pp. 57–58.

14 Quoted, ibid., p. 57.

General Works

Books and Exhibition Catalogues

Alloway, Lawrence. *Topics in American Art Since 1945.* New York: W. W. Norton, 1975.

Andersen, Wayne. *American Sculpture in Process: 1930/1970.* Boston: New York Graphic Society, 1975.

Arthur, John. *Realist Drawings & Watercolors.* Boston: New York Graphic Society, 1980.

Battcock, Gregory, ed. *The New Art.* New York: E. P. Dutton, 1973.

_____. *Super Realism.* New York: E. P. Dutton, 1975.

Butler, Susan, L. *Late Twentieth Century Art from the Sydney and Frances Lewis Foundation.* Philadelphia: Institute of Contemporary Art, University of Pennsylvania, 1979.

Cathcart, Linda L. *American Painting of the 1970s.* Buffalo, N.Y.: Albright Knox Art Gallery, 1979.

Chase, Linda. *Hyperrealism.* New York: Rizzoli, 1975.

Clark, Kenneth. *The Nude / A Study in Ideal Form.* New York Pantheon, 1956.

Coke, Van Deren. *The Painter and the Photograph.* Albuquerque, N.M.; University of New Mexico Press, 1964.

Complete Guide to Photo Realist Printmaking, The. New York: Louis K. Meisel Gallery, 1978.

Dickson, Harold E. *Portraits USA 1776–1976.* University Park, Pa.: Pennsylvania State University Museum of Art, 1976.

Documents, Drawings, and Collages/Fifty American Works on Paper from the Collection of Mr. and Mrs. Stephen D. Paine, Williamstown, Mass.: Williams College Museum of Art, 1979.

Downes, Rackstraw, ed. *Fairfield Porter: Art in Its Own Terms, Selected Criticism, 1935–1975.* New York: Taplinger, 1979.

Eisler, Georg. *From Naked to Nude.* New York: William Morrow, 1977.

Elsen, Albert E. *The Partial Figure in Modern Sculpture.* Baltimore: Baltimore Museum of Art, 1969.

Gerdts, William H. *The Great American Nude.* New York and Washington: Praeger, 1974.

Goldwater, Robert. *What is Modern Sculpture?* New York: The Museum of Modern Art, 1969.

Gombrich, E. H. *Art and Illusion.* Bollingen Series XXV, no. 5. Princeton: Princeton University Press, 1961.

Goodyear, Frank H., Jr., and Ann Percy. *Contemporary Drawings: Philadelphia, I & II.* Philadelphia: Pennsylvania Academy of the Fine Arts, 1978.

Greenberg, Clement. *Art and Culture.* Boston: Beacon Press, 1961.

Hills, Patricia, and Roberta K. Tarbell. *The Figurative Tradition and the Whitney Museum of American Art/Paintings and Sculpture from the Permanent Collection.* Cranbury, N. J.: Associated University Presses, 1980.

Hodin, J. P., and various authors. *Figurative Art since 1945.* London: Thames and Hudson, 1971.

Hoopes, Donelson F., and Nancy W. Moure. *American Narrative Painting.* Los Angeles: Los Angeles County Museum of Art, 1974.

Hopkins, Henry T. *Painting and Sculpture in California: The Modern Era.* San Francisco: Museum of Modern Art, 1976.

Kultermann, Udo. *New Realism.* Greenwich, Conn.: New York Graphic Society, 1972.

Lindey, Christine. *Superrealist Painting and Sculpture.* New York: William Morrow, 1980.

_____. *The New Sculpture, Environments and Assemblages.* New York: Praeger, 1968.

Lucie-Smith, Edward. *Super Realism.* Oxford: Phaidon, 1979.

Marshall, Richard. *New Image Painting.* New York: Whitney Museum of American Art, 1979.

Mathey, Francois. *American Realism.* New York: Skira/Rizzoli, 1978.

McShine, Kynaston, ed. *The Natural Paradise: Painting in America 1800–1950.* New York: The Museum of Modern Art, 1976.

Meisel, Louis K. *Photorealism.* New York: Harry Abrams, 1980.

Nochlin, Linda. *Realism and Tradition in Art 1848–1900.* Sources and Documents in the History of Art Series. Englewood Cliffs, N. J.: Prentice-Hall, 1966.

_____. *Realism.* Baltimore: Penguin Books, 1971.

234 Novak, Barbara. *American Painting of the Nineteenth Century: Realism, Idealism and the American Experience.* New York: Praeger, 1969.

Nygren, Edward J. *The Human Form/Contemporary American Figure Drawing and the Academic Tradition.* Washington, D.C.: Corcoran Gallery of Art, 1980.

Pitz, Henry C. *The Brandywine Tradition.* Boston: Houghton Mifflin, 1969.

Rose, Bernice. *Drawing Now.* New York: The Museum of Modern Art, 1976.

Russell, John, and Suzi Gablik. *Pop Art Redefined.* New York: Praeger, 1969.

Stebbins, Theodore E., Jr. *American Master Drawings and Watercolors.* New York: Harper & Row, 1976.

Szarkowski, John. *Mirrors and Windows: American Photography since 1960.* New York: The Museum of Modern Art, 1978.

Taylor, Joshua C. *America as Art.* Washington: Smithsonian Institution Press, 1976.

―――――. *The Fine Arts in America.* Chicago and London: University of Chicago Press, 1979.

Tucker, Marcia. *"Bad" Painting.* New York: The New Museum, 1978.

Van Devanter, Anne C., and Alfred V. Frankenstein. *American Self-Portraits, 1670–1973.* Washington, D.C.: International Exhibitions Foundation, 1974.

Varnedoe, J. Kirk, ed. *Modern Portraits / The Self and Others.* New York: Wildenstein Gallery, 1975.

Venturi, Robert. *Complexity and Contradiction in Architecture.* New York: The Museum of Modern Art, 1966.

Venturi, Robert, Denise Scott Brown, and Steven Izenour. *Learning from Las Vegas.* Cambridge, Mass. and London: MIT Press, 1972.

Waldman, Diane. *Twentieth-Century American Drawing: Three Avant-Garde Generations.* New York: Solomon R. Guggenheim Museum, 1976.

Yeh, Susan Fillin. *The Precisionist Painters 1916–1949: Interpretations of a Mechanical Age.* Huntington, N.Y.: Hecksher Museum, 1978.

Articles

Alloway, Lawrence. "Notes on Realism." *Arts Magazine* 44, no. 6 (April 1970): 26–29.

Andersen, Wayne. "The Fifties." *Artforum* 5, no. 10 (June 1967): 60–67.

Chase, Linda. "The Connotation of Denotation." *Arts Magazine* 48, no. 5 (February 1974): 38–41.

Chase, Linda, Nancy Foote, and Ted McBurnett. "The Photo-Realists: 12 Interviews." *Art in America* 60, no. 6 (November–December 1972): 73–89.

Davidson, Jalane E. "Esthetics, Realist Art and Hilton Kramer." Boston, May 23, 1979 (unpublished).

Fuller, Peter. "The Failure of American Printing / I. All Dressed Up and No Place to Go." *Village Voice* (August 27,1979): 41–43.

―――――. "The Failure of American Painting / II. Depth Be Not Cowed." *Village Voice* (September 3, 1979): 45–47.

Fried, Michael. "Art and Objecthood." *Artforum* 5, no. 10 (June 1967): 12–23.

Goodyear, Frank H., Jr. "Contemporary Realism: The Challenge of Definition." *American Art Review* 4, no. 6 (November 1978): 52–59.

Graham, William. "Realism is Alive and Well in Detroit." *New Art Examiner* 7, no. 2 (November 1979): 9.

Greenberg, Clement. "Seminar Six." *Arts Magazine* 50, no. 10 (June 1976): 90–93.

Greenwood, Michael. "Realism, Naturalism and Symbolism." *Artscanada* 33, no. 4 (December 1976–January 1977): xxix–5.

―――――. "Towards a Definition of Realism." *Artscanada* 33, no. 4 (December 1976–January 1977): 6–22.

―――――. "Current Representational Art." *Artscanada* 33, no. 4 (December 1976–January 1977): 23–43.

Gussow, Alan. "Let's Put the Land in Landscapes." *The New York Times*, March 14, 1976, Section 2, p. 1.

Henry, Gerrit. "The Artist and the Face: A Modern American Sampling." *Art in America* 63, no. 1 (January–February 1975): 34–41.

Huxtable, Ada Louise. "The Gospel According to Gideon and Gropius is under Attack." *The New York Times,* June 27, 1976, Section 2, p. 1.

Katz, Alex. "Is there a new Academy?, Part II." *Art News* 58 (September 1959): 39.

Kind, Joshua. "The Bourgeois Modernism." *New Art Examiner* 7, no. 2 (November 1979): 4–5.

"Kinds of Realism." *Allan Frumkin Gallery Newsletter,* ed. J. Martin (New York: Winter 1979).

Kramer, Hilton. "Art: Five-Gallery Realist Show." *The New York Times,* September 12, 1980, Section C, p. 20.

―――――. "A Refuge from the Vexing 70s." *The New York Times,* March 25, 1977, Section D, p. 31.

―――――. "The Return of Realism." *The New York Times,* March 12, 1978, Section 2, pp. 1 ff.

―――――. "The Return of the Still Life." *The New York Times,* March 4, 1979, p. 29.

―――――. "Why Figurative Art Confounds Our Museums." *The New York Times,* January 2, 1977, Section D, p. 19.

Kultermann, Udo. "Vermeer and Contemporary American Painting." *American Art Review* 4, no. 6 (November 1978): 114–119.

Laderman, Gabriel. "Unconventional Realists." *Artforum* 6, no. 3 (November 1967): 42–46.

_____. "Problems of Criticism, VII: Notes from the Underground." *Artforum* 9, no. 1 (September 1970): 59–61.

Levin, Kim. "Farewell to Modernism." *Arts Magazine* 54, no. 2 (October 1979): 90–92.

_____. "The Ersatz Object." *Arts Magazine* 48, no. 5 (February 1974): 52–55.

Marandel, J. Patrice. "The Deductive Image: Notes on Some Figurative Painters." *Art International* 16, no. 7 (September 20, 1971): 58–61.

Morris, Robert. "Notes on Sculpture, Part 3." *Artforum* 5, no. 10 (June 1967): 24–29.

Nemser, Cindy. "Sculpture and the New Realism." *Arts Magazine* 44, no. 6 (April 1970): 39–41.

_____. "Representational Painting in 1971." *Arts Magazine* 46, no. 3 (December 1971–January 1972): 41–46.

Nochlin, Linda. "The Realist Criminal and the Abstract Law." *Art in America* 61, no. 5 (September–October 1973): 54–61.

_____. "The Realist Criminal and the Abstract Law." *Art in America* 61, no. 6 (November–December 1973): 97–103.

_____. "Some Women Realists: Part I." *Arts Magazine* 48, no. 5 (February 1974): 46–51.

Pieszak, Devonna. "Figurative Painting — Can It Rescue Art?" *New Art Examiner* 7, no. 2 (November 1979): 1 ff.

Ratcliff, Carter. "The Contemporary Landscape." *Portfolio* 1, no. 2 (August–September 1979): 25–26.

Raynor, Vivien. "Art: Representation is Alive in SoHo." *The New York Times*, December 30, 1977, Section C, p. 23.

Raymond, H. D. "Beyond Freedom, Dignity, and Ridicule." *Arts Magazine* 48, no. 5 (February 1974): 25–26.

"Realism vs. Existentialism." *Allan Frumkin Gallery Newsletter*, ed. J. Martin (New York: Spring 1978).

Reality: A Journal of Artists' Opinions (New York). 1, no. 1 (Spring 1953); no. 2 (Spring 1954); no. 3 (Summer 1955).

Rose, Barbara. "Filthy Pictures: Some Chapters in the History of Taste." *Artforum* 3, no. 8 (May 1965): 20–25.

_____. "Self-Portraiture: Theme with a Thousand Faces." *Art in America* 63, no. 1 (January–February 1975): 66–73.

Schorr, Justin. "Destination: Realism." *Art in America* 52, no. 1 (June 1964): 115–118.

Seitz, William C. "The Real and the Artificial: Painting of the New Environment." *Art in America* 60, no. 6 (November–December 1972): 58–72.

Tapley, George M., Jr. "History and the Place of Realist Painting Today." *New Art Examiner* 7, no. 2 (November 1979): 5.

Tillim, Sidney. "Notes on Narrative and History Painting." *Artforum* 15, no. 9 (May 1977): 41–43.

_____. "Realism and 'The Problem.'" *Arts Magazine* 37 (September 1963): 48–52.

_____. "The Reception of Figurative Art: Notes on a General Misunderstanding." *Artforum* 7, no. 6 (February 1969): 30–33.

_____. "Scale and the Future of Modernism." *Artforum* 6, no. 2 (October 1967): 14–18.

_____. "A Variety of Realisms." *Artforum* 7, no. 10 (Summer 1969): 42–48.

Catalogues for Group Exhibitions
(chronological)

New York. The Museum of Modern Art. *American Realists and Magic Realists.* 1943. Edited by Dorothy C. Miller and Alfred H. Barr, Jr. Introduction by Lincoln Kirstein.

New York. The Museum of Modern Art. *New Images of Man.* [1959.] Text by Peter Selz.

New York. The Museum of Modern Art. *Recent Painting USA: The Figure.* May 23–Sept. 4, 1962. Circulating exhibition.

New York. Sidney Janis Gallery. *New Realists.* October 31–December 1, 1962. Preface by John Ashbery.

New York. Robert Schoelkopf Gallery. *9 Realist Painters.* December 10, 1963–January 4, 1964.

Worcester, Mass. Worcester Art Museum. *The New American Realism.* February 18–April 4, 1965.

New York. The Museum of Modern Art. *The Art of the REAL USA 1948–1968.* [1968.] Text by E. C. Goossen.

Poughkeepsie, N.Y. Vassar College Art Gallery. *Realism Now.* May 8–June 12, 1968. Essay by Linda Nochlin.

Tulsa, Okla. Philbrook Art Center. *The American Sense of Reality.* March 4–25, 1969. Circulating exhibition.

Milwaukee, Wisc. Milwaukee Art Center. *Directions 2: Aspects of a New Realism.* June 21–August 10, 1969. Essays by Sidney Tillim and William S. Wilson. Circulating exhibition.

New York. Whitney Museum of American Art. *22 Realists.* [1970.] Essay by James Monte.

Philadelphia. Institute of Contemporary Art, University of Pennsylvania. *The Highway.* January 14–February 25, 1970. Essays by Denise Scott Brown, Robert Venturi, John W. McCoubrey. Circulating exhibition.

Minneapolis. Walker Art Center. *Figures Environments.* May 15–June 13, 1970. Essays by Martin Friedman and Dean Swanson. Circulating exhibition.

Stockton, Calif. Pioneer Museum and Haggin Galleries. *Beyond the Actual / Contemporary Realist Painting.* November 6–December 6, 1970.

Chicago. Museum of Contemporary Art. *Radical Realism.* May 22–July 4 [1971].

236 Menomonie, Wisc. Art Center Gallery, Stout State University. *Drawings by Representational Painters.* February 16–March 17, 1971.

Philadelphia. Moore College of Art. *The New Landscapes.* October 15–November 19, 1971. Essay by Dianne Perry Vanderlip.

Potsdam, N.Y. Art Gallery: Brainerd Hall, State University College at Potsdam. *New Realism.* November 5–December 12, 1971.

The Realist Revival. 1972. American Federation of Arts circulating exhibition. Scott Burton, guest director.

New York. Sidney Janis Gallery. *Sharp-Focus Realism.* January 6–February 5, 1972.

Boston, Boston University School of Fine and Applied Arts Gallery. *The American Landscape/1972.* January 21–February 19, 1972. Essay by Mark Strand.

Kassel, Germany. *Documenta 5: Befragung der Realitat, Bildwelten heute,* June 30–October 8, 1972. "Realismus," by Jean-Christophe Ammann.

Cambridge, Mass. Fogg Art Museum, Harvard University. *Recent Figure Sculpture.* September 15–October 24, 1972. Essay by Jeanne L. Wasserman.

Stuttgart, Germany. Wurttembergischer Kunstverein. *Amerikanischer Fotorealismus.* November 16–December 26, 1972. Circulating exhibition.

Paris. Galerie Ardith. *Hyperrealistes americains.* [1973.]

Paris. Galerie des 4 Mouvements. *Grand maitres hyperrealistes americains.* 1973.

Rochester, N.Y. Memorial Art Gallery of the University of Rochester. *Photo-Realism 1973/The Stuart M. Speiser Collection.* Essay by Louis K. Meisel. [1973.]

San Jose, Calif. University Art Gallery, San Jose State University. *East Coast/West Coast/New Realism (Recent Photo-Realist Painting from the Two Coasts).* April 24–May 18, 1973.

Los Angeles. Los Angeles Municipal Art Gallery. *Separate Realities.* September 19–October 21, 1973. Essay by Laurence Dreiband.

Lincoln, Mass. De Cordova Museum. *The Super-Realist Vision.* October 7–December 9, 1973. Foreword by Carlo M. Lamagna.

Brussels. Galerie Isy Brachot. *Hyperrealisme/maitres americains et europeens.* December 14–February 9, 1974.

Worcester, Mass. Worcester Art Museum. *Three Realists: Close, Estes, Raffael.* February 27–April 7, 1974. Essay by Leon Shulman.

New Haven, Conn. Yale University Art Gallery. *Seven Realists.* March 28–June 2, 1974. Preface by Alan Shestack.

New York. Whitney Museum of American Art. *American Pop Art.* April 6–June 16, 1974. Text by Lawrence Alloway.

Hartford, Conn. Wadsworth Atheneum. *New/PhotoRealism Painting & Sculpture of the 1970s.* April 10–May 19, 1974. Essay by Jack Cowart.

Rotterdam. Museum Boymans–van Beuningen. *Kijher naar de werkelijtcheid amerikaanse hyperrealister europen realister.* June 1–August 18, 1974.

Cleveland. The Cleveland Museum of Art. *Aspects of the Figure.* July 20–September 1, 1974.

Wilmington, Del. Delaware Art Museum. *Contemporary American Paintings from the Lewis Collection.* September 13–October 27, 1974.

New Wilmington, Pa. Westminster College. *The Figure in Recent American Painting.* October 1–November 5, 1974. Essays by Larry Day, George Hildrew, W. J. Kelly. Circulating exhibition.

Akron, Ohio. Akron Art Institute. *Selections in Contemporary Realism.* October 27–December 1, 1974. Circulating exhibition. Edited by Robert Doty, preface by Philip Comfort.

University Park, Pa. State University Museum of Art. *Living American Artists and the Figure.* November 2–December 22, 1974.

Flushing, N.Y. The Queens Museum. *New Images: Figuration in American Painting.* November 16–December 19 [1974].

Wichita, Kan. Edwin A. Ulrich Museum of Art, Wichita State University. *The New Realism, Rip-Off or Reality?* 1975.

New York. Louis K. Meisel Gallery. *Watercolors and Drawings—American Realists.* [1975.]

New Wilmington, Pa. Westminster College Art Gallery. *In Praise of Space/The Landscape in American Art.* 1975. Essays by Michael Eisenman, Don Kimes, Bonnie Sklarski, Barbara White.

Baltimore. The Baltimore Museum of Art. *Super Realism.* November 18, 1975–January 11, 1976. Text by Tom L. Freudenheim, Brenda Richardson.

Cincinnati. The Taft Museum. *Look Again.* Essay by Marsha Semmel. [1976.]

Canada. Rothmans of Pall Mall, Ltd. *Aspects of Realism.* 1976–1978.

Bethlehem, Pa. Lehigh University. *American Figure Drawing.* February 15–March 19, 1976. Essays by W. J. Kelly, Larry Day. Circulating exhibition.

Los Angeles. Los Angeles County Museum of Art. *L.A. 8: Painting and Sculpture 76.* April 6–May 30, 1976.

Washington, D.C. Corcoran Gallery of Art (U.S. Department of Interior Bicentennial Exhibition). *America 1976.* April 27–June 6, 1976. Essays by Robert Rosenblum, Neil Welliver, poetry by John Ashbery, Richard Howard. Circulating exhibition.

Syracuse, N.Y. Everson Museum of Art. *Paintings by Three American Realists: Alice Neel/Sylvia Sleigh/May Stevens.* September 17–October 31, 1976. Introduction by Phyllis Derfner.

New York. Genesis Galleries, Ltd. *Close to Home.* October 5–November 13, 1976.

New York. Nancy Hoffman Gallery. *Drawings/Wolfgang Gafgen, Juan Gonzalez, Joe Nicastri, Bill Richards.* November 6–December 9, 1976. Circulating exhibition.

South Bend, Ind. University of Notre Dame Art Gallery. *Aspects of Realism from the Nancy Hoffman Gallery.* November 7, 1976–January 2, 1977.

Hollywood, Fla. The Art and Culture Center of Hollywood. *Photo-Realism in Painting.* December 3, 1976–January 10, 1977. Circulating exhibition.

New York. Green Mountain Gallery, Bowery Gallery, Prince Street Gallery, First Street Gallery, SoHo Center for Visual Artists. *Artists' Choice, Figurative Art in New York.* December 11, 1976–January 5, 1977. Introduction by Lawrence Alloway. Essays by Stephen Grillo, Tomar Levine, Howard Kalish, Lucien Day.

Jacksonville, Fla. Jacksonville Art Museum. *New Realism.* 1977. Introduction by Bruce Dempsey.

Laguna Beach, Calif. Laguna Beach Museum of Art. *Illusionistic-Realism Defined in Contemporary Ceramic Sculpture.* January 4–February 3, 1977. Foreword by Elaine Levin.

Madison, Wisc. The Madison Art Center. *Contemporary Figurative Painting in the Midwest.* February 26–April 10, 1977.

New York. Davis & Long Company, Robert Schoelkopf Gallery, *Brooklyn College Art Department Past and Present 1942–1977.* September 13–October 8, 1977. Text by Mona Hadler and Jerome Viola.

Philadelphia. Pennsylvania Academy of the Fine Arts. *8 Contemporary American Realists.* September 16–October 30, 1977. Essays by Frank H. Goodyear, Jr. Circulating exhibition.

Sparkill, N.Y. Thorpe Intermedia Gallery. *Outside the City Limits/Landscape by New York City Artists.* October 16–November 13, 1977. Introduction by Lola Gelman, John Perreault.

Lawrence, Kan. Helen Foresman Spencer Museum of Art. *Artists Look at Art.* January 15–March 12, 1978. Text by William J. Hennessey.

New York. Harold Reed Gallery. *Selected 20th Century American Nudes.* February 16–March 4, 1978. Essay by John Perreault.

Philadelphia. Philadelphia Museum of Art. *8 Artists.* April 29–June 25, 1978. Text by Anne d'Harnoncourt.

Washington, D.C. Middendorf/Lane Gallery. *Washington Realists.* September 10–October 20, 1978.

Rochester, Mich. Meadow Brook Art Gallery, Oakland University. *Return of Realism, Part Two, Detroit Realists.* November 19–December 20, 1978.

Jackson, Miss. Mississippi Museum of Art. *Southern Realism.* September 7–November 11, 1979.

New York. Artists' Choice Museum, Inc. *Artists' Choice Museum Prospectus & Benefit Exhibition.* September 8–22, 1979. Essay by Howard Kalish.

Philadelphia. Pennsylvania Academy of the Fine Arts. *Seven on the Figure.* September 20–December 16, 1979. Essay by Frank H. Goodyear, Jr.

Minneapolis. Walker Art Center. *Eight Artists: The Elusive Image.* (Design Quarterly 111/112). September 30–November 18, 1979. Essays by Lisa Lyons, Melinda Ward, Marie Cieri, Martin Friedman, Nancy Rosen, Christopher Knight.

New York. Harold Reed Gallery. *Woman.* November 20–December 15, 1979. Text by Carter Ratcliff.

Washington, D.C. The Corcoran Gallery of Art. *Images of the 70s: 9 Washington Artists.* January 18–March 16, 1980. Introduction, interviews by Clair List.

Sparkill, N.Y. Thorpe Intermedia Gallery. *New York Realists 1980.* March 30–April 27, 1980.

New York. Goddard-Riverside Community Center. *Sixteenth Annual Art Show, Still Life Today.* May 1–20, 1980.

New York Artists' Choice Museum. *Younger Artists: A Benefit Exhibition.* September 6–18, 1980.

Tulsa, Okla. Philbrook Art Center, *Realism/Photorealism.* October 5–November 23, 1980. Essays by John Arthur.

San Antonio, Texas. San Antonio Museum of Art. *Real, Really Real, Super Real.* March 1–April 26, 1981. Essays by Alvin Martin, Linda Nochlin, Philip Pearlstein. Circulated.

Individual Artists

Lennart Anderson

New York. Davis & Long Company. *Lennart Anderson.* March 27–April 17, 1976.

John Baeder

Baeder, John. *Diners.* New York: Harry N. Abrams, 1978. Introduction by Vincent Scully.

William Bailey

Paris. Galerie Claude Bernard. *William Bailey peintures.* March 1978. Essay by Hilton Kramer.

New York. Robert Schoelkopf Gallery. *William Bailey.* January 6–February 10, 1979. Introduction by Mark Strand.

Kramer, Hilton. "Art: Stuart Davis and William Bailey." *The New York Times,* January 12, 1979, Section C, p. 14.

ffrench-frazier, Nina. "William Bailey." *Arts Magazine* 53, no. 8 (April 1979): 9.

238 Gruen, John. "William Bailey: Mystery and Mastery." *Art News* 78, no. 9 (November 1979): 140–145.

Jack Beal

[N.F.]. "Jack Beal at Frumkin." *Arts Magazine* 44, no. 6 (April 1970): 59.

Madison, Wisc. Madison Art Center. *Jack Beal Prints and Related Drawings.* October 2–November 27, 1977. Introduction by Joseph Wilfer.

Kramer, Hilton. "Art: Moral Vision in Mannered Style." *The New York Times,* February 17, 1978, p. 21.

Pieszak, Devonna. "Interview with Jack Beal." *New Art Examiner* 7, no. 2 (November 1979): 3ff.

Kramer, Hilton. "Jack Beal's Unabashed Social Realism." *The New York Times,* February 10, 1980, Section 2, p. 29.

New York. Allan Frumkin Gallery. *Jack Beal.* n.d.

Robert Bechtle

Sacramento, Calif. E. B. Crocker Art Gallery. *Robert Bechtle: Retrospective.* September 15–October 14, 1973. Essays by Ivan Karp, Susan Regan McKillop. Circulated.

Tom Blackwell

New York. Louis K. Meisel Gallery. *Tom Blackwell.* October 8–29, 1977.

Nell Blaine

Southampton, N.Y. Parrish Art Museum. *Nell Blaine.* July 6–August 11, 1974. Essay by Edward Bryant.

Carolyn Brady

Lubell, Ellen. "Carolyn Brady." *Arts Magazine* 52, no. 2 (October 1977): 24.

Diane Burko

New York. Genesis Galleries, Ltd. *Diane Burko — Recent Paintings and Drawings.* [March 1979.] Essay by David Bourdon.

John Button

Ellenzweig, Allen. "John Button and 'Romantic Reality.'" *Arts Magazine* 50, no. 3 (November 1975): 92–94.

Vija Celmins

Newport Beach, Calif. Newport Harbor Art Museum. *Vija Celmins: A Survey Exhibition.* December 15, 1979–February 3, 1980. Essay by Susan C. Larsen. Circulated.

Hilo Chen

New York. Louis K. Meisel Gallery. *Hilo Chen.* October 1978.

John Clem Clarke

Reed, Dupuy Warrick. "John Clem Clarke: Another Glimpse of Childhood." *Arts Magazine* 53, no. 8 (April 1979): 158–162.

Chuck Close

Nemser, Cindy. "An Interview with Chuck Close." *Artforum* 8, no. 5 (January 1970): 51–55.

Dykes, William. "The Photo as Subject / The Paintings and Drawings of Chuck Close." *Arts Magazine* 48, no. 5 (February 1974): 28–53.

Close, Chuck. "I Translate from a Photo," in "The Art of Portraiture, in the Words of Four New York Artists." *The New York Times,* October 31, 1976, Section D, p. 29.

New York. The Pace Gallery. *Chuck Close: Recent Work.* April 30–June 4, 1977.

Harshman, Barbara. "An Interview with Chuck Close." *Arts Magazine* 52, no. 10 (June 1978): 142–145.

Levin, Kim. "Chuck Close: Decoding the Image." *Arts Magazine* 52, no. 10 (June 1978): 146–149.

New York. The Pace Gallery. *Chuck Close: Recent Work.* October 26–November 24, 1979. Essay by Kim Levin.

Munich, Germany. Kunstraum München. *Chuck Close.* Text by Hermann Kern. [1979.]

Minneapolis. Walker Art Center. *Close Portraits.* September 28–November 16, 1980. Text by Lisa Lyons and Martin Friedman. Circulated.

Robert Cottingham

Welish, Marjorie. "Robert Cottingham at O. K. Harris." *Art in America* 67, no. 2 (March–April 1979): 152.

Rebecca Davenport

Norfolk, Va. Chrysler Museum. *Rebecca Davenport / Paintings and Drawings 1971–1974.* November 19–December 31, 1974. Introduction by Roy Slade.

John DeAndrea

Masheck, Joseph. "Verist Sculpture: Hanson and DeAndrea." *Art in America* 60, no. 6 (November–December 1972): 90–97.

George Deem

Buonagurio, Edgar. "George Deem." *Arts Magazine* 52, no. 3 (November 1977): 8.

Lois Dodd

Addison, Maine. Cape Split Place. *Lois Dodd: Selected Paintings 1969–1979.* September 16–November 10, 1979. Essay by Milton W. Brown. Circulated.

Houston, Texas. Sewall Art Gallery, Rice University. *Dodd–Groell–Gelber.* February 4–March 21 (n.y.). Essay by Lawrence Campbell. Circulated.

Rackstraw Downes

Downes, Rackstraw. "What the Sixties Meant to Me." *Art Journal* 34, no. 2 (Winter 1974–1975): 129–131.

Henry, Gerrit. "New York Review: Rackstraw Downes." *Art News* 77, no. 5 (May 1978): 180.

Schjeldahl, Peter. "Rackstraw Downes." *Artforum* 16, no. 10 (Summer 1978):

Don Eddy

Williamstown, Mass. Williams College Museum of Art. *Don Eddy.* April 14–May, 1975. Essay by John Hallmark Neff.

Hartman, Rose. "Don Eddy." *Current* 1, no. 6 (February–March–April 1976): 40.

Neff, John H. "Painting and Perception: Don Eddy." *Arts Magazine* 54, no. 4 (December 1979): 98–102.

Martha Mayer Erlebacher

Lubell, Ellen. "In Praise of the Figure: The Paintings of Martha Mayer Erlebacher." *Arts Magazine* 53, no. 2 (October 1978): 138–141.

Richard Estes

Boston. Museum of Fine Arts. *Richard Estes: The Urban Landscape.* May 31–August 6, 1978. Essay by John Canaday, interview by John Arthur. Circulated.

Janet Fish

Shirey, David L. "Through a Glass, Brightly." *Arts Magazine* 48, no. 5 (February 1974): 27.

New York. Robert Miller Gallery. *Janet Fish.* November 22–December 31, 1980.

Audrey Flack

Nemser, Cindy. "Conversation with Audrey Flack." *Arts Magazine* 48, no. 5 (February 1974): 34–37.

New York. Louis K. Meisel Gallery. *Audrey Flack "The Gray Border Series."* April 10–May 1, 1976. Essay by Bruce Glaser.

New York. Louis K. Meisel Gallery. *Audrey Flack "Vanitas."* Essay by Lawrence Alloway. [1978.]

Flack, Audrey. *Audrey Flack on Painting.* New York: Harry Abrams, 1981.

Tampa, Fla. SVC/Fine Arts gallery, University of Southern Florida. *Audrey Flack Works on Paper 1950-1980.* January 7–February 12, 1981. Essay by Linnea S. Dietrich.

Jane Freilicher

Shorr, Harriet. "Jane Freilicher." *Arts Magazine* 51, no. 9 (May 1977): 9.

Frank Gallo

New York. Bernard Danenberg Contemporaries. *Frank Gallo.* February 15–March 11, 1972. Introduction by Lawrence Alloway.

Paul Georges

Welish, Marjorie. "Reviews: Cranford, N.J. / Paul Georges at Tomasulo Art Gallery, Union College." *Art in America* 67, no. 4 (July–August 1979): 119.

Gregory Gillespie

Washington, D.C. Hirshhorn Museum and Sculpture Garden. *Gregory Gillespie.* December 22, 1977–February 12, 1978. Introduction by Abram Lerner. Circulated.

Ralph Goings

Schjeldahl, Peter. "Ralph Goings at O. K. Harris." *Art in America* 61, no. 5 (September–October 1973): 111–112.

Sidney Goodman

University Park, Pa. Museum of Art, Pennsylvania State University. *Sidney Goodman: Paintings, Drawings and Graphics 1959-1979.* July 5–October 12, 1980. Essay by Richard Porter. Circulated.

Robert Graham

Dallas, Texas. Dallas Museum of Fine Arts. *Robert Graham.* May 24–June 25, 1972. Essay by Robert M. Murdock.

Isenberg, Barbara. "Robert Graham: Ignoring the lessons of modern art." *Art News* 78, no. 1 (January 1979): 66–69.

Harold Gregor

Turner, Norman. "Harold Gregor." *Arts Magazine* 52, no. 1 (September 1977): 28.

Duane Hanson

Masheck, Joseph. "Verist Sculpture: Hanson and DeAndrea." *Art in America* 60, no. 6 (November–December 1972): 90–97.

Wichita, Kan. Edwin A. Ulrich Museum of Art, Wichita State University. *Duane Hanson, 1976–77.* Essay by Martin H. Bush.

Greenwood, Michael. "Current Representational Art, Five Other Visions/Duane Hanson and Joseph Raffael." *Artscanada* 33, no. 4 (December 1976–January 1977): 23–29.

Edwards, Ellen. "Duane Hanson's blue collar society." *Art News* 77, no. 4 (April 1978): 56–60.

Ian Hornak

Gruen, John. "Ian Hornak's Personal Painting." *Arts Magazine* 50, no. 6 (February 1976): 81–83.

Yvonne Jacquette

Kramer, Hilton. "Art: Yvonne Jacquette." *The New York Times,* April 27, 1979, Section 3, p. 21.

Wolf Kahn

New York. Borgenicht Gallery. *Wolf Kahn.* March 2–28, 1974.
New York. Borgenicht Gallery. *Wolf Kahn* (n.d.)

Alex Katz

Paris. Galerie Marguerite Lamy. *Alex Katz.* May–June 1975.

New York. Marlborough Gallery Inc. *Alex Katz.* March 1976.

Ratcliff, Carter. "New York Letter." *Art International* 20, nos. 2–3 (February–March 1976): 39–40.

Katz, Alex. *Face of the Poet.* New York: Brooke Alexander, Inc., Marlborough Graphics, Inc., 1978.

New York. Marlborough Gallery, Inc. *Alex Katz Recent Paintings.* February 25–March 25, 1978.

Waltham, Mass. Rose Art Museum, Brandeis University. *Alex Katz in the Seventies.* May 27–July 9, 1978. Essay by Roberta Smith.

Sandler, Irving. *Alex Katz.* New York: Harry Abrams, 1979.

New York. Robert Miller Gallery. *Alex Katz's Cutouts.* February 21–March 17, 1979. Essay by Carter Ratcliff.

New York. Robert Miller Gallery. *Alex Katz 1957–59.* February 5–March 7, 1981. Essay by Irving Sandler.

Robert Kulicke

University Park, Pa. Museum of Art, Pennsylvania State University. *Robert Kulicke Painter, Designer, Craftsman.* April 16–June 25, 1978.

Gabriel Laderman

Perl, Jed. "Gabriel Laderman." *Arts Magazine* 51, no. 9 (May 1977): 5.

Alfred Leslie

Boston. Museum of Fine Arts. *Alfred Leslie.* Essay by Robert Rosenblum. Circulated. [1976.]

Richard, Paul. "The Figure Paintings of Alfred Leslie: Larger Than Life—and Scary." *Washington Post,* November 1, 1976, Section C, p. 11.

"A Tribute to Anthology Film Archives." *Avant-Garde Film Preservation Program* (An Evening Dedicated to Frederick Kiesler). The Museum of Modern Art, October 19, 1977; American Film Institute, John F. Kennedy Center, Washington, D.C., November 10, 1977.

Kramer, Hilton. "Art: New Realism Writ Large by Leslie." *The New York Times,* November 17, 1978, Section C, p. 20.

Arthur, John. "Alfred Leslie Talks with John Arthur." *Drawing* 1, no. 4 (November–December 1979): 81–85.

New York. Allan Frumkin Gallery. *Alfred Leslie.* 1976.

New York. Allan Frumkin Gallery. *Alfred Leslie.* [1980.]

New York. Allan Frumkin Gallery. *Alfred Leslie.* (n. d.)

New York. Allan Frumkin Gallery. *Alfred Leslie.* Essay by Gerard Haggerty. (n. d.)

Michael Mazur

Brockton, Mass. Brockton Art Center–Fuller Memorial. *Michael Mazur/Vision of a Draughtsman.* 1976. Essay by Frank Robinson. Circulated.

Willard Midgette

"Willard Midgette's Indians." *Allan Frumkin Gallery Newsletter* 2 (Fall 1976): 5.

New York. Allan Frumkin Gallery. *Willard Midgette Indians.* Text by David Hickey. (n.d.)

Richard McDermott Miller

Tillim, Sidney. "Richard McD. Miller, Primary Realist." *Artforum* 5, no. 10 (June 1967): 47–50.

John Moore

Medoff, Eve. "John Moore–Realism Reinvented." *American Artist* 42, no. 428 (March 1978): 36–72.

Malcolm Morley

Alloway, Lawrence. "Morley Paints a Picture." *Art News* 67 (Summer 1968): 42–71.

Perreault, John. "Postcards and a Plastic Rose." *Village Voice,* October 25, 1973, p. 41.

New York. The Clocktower, Institute of Art and Urban Resources, Inc. *Malcolm Morley.* October 7–30, 1976. Essay by Lawrence Alloway.

Tatransky, Valentin. "Malcolm Morley: Toward Erotic Painting." *Arts Magazine* 53, no. 8 (April 1979): 166–168.

Catherine Murphy

Washington, D.C. The Phillips Collection. *Catherine Murphy.* February 14–March 28, 1976. Essay by Judith Hoos. Circulated.

Gruen, John. "Catherine Murphy: The Rise of a Cult Figure." *Art News* 77, no. 10 (December 1978): 54–57.

Alice Neel

Athens, Ga. Georgia Museum of Art, University of Georgia. *Alice Neel.* September 7–October 19, 1975. Essay by Cindy Nemser.

Neel, Alice. "I Paint Tragedy and Joy," in "The Art of Portraiture, in the Words of Four New York Artists." *The New York Times,* October 31, 1976, Section D, p. 29.

Fort Lauderdale, Fla. Fort Lauderdale Museum of Art. *Alice Neel.* February 8–26, 1978. Foreword by Henry R. Hope.

New York. Graham Gallery. *Alice Neel.* November 1–25, 1978. Essay by Ann Sutherland Harris.

Bridgeport, Conn. University of Bridgeport. *Alice Neel/A Retrospective Showing.* February 25–April 11, 1979. Essay by Martha B. Scott. Circulated.

Fort Wayne, Ind. Fort Wayne Museum of Art. *Alice Neel.* September 14–November 1, 1979.

Jud Nelson

Ensworth, Patricia. "Jud Nelson." *Arts Magazine* 51, no. 10 (June 1977): 7.

Klein, Michael R. "Jud Nelson: Sculpture as Seeing." *Arts Magazine* 54, no. 1 (September 1979): 135–137.

Don Nice

Ratcliff, Carter. "New York Letter." *Art International* 20, nos. 2–3 (February–March 1976): 39–40.

Kuspit, Donald B. "Review of Exhibitions, New York: Don Nice at Nancy Hoffman." *Art in America* 64, no. 2 (March–April 1976): 111–112.

Zimmer, William. "Animals, Plants and Monochromatic Paintings." *SoHo Weekly News,* March 17, 1977, p. 24.

Bourdon, David. "Art, Don Nice." *Village Voice* (March 21, 1977): p. 79.

Schwartz, Ellen. "New York Reviews: Don Nice." *Art News* 76, no. 5 (May 1977): 135.

Ensworth, Patricia. "Don Nice." *Arts Magazine* 53, no. 3 (November 1978): 7.

George Nick

Leja, Michael. "George Nick." *Arts Magazine* 51, no. 9 (May 1977): 15.

David Park

Berkeley, Calif. University Art Gallery, University of California, Berkeley. *David Park/Memorial Exhibition/The University Years 1955–1960.* October 6–November 8, 1964. Essay by Paul Mills. Circulated.

Newport Harbor, Calif. Newport Harbor Art Museum. *David Park.* September 16–November 13, 1977. Essay by Betty Turnbull. Circulated.

David Parrish

Kahan, Mitchell Douglas. *David Parrish.* Montgomery, Ala.: Montgomery Museum of Fine Arts, 1981.

Philip Pearlstein

Pearlstein, Philip. "Figure Paintings Today Are Not Made in Heaven." *Art News* 61, no. 3 (Summer 1962): 39–52.

Athens, Ga. Georgia Museum of Art, University of Georgia. *Philip Pearlstein*. September 20–November 8, 1970. Essay by Linda Nochlin. Circulated.

Schwartz, Ellen. "A Conversation with Philip Pearlstein." *Art in America* 59, no. 5 (September–October 1971): 50–57.

Herrera, Hayden. "Pearlstein's Portraits at Face Value." *Art in America* 63, no. 1 (January–February 1975): 46–47.

Kramer, Hilton. "Portraits of Remorseless Authenticity." *The New York Times*, February 15, 1976, Section 2, p. 35.

Pearlstein, Philip. "The Process Is My Goal," in "The Art of Portraiture, in the Words of Four New York Artists." *The New York Times*, October 31, 1976, Section D, p. 29.

New York. Allan Frumkin Gallery. *Philip Pearlstein Watercolors and Drawings*. January–February 1977.

Springfield, Mo. Springfield Art Museum. *The Lithographs and Etchings of Philip Pearlstein*. February 25–March 26, 1978. Essay by Richard S. Field. Circulated.

New York. Allan Frumkin Gallery. *Philip Pearlstein / New Watercolors*. [1980.]

New York. Allan Frumkin Gallery. *Philip Pearlstein*. [n.d.]

Fairfield Porter
O'Hara, Frank. "Porter Paints a Picture." *Art News* 53, no. 9 (January 1955): 38–41.

New York. Hirschl & Adler Galleries. *Fairfield Porter, His Last Works*. May 4–28, 1976.

New York. Hirschl & Adler Galleries. *Fairfield Porter*. November 3–December 1, 1979.

Stephen Posen
Ashton, Dore. "Stephen Posen and the Mixed Metaphor." *Arts Magazine* 53, no. 2 (October 1978): 134–137.

Mackie, Alwynne. "Dialectic in Modernism: The Paintings of Stephen Posen." *Art International* 23, no. 8 (December 1979): 55 ff.

Joseph Raffael
Fuller, Mary. "The Water Becomes the Lily, An Interview with Joseph Raffael." *Current* 2, no. 2 (August–September–October 1976): 16–22.

Butterfield, Jan. "'I Have Always Copied': An Interview with Joseph Raffael." *Arts Magazine* 51, no. 2 (October 1976): 122–126.

Lubell, Ellen. "Joseph Raffael." *Arts Magazine* 51, no. 4 (December 1976): 34.

Kuspit, Donald B. "Review of Exhibitions, New York: Joseph Raffael at Nancy Hoffman." *Art in America* 65, no. 2 (March–April 1977): 115–116.

Greenwood, Michael. "Current Representational Art, Five Other Visions/Duane Hanson and Joseph Raffael." *Artscanada* 33, no. 4 (December 1976–January 1977): 23–29.

San Francisco. San Francisco Museum of Modern Art. *Joseph Raffael: The California Years, 1969–1978*. January 20–March 5, 1978. Essay by Thomas H. Garver. Circulated.

Gamwell, Lyn. "Joseph Raffael: The California Years, 1969–1978." *Artweek* 9, no. 6 (February 11, 1978): 1–16.

Tarshis, Jerome. "Nature Up Close." *Horizon* 21, no. 9 (September 1978): 59–63.

Mackie, Alwynne. "Joseph Raffael's Realism." *Art International* 22, no. 7 (November–December 1978): 20–65.

Paul Sarkisian
Chicago. Museum of Contemporary Art. *Paul Sarkisian*. February 5–March 19, 1972. Essay by Franz Schulze.

Lubell, Ellen. "The Eyes Have It." *SoHo Weekly News*, November 9, 1978, p. 34.

Chicago. The Arts Club of Chicago. *Paul Sarkisian Paintings*. May 22–June 25, 1979.

Ben Schonzeit
Mackie, Alwynne. "Ben Schonzeit and the Changing Faces of Realism." *Art International* 22, no. 8 (January 1979): 24–32.

George Segal
Kaprow, Allan. "Segal's Vital Mummies." *Art News* 62, no. 10 (February 1964): 30 ff.

Geldzahler, Henry. "Interview with George Segal." *Artforum* 3, no. 2 (November 1964): 26–29.

Pincus-Witten, Robert. "George Segal as Realist." *Artforum* 5, no. 10 (Summer 1967): 84–87.

Van der Marck, Jan. *George Segal*. New York: Harry Abrams, 1975.

Philadelphia. Institute of Contemporary Art, University of Pennsylvania. *George Segal: Environments*. February 24–April 8, 1976. Essay by Jose L. Barrio-Garay.

Crosman, Christopher B. and Nancy E. Miller. "A Conversation with George Segal." *Gallery Studies 1*: Buffalo, New York, Buffalo Fine Arts Academy and Albright-Knox Art Gallery, 1977.

Sylvia Sleigh
Bloomington. Indiana State University, College of Arts & Sciences, Art Department. *Sylvia Sleigh*. October 1977. Circulated.

Raphael Soyer
New York. Whitney Museum of American Art. *Raphael Soyer*. October 25–December 2, 1967. Text by Lloyd Goodrich. Circulated.

Washington, D.C. National Collection of Fine Arts, Smithsonian Institution. *Raphael Soyer: Drawings and Watercolors*. Essay by Janet A. Flint. [1977.]

Berman, Avis. "Raphael Soyer at 80: 'Not Painting would be like not breathing.'" *Art News* 78, no. 10 (December 1979): 38–43.

Washington, D.C. Hirshhorn Museum and Sculpture Garden, Smithsonian Institution. *A Birthday Celebration / Raphael Soyer*. December 5, 1979–January 20, 1980.

Altoon Sultan
New York. Marlborough Gallery. *Altoon Sultan Recent Works*. December 6–29, 1979.

242 *Wayne Thiebaud*

Phoenix. Phoenix Art Museum. *Wayne Thiebaud Survey 1947–1976.* September 10–October 17, 1976. Essay by Gene Cooper.

Albright, Thomas. "Wayne Thiebaud: Scrambling Around with Ordinary Problems." *Art News* 77, no. 2 (February 1978): 82–86.

Sidney Tillim

Edmonton, Canada. The Edmonton Art Gallery. *Sidney Tillim/An Exhibition of Narrative and History Paintings.* September 15–October 15, 1973. Essay by Terry Fenton.

Andy Warhol

New York. Whitney Museum of American Art. *Andy Warhol Portraits of the 70s.* November 20, 1979–January 27, 1980. Essay by Robert Rosenblum.

James Weeks

Waltham, Mass. Rose Art Museum, Brandeis University. *James Weeks.* April 2–May 14, 1978. Essay by Bonny B. Saulnier. Circulated.

Neil Welliver

New York. Brooke Alexander, Inc. *Neil Welliver Watercolors and Prints 1973–1978.* March 25–April 22, 1978. Essay by David Bourdon.

Medoff, Eve. "Neil Welliver–Painting, Inclusive and Intense." *American Artists* 43, no. 441 (April 1979): 48–53.

Robert White

Oneonta, N. Y. Anderson Center for the Arts, Hartwick College. *Sculpture and Drawings by Robert White.* February 15–March 11, 1977.

Andrew Wyeth

Buffalo, N.Y. Albright-Knox Art Gallery. *Andrew Wyeth Temperas, Watercolors and Drawings.* November 2–December 9, 1962. Introduction by Joseph Verner Reed.

Philadelphia. Pennsylvania Academy of the Fine Arts. *Andrew Wyeth.* October 5–November 27, 1966. Text by Edgar P. Richardson. Circulated.

Hoving, Thomas. *Two Worlds of Andrew Wyeth.* Boston: Houghton Mifflin, 1978.

London, England. Royal Academy of Arts. *Andrew Wyeth.* June 7–August 31, 1980. Essay by Marina Vaizey.

James Wyeth

New York. Coe Kerr Gallery. *James Wyeth Recent Paintings.* November 7–25, 1974. Essay by Theodore E. Stebbins, Jr. Circulated.

Omaha, Neb. Joslyn Art Museum. *James Wyeth.* November 16, 1975–January 18, 1976. Essay by Theodore E. Stebbins, Jr.

Philadelphia. Pennsylvania Academy of the Fine Arts. *Jamie Wyeth.* September 19–December 14, 1980. Circulated.

Fumio Yoshimura

Shirey, David L. "The Beauty of Machines." *The New York Times,* November 28, 1976, Section 11, p. 37.

Color Plates

Plate

1 Neil Welliver. *Breached Beaver Dam,* 1976. Oil on canvas, 96 x 96 inches. Collection of the North Carolina Museum of Art, Raleigh, N.C.

2 Stephen Posen. *Variations on a Millstone,* 1976. Oil on canvas, 86½ x 68½ inches. Pennsylvania Academy of the Fine Arts, Philadelphia. Ph: Will Brown

3 William Bailey. *Monte Migiana Still Life,* 1979. Oil on canvas, 54 x 60 inches. Pennsylvania Academy of the Fine Arts, Philadelphia. Ph: Will Brown

4 William Beckman, *Double Nude (Diana and William Beckman),* 1978. Oil on wood panel, 64 x 59 inches. The Herbert W. Plimpton Collection on extended loan to the Rose Art Museum, Brandeis University. Ph: Muldoon Studio, Waltham, Mass.

5 Philip Pearlstein. *Two Female Models on Eames Chair and Stool,* 1976–1977. Oil on canvas, 60 x 72 inches. Milton D. Ratner Family Collection. Ph: courtesy of Allan Frumkin Gallery, New York

6 Gregory Gillespie. *Myself Painting a Self-Portrait,* 1980. Oil and alkyd on plywood, 57 x 96 inches. Ph: courtesy of Forum Gallery, New York

7 D. J. Hall. *Self-Realist,* 1975. Oil on canvas, 39 x 57 inches. Private collection

8 Paul Wiesenfeld. *Portrait of the Artist's Children,* 1979. Oil on canvas, 41 x 51 inches. Ph: courtesy of Robert Schoelkopf Gallery, New York

9 Jack Beal. *Sydney and Frances Lewis,* 1974–1975. Oil on canvas, 72 x 78 inches. Collection of Washington and Lee University, Virginia

10 Alex Katz. *The Light #3,* 1975. Oil on canvas, 72 x 120 inches. Collection of Mr. and Mrs. Samuel H. Lindenbaum. Ph: courtesy of Marlborough Gallery, New York

11 Alice Neel. *Andy Warhol,* 1970. Oil on canvas, 60 x 40 inches. Collection of the Whitney Museum of American Art; promised gift of Timothy Collins. Ph: Geoffrey Clements

12 Martha Mayer Erlebacher. *In a Garden,* 1976. Oil on canvas, 64 x 64 inches. Ph: eeva-inkeri, courtesy of Robert Schoelkopf Gallery, New York

13 Sidney Goodman. *Nude on a Red Table,* 1977–1980. Oil on canvas, 53¼ x 78 inches. Pennsylvania Academy of the Fine Arts, Philadelphia. Ph: Eric Pollitzer

14 Philip Pearlstein. *Female Model on Ladder,* 1976. Oil on canvas, 72 x 96 inches. Courtesy of Allan Frumkin Gallery, New York

15 Ben Kamihira. *Chinatown Centennial,* 1974–1978. Oil on canvas, 66⅛ x 54½ inches. Collection of the artist

16 Willard Midgette. *Sitting Bull Returns at the Drive-In,* 1976. Oil on canvas, 108 x 134 inches. Collection of Donald B. Anderson. Ph: eeva-inkeri, courtesy of Allan Frumkin Gallery, New York

17 Catherine Murphy. *Elena, Harry and Alan in the Backyard,* 1978. Oil on canvas, 39½ x 45½ inches. Private collection. Ph: Bruce C. Jones, courtesy of Xavier Fourcade, Inc.

18 Andrew Wyeth. *Distant Thunder,* 1961. Tempera, 47½ x 30 inches. Private collection

19 Alfred Leslie. *A Birthday for Ethel Moore,* 1976. Oil on canvas, 108 x 132 inches. Collection of Alfred Leslie, © 1976. Ph: courtesy of Allan Frumkin Gallery, New York

20a-d Jack Beal. *The History of Labor in America,* 1976–1977. Four paintings, *Colonization, Settlement, Industry, Technology,* each 12 feet 3 inches x 12 feet 6 inches. United States General Services Administration, Department of Labor. Phs: John Tennent

21 Alex Katz. *Swamp Maple — 4:30,* 1968. Oil on canvas, 144 x 93 inches. Collection of the artist

22 Fairfield Porter. *Blue Landscape,* 1974. Oil on canvas, 45½ x 45½ inches. Lent by the Parrish Art Museum, gift of the Estate of Fairfield Porter. Ph: Gary W. Clark

23 Jane Freilicher. *Afternoon in October,* 1976. Oil on canvas, 51 x 77 inches. Private collection. Ph: courtesy of Fischbach Gallery, New York

24 Neil Welliver. *Moosehorn,* 1978. Oil on canvas, 60 x 72 inches. Collection of Albert J. Wood. Ph: courtesy of Fischbach Gallery, New York

25 William Beckman. *My Father Combining,* 1979. Pastel, 36 x 60 inches. Private collection, Boston

26 Jamie Wyeth. *Bale,* 1972. Oil on canvas, 28½ x 35 inches. Private collection. Ph: courtesy of Coe Kerr Gallery, New York

27 Rackstraw Downes. *Behind the Store at Prospect,* 1979–1980. Oil on canvas, 18¾ x 46¾ inches. Pennsylvania Academy of the Fine Arts, Philadelphia. Ph: courtesy of Kornblee Gallery, New York

28 Ian Hornak. *Persephone Leaving Variation II,* 1975. Oil on canvas, 72 x 48 inches. Collection Citibank, N.A. Ph: Edward Peterson

29 Milet Andrejevic. *Toward Bethesda Fountain,* 1978. Egg oil tempera on canvas, 39 x 50 inches. Collection of Lehman Brothers Kuhn Loeb Inc.

30 Susan Shatter. *Panorama of Machu Picchu, Peru,* 1978. Acrylic on paper mounted on linen, 48½ x 113½ inches. Ph: Greg Heins, courtesy of Harkus Krakow Gallery, Boston

31 Nickolas Boisvert. *Flameout near the Cockscomb,* 1980. Acrylic on paper, 29 x 45 inches. Collection of the artist

32 Joseph Raffael. *A Frog in Its Pond,* 1977. Oil on canvas, 78 x 114 inches. Private collection. Ph: courtesy of Nancy Hoffman Gallery, New York

33 Harold Gregor. *Illinois Corncrib #33,* 1978. Oil and acrylic on canvas, 36 x 51 inches. Private collection. Ph: Thomas Rose, courtesy of Tibor de Nagy Gallery, New York

34 Setsko Karasuda. *Summer Day,* 1978. Oil on canvas, 49 x 77 inches. Collection of Western Electric Company. Ph: Lee Fatherree, courtesy of William Sawyer Gallery, San Francisco

35 John Moore. *South,* 1979. Oil on canvas, 72 x 48 inches. Private collection

36 Richard Estes. *Ansonia,* 1977. Oil on canvas, 48 x 69 inches. Collection of the Whitney Museum of American Art, gift of Sydney and Frances Lewis

37 Don Eddy. *Hosiery, Handbags, and Shoes,* 1974. Acrylic on canvas, 40 x 57 inches. The Ludwig Collection, Aachen. Ph: courtesy of Nancy Hoffman Gallery, New York

38 Richard Estes. *Helene's Florist,* 1971. Oil on canvas, 48 x 72 inches. The Toledo Museum of Art, gift of Edward Drummond Libbey

39 Robert Cottingham. *Lao,* 1978. Oil on canvas, 30 x 30 inches. Ph: courtesy of O. K. Harris Works of Art, New York

40 Idelle Weber. *Cha-Cha: Brooklyn Terminal Market,* 1979. Oil on linen, 36½ x 73 inches. Private collection. Ph: courtesy of O. K. Harris Works of Art, New York

41 John Stuart Ingle. *Still Life XXX,* 1980. Watercolor, 30 x 42½ inches. Collection of Philip Morris Inc., New York. Ph: Parker Cane

42 James Valerio. *Still Life #2,* 1978. Oil on canvas, 93½ x 116 inches. Collection of Graham Gund. Ph: courtesy of Allan Frumkin Gallery, New York

43 Paul Georges. *Still Life with Rembrandt,* 1975. Oil on canvas, 41 x 53 inches. Collection of Dr. Michel Amzallag

44 Lennart Anderson. *Still Life with Kettle,* 1977. Oil on canvas, 46 x 38⅛ inches. Cleveland Museum of Art, Wishing Well Fund

45 Robert Kulicke. *Gardenias in a Bottle,* 1975. Oil on board, 9¾ x 7⅝ inches. Collection of Jean Reist Stark D'Andrea

46 Wayne Thiebaud. *Buffet,* 1972–1975. Oil on canvas, 48 x 60 inches. Ph: courtesy of the artist

47 Janet Fish. *F.W.F.,* 1976. Oil on canvas, 72 x 56 inches. Ph: courtesy of Kornblee Gallery, New York

48 Carolyn Brady. *White Tulip, I,* 1980. Watercolor on paper, 31½ x 44 inches. Private collection. Ph: courtesy of Nancy Hoffman Gallery, New York

49 Don Nice. *Peaceable Kingdom,* 1978. Acrylic on linen/watercolor on paper, triptych, 9 x 36 feet. Ph: courtesy of Nancy Hoffman Gallery, New York

50 Jack Mendenhall. *Dressing Room with Chandelier,* 1978. Oil on canvas, 71 x 68½ inches. Private collection, England. Ph: D. James Dee, courtesy of O. K. Harris Works of Art, New York

51 David Parrish. *Yamaha.* 1978. Oil on canvas, 78 x 77 inches. Wadsworth Atheneum, Hartford; Ella Gallup Sumner and Mary Catlin Sumner Collection

52 George Segal. *The Butcher Shop,* 1965. Plaster, wood, vinyl, metal, Plexiglas, 94 x 99¼ x 49 inches. Art Gallery of Ontario, Toronto, gift from the Women's Committee Fund, 1966

53 Duane Hanson. *Couple with Shopping Bags,* 1976. Cast vinyl, polychromed in oil, life-size. Private collection. Ph: Eric Pollitzer, courtesy of O. K. Harris Works of Art, New York

54 John DeAndrea. *Clothed Artist and Model,* 1976. Construction of wood, plaster, vinyl, plastic, 77 x 96 x 96 inches. Private collection

55 Robert Graham. *Heather,* 1979. Bronze, 69½ x 12 x 12 inches. Collection of the artist. Ph: courtesy of the artist and Robert Miller Gallery, New York

56 Walter Erlebacher. *The Death of Apollo,* 1970. Lead alloy and oak, 22¼ x 29 x 46⅝ inches. Collection of the artist. Ph: Joel Breger

Black and White Illustrations

Figure

1 Fairfield Porter. *April Overcast,* 1975. Oil on board, 18 x 22 inches. The Parrish Art Museum, Southampton, gift of the Estate of Fairfield Porter. Ph: Helga Photo Studio, courtesy of Hirschl and Adler, New York

2 Richard Estes. *Escalator,* 1970. Oil on canvas, 42½ x 62 inches. Private collection

3 Charles Sheeler. *Stairway to Studio,* 1924. Tempera, conté crayon, and pencil, 25½ x 20 inches. Private collection. Ph: Will Brown

4 Charles Sheeler. *Rocks at Steichen's,* 1937. Conté crayon on off-white wove paper, 16 x 13¾ inches. The Baltimore Museum of Art

5 Philip Pearlstein. *White House Ruin, Canyon de Chelly — Morning,* 1975. Oil on canvas, 5 x 5 feet. Collection Graham Gund. Ph: eeva-inkeri, courtesy of Allan Frumkin Gallery, New York

6 Alex Katz. *Ada with White Dress,* 1958. Oil on canvas, 60 x 48 inches. Collection of the artist. Ph: courtesy of Marlborough Gallery, New York

7 Chuck Close. *Robert I/154,* 1974. Ink and graphite on paper, 30 x 22 inches. Ohio State University Art Gallery. Ph: Bevan Davies, courtesy of The Pace Gallery, New York

8 Chuck Close. *Robert II/616,* 1974. Ink and graphite on paper, 30 x 22 inches. Ohio State University Art Gallery. Ph: Bevan Davies, courtesy of The Pace Gallery, New York

9 Chuck Close. *Robert III/2464,* 1974. Ink and graphite on paper, 30 x 22 inches. Ohio State University Art Gallery. Ph: Bevan Davies, courtesy of The Pace Gallery, New York

10 Chuck Close. *Robert IV/9856,* 1974. Ink and graphite on paper, 30 x 22 inches. Ohio State University Art Gallery. Ph: Bevan Davies, courtesy of The Pace Gallery, New York

11 Chuck Close. *Robert/104,072,* 1973–1974. Synthetic polymer paint and ink with graphite on gessoed canvas, 108 x 84 inches. Collection of The Museum of Modern Art, New York; fractional gift of J. Frederic Byers III and promised gift of an anonymous donor. Ph: Bevan Davis, courtesy of The Pace Gallery, New York

12 Don Eddy. *Silverware V for S,* 1977. Acrylic on canvas, 40 x 40 inches. Ph: Bevan Davies, courtesy of Nancy Hoffman Gallery, New York

13 Jack Beal. *Hope, Faith, Charity,* 1977–1978. Oil on canvas, 72 x 72 inches. Ph: eeva-inkeri, courtesy of Allan Frumkin Gallery, New York

14 Alfred Leslie. *Alfred Leslie,* 1966–1967. Oil on canvas, 108 x 72 inches. Collection of the Whitney Museum of American Art, gift of the Friends of the Whitney Museum of American Art. Ph: Geoffrey Clements

15 Philip Pearlstein. *Models in the Studio V,* 1962. Oil on canvas, 50 x 44 inches. Collection of Dorothy Pearlstein. Ph: Nathan Rabin, courtesy of Allan Frumkin Gallery, New York

16 Charles Sheeler. *Self-Portrait,* 1923. Conté crayon, water, and pencil, 19¾ x 25¾ inches. The Museum of Modern Art, gift of Abby Aldrich Rockefeller

17 Claes Oldenburg. *Symbolic Self-Portrait with Equals,* 1970. Pencil, colored pencil, spray enamel on graph paper and tracing paper, 11 x 8½ inches. Moderna Museet, Stockholm. Ph: courtesy of Leo Castelli Gallery, New York

18 Jasper Johns. *Souvenir,* 1964. Encaustic on canvas with objects, 28¾ x 21 inches. Collection of the artist. Ph: courtesy of Leo Castelli Gallery, New York

19 Sidney Goodman. *Profile in the Dark,* 1977–1978. Charcoal, 23 x 21½ inches. Private collection. Ph: Eric Pollitzer, courtesy of Terry Dintenfass Gallery, New York

20 Philip Pearlstein. *Standing Female Model and Mirror,* 1973. Oil on canvas, 60 x 72 inches. Private collection. Ph: Eric Pollitzer, courtesy of Allan Frumkin Gallery, New York

21 Arthur Elias. *The Artist's Reflection,* 1979. Oil on canvas, 40 x 48 inches. Collection of the artist

22 Jamie Wyeth. *Pumpkin Head,* 1972. Oil on canvas, 30 x 30 inches. Collection of Mr. and Mrs. Joseph Segel

23 Martha Mayer Erlebacher. *Self-Portrait,* 1975. Oil on canvas, 22 x 22 inches . Ph: eeva-inkeri, courtesy of Robert Schoelkopf Gallery, New York

24 William Beckman. *Self-Portrait,* 1978. Oil on wood panel, 16¼ x 13⅜ inches. Private collection. Ph: eeva-inkeri

25 Gregory Gillespie. *Self-Portrait,* 1975. Oil and magna on wood, 30¼ x 24¾ inches. Sydney and Frances Lewis Collection. Ph: eeva-inkeri, courtesy of Forum Gallery, New York

26 Jack Beal. *Envy,* 1977. Oil on canvas, 26 x 22 inches. Collection Galerie Claude Bernard. Ph: courtesy Allan Frumkin Gallery, New York

27 Gillian Pederson-Krag. *Interior: Woman with a Mirror,* 1974. Oil on canvas, 53 x 52 inches. Collection of the artist. Ph: Will Brown, courtesy of Tatistcheff & Co., New York

28 Audrey Flack. *Self-Portrait,* 1974. Acrylic on canvas, 80 x 64 inches. Private collection. Ph: courtesy of Louis K. Meisel Gallery, New York

29 Chuck Close. *Self-Portrait,* 1977. Watercolor on paper mounted on canvas, 81 x 58¾ inches. Museum of Modern Art, Vienna; The Ludwig Collection, Aachen

30 Alex Katz. *Self-Portrait with Sunglasses,* 1969. Oil on canvas, 96 x 72 inches. Collection of Mrs. Robert B. Mayer, Chicago. Ph: Robert E. Mates and Paul Katz, courtesy of Marlborough Gallery, New York

31 Vincent Arcilesi. *Duane Street Loft,* 1976–1977. Oil on canvas, 108 x 144 inches. Collection of the artist. Ph: Eric Pollitzer

32 George Deem. Diptych: *The Artist in His Studio,* 1979. Left: *New York Artist in His Studio;* right: *Vermeer's Artist in His Studio.* Each panel, oil on canvas, 53 x 44 inches. Collection of the artist

33 Philip Pearlstein. *Portrait of the Artist's Daughters,* 1967. Oil on canvas, 60 x 72 inches. Collection of Dorothy Pearlstein. Ph: Nathan Rabin, courtesy of Allan Frumkin Gallery, New York

34 Alex Katz. *Phyllis,* 1975. Pencil on paper, 15¾ x 22½ inches. Ph: Robert E. Mates, courtesy of Betty Greenberg Gallery, New York

35 Alex Katz. *Carter,* 1975. Pencil on paper, 14½ x 22 inches. Ph: courtesy of Marlborough Gallery, New York

36 Philip Pearlstein. *Portrait of Mr. and Mrs. Edmund Pillsbury,* 1973. Oil on canvas, 48 x 60 inches. Collection of Mrs. John S. Pillsbury, Sr. Ph: Eric Pollitzer, courtesy of Allan Frumkin Gallery, New York

37 Theo Wujcik. *Philip Pearlstein,* 1979. Silverpoint on prepared board, 24 x 36 inches. Collection of Jalane and Richard Davidson. Ph: Greg Heins

38 Alfred Leslie. *Dina Cheyette,* 1976. Pencil on paper, 39¾ x 30 inches. Private collection. Ph: Will Brown

39 Alfred Leslie. *Angelica Fenner,* 1978. Oil on canvas, 108 x 84 inches. Collection of Alfred Leslie © 1978. Ph: eeva-inkeri, courtesy of Allan Frumkin Gallery, New York

40 Martha Mayer Erlebacher. *Red Torso #141,* 1976. Red pencil and pink chalk on paper, 12½ x 19 inches. Collection of Jalane and Richard Davidson. Ph: Greg Heins

41 Theophil Groell. *Seated Model with Chair,* 1979. Oil on canvas, 14 x 14 inches. Ph: Parker Cane, courtesy of Tatistcheff & Co., New York

42 Theophil Groell. *Figure in a Landscape #5 (The River's Source),* 1979. Oil on canvas, 20 x 20 inches. Ph: Parker Cane, courtesy of Tatistcheff & Co., New York

43 James Valerio. *Reclining Dancer,* 1978. Oil on canvas, 84 x 100 inches. Collection of the artist

44 Sylvia Sleigh. *Imperial Nude: Paul Rosano,* 1975. Oil on canvas, 42 x 60 inches. Private collection. Ph: Geoffrey Clements, courtesy of SOHO 20 Gallery and G. W. Einstein Co., Inc.

45 Jerry Ott. *Elaine/Studio Wall,* 1974. Acrylic on canvas, 55 x 70 inches. Private collection. Ph: courtesy of Louis K. Meisel Gallery, New York

46 Hilo Chen. *Bathroom #19,* 1978. Oil on canvas, 54 x 80 inches. Private collection. Ph: courtesy of Louis K. Meisel Gallery, New York

47 Hilo Chen. *Beach 60,* 1979. Oil on canvas, 54 x 36 inches. Private collection. Ph: courtesy of Louis K. Meisel Gallery, New York

48 John Kacere. *Maude,* 1977. Oil on canvas, 36 x 54 inches. Private collection. Ph: D. James Dee, courtesy of O. K. Harris Works of Art, New York

49 Alex Katz. *Good Afternoon #1,* 1974. Oil on canvas, 72 x 96 inches. Private collection. Ph: courtesy of Marlborough Gallery, New York

50 Jack Beal. *Harvest,* 1979–1980. Oil on canvas, 96 x 96 inches. Ph: eeva-inkeri, courtesy of Allan Frumkin Gallery, New York

51 Willard Midgette. *Hitchhiker,* 1976. Oil on canvas, 108 x 135 inches. Ph: eeva-inkeri, courtesy of Allan Frumkin Gallery, New York

52 Rackstraw Downes. *The Oval Lawn,* 1977. Oil on canvas, 17 x 47 inches. Ph: eeva-inkeri, courtesy of Kornblee Gallery, New York

53 Jack Beal. *Sloth,* 1977–1978. Oil on canvas, 38 x 31¾ inches. Collection of Dr. and Mrs. Wesley Halpert. Ph: eeva-inkeri, courtesy of Allan Frumkin Gallery, New York

54 Alfred Leslie. *The Killing Cycle—#6: Loading Pier,* 1975. Oil on canvas, 108 x 72 inches. Collection of Mr. and Mrs. Robert H. Orchard. Ph: eeva-inkeri, courtesy of Allan Frumkin Gallery, New York

55 Joseph Raffael. *Lily Painting Hilo II,* 1975. Oil on canvas, 84 x 132 inches © Joseph Raffael. The Oakland Museum, gift of Collectors Gallery and the National Endowment for the Arts. Ph: courtesy of Nancy Hoffman Gallery, New York

56 Alfred Leslie. *Constance West,* 1968–1969. Oil on canvas, 108 x 72 inches. Collection of Robert C. Scull. Ph: Geoffrey Clements, courtesy of Allan Frumkin Gallery, New York

57 Alfred Leslie. *Act and Portrait: Your Kindness,* 1968–1970. Oil on canvas, 60 x 48 inches. The Sydney and Frances Lewis Collection. Ph: Geoffrey Clements

58 Alfred Leslie. *Act and Portrait: Common Sense,* 1968–1970. Oil on canvas, 108 x 72 inches. The Sydney and Frances Lewis Collection. Ph: Geoffrey Clements

59 Alfred Leslie. *Act and Portrait: Coming to Term,* 1968–1970. Oil on canvas, 60 x 48 inches. The Sydney and Frances Lewis Collection. Ph: Geoffrey Clements

60 Alfred Leslie. *The Killing Cycle—#4: Accident,* 1966–1968. Oil on canvas, 72 x 108 inches. Collection of Mr. and Mrs. Robert H. Orchard. Ph: P. Richard Fell, courtesy of Allan Frumkin Gallery, New York

61 Jack Beal. *Prudence, Avarice, Lust, Justice, Anger,* 1977–1978. Oil on canvas, 72 x 78 inches. University of Virginia Art Museum, Charlottesville. Ph: eeva-inkeri, courtesy of Allan Frumkin Gallery, New York

62 Sidney Tillim. *Count Zinzendorf Spared by the Indians,* 1970–1971. Oil on canvas, 60 x 80 inches. Collection of the artist. Ph: Geoffrey Clements

63 Paul Georges. *My Kent State,* 1971. Oil on canvas, 92 x 142 inches

64 Catherine Murphy. *View of World Trade Center from a Rose Garden,* 1976. Oil on canvas, 37 x 29 inches. Hirshhorn Museum and Sculpture Garden, Smithsonian Institution. Ph: courtesy of Xavier Fourcade, Inc., New York

65 Alex Katz. *Winter Scene,* 1951–1952. Oil on board, 24 x 24 inches. Collection of the artist

66 Alex Katz. *Luna Park,* 1960. Oil on canvas, 40 x 30 inches. Collection of the artist. Ph. Rudolph Burchhardt

67 John Gordon. *Street in Iowa City,* 1978. Oil on canvas, 36 x 48 inches. Ph: Nathan Rabin, courtesy of Tatistcheff & Co., New York

68 Nell Blaine. *Landscape near Connecticut River,* 1973. Oil on canvas, 21¼ x 32 inches. Ph: Edward Peterson, courtesy of Fischbach Gallery, New York

69 Wolf Kahn. *Connecticut River,* 1976–1977. Oil on canvas, 44 x 72 inches. Collection of the Rahr-West Museum, Manitowoc, Wisconsin; gift of Mrs. John D. West

70 Andrew Wyeth. *Public Sale,* 1943. Tempera, 22 x 48 inches. Private collection. Ph: Rick Echelmeyer

71 Andrew Wyeth. *Teel's Island,* 1954. Drybrush, 10 x 23 inches. Holly and Arthur Magill Collection

72 Jamie Wyeth. *Pumpkins at Sea,* 1971. Oil on canvas, 22 x 40 inches. Private collection

73 Keith Jacobshagen. *Grain Silo 162 St. & Raymond Road Aug. 4, 1978 4:30–5:45 P. M. 92°,* 1978. Oil on canvas, 6¾ x 7 inches. Private collection. Ph: Will Brown

74 Ben Schonzeit. *Continental Divide,* 1975. Acrylic on canvas, 84 x 168 inches. Denver Art Museum, gift of Mr. Robert Mulholland. Ph: Eric Pollitzer, courtesy of Nancy Hoffman Gallery, New York

75 Timothy O'Sullivan. *Ancient Ruins in the Canyon de Chelle in a niche 50' above present canyon bed,* 1873. Albumen print, 10⅞ x 7⅞ inches. Courtesy of the Library of Congress

76 Joseph Raffael. *Highland Magic (Black Crag, Scotland),* 1975. Oil on canvas, 96 x 144 inches. Ph: courtesy of Nancy Hoffman Gallery, New York

77 Harold Gregor. *Illinois Landscape #32,* 1979. Oil and acrylic on canvas, 69 x 84 inches. Collection of Wayne Andersen. Ph: Russell Hart, courtesy of Tibor de Nagy Gallery

78 Vija Celmins. *Untitled (Big Sea #1),* 1969. Graphite on acrylic ground on paper, 34⅛ x 45¼ inches. Chermayeff & Geismar Associates. Ph: Schenck & Schenck, courtesy of David McKee Gallery, New York

79 Bill Richards. *Fernswamp (with a Hanging Branch),* 1975. Pencil on paper 18 x 22 inches. Collection of the Chase Manhattan Bank. Ph: Bevan Davies, courtesy of Nancy Hoffman Gallery, New York

80 Bill Richards. *Shadow Brook,* 1977–1978. Graphite on paper, 18¼ x 22½ inches. Collection of Mrs. Glen C. Janss. Ph: Bevan Davies, courtesy of Nancy Hoffman Gallery, New York

81 William Nichols. *Day Lilies,* 1978–1979. Acrylic on canvas, 64 x 92½ inches. Collection of Security Pacific National Bank. Ph: D. James Dee, courtesy of O. K. Harris Works of Art, New York

82 George Nick. *Mother's Day, Newburyport,* 1977. Oil on canvas, 36 x 48 inches. Institute of Contemporary Art, Boston, Ph: Tom Rose, courtesy of Tibor de Nagy Gallery, New York

83 Ralph Goings. *McDonald's Pick-up,* 1970. Oil on canvas, 41 x 41 inches. Collection of Mr. and Mrs. Ivan Karp. Ph: courtesy of O. K. Harris Works of Art, New York

84 John Baeder. *Silver Top Diner,* 1974. Oil on canvas, 30 x 48 inches. Collection of Arthur and Jeanne Cohen. Ph: D. James Dee

85 Malcolm Morley. S. S. *United States with New York Skyline,* 1965. Liquitex on canvas, 45½ x 59½ inches. Morton Neumann Family Collection. Ph: Eric Pollitzer, courtesy of Nancy Hoffman Gallery, New York

86 Davis Cone. *Greenwich Theater,* 1979. Acrylic on canvas, 41 x 36 inches. Private collection. Ph: D. James Dee, courtesy of O. K. Harris Works of Art, New York

87 Noel Mahaffey. *St. Louis, Missouri,* 1971. Acrylic on canvas, 60 x 72 inches. Private collection. Ph: courtesy of Barbara Toll Fine Art, New York

88 Richard Haas. *View of Manhattan, Brooklyn Bridge,* 1979. Watercolor, 27½ x 42½ inches. Collection of Jalane and Richard Davidson. Ph: courtesy of Brooke Alexander, Inc., New York

89 Paul Wonner. *Dutch Still Life with Pot of Chrysanthemums,* 1978. Acrylic on canvas, 70 x 48 inches. Ph: courtesy of John Berggruen Gallery, San Francisco

90 Ron Kleemann. *Big Foot Cross,* 1977–1978. Acrylic on canvas, 54½ x 78 inches. The Solomon R. Guggenheim Museum, New York. Ph: Robert E. Mates

91 James Valerio. *Still Life,* 1979. Charcoal and pencil on paper, 48 x 85 inches. Prudential Insurance Company of America. Ph: Quiriconi-Tropea, Chicago, courtesy of Allan Frumkin Gallery, New York

92 Michael Webb. *The Studio #2,* 1978. Pencil and white conté crayon on paper, 48 x 84 inches. Collection of the artist. Ph: Will Brown

93 Louisa Matthiasdottir. *Still Life with Eggplant,* 1976. Oil on canvas, 15 x 21 inches. Private collection, Darien, Connecticut. Ph: eeva-inkeri, courtesy of Robert Schoelkopf Gallery, New York

94 Lennart Anderson. *Still Life with White Pitcher,* 1956–1958. Oil on canvas, 26 x 34 inches. Private collection. Ph: Rick Echelmeyer

95 Gabriel Laderman. *Still Life #5,* 1976. Oil on canvas, 30 x 36 inches. Private collection. Ph: eeva-inkeri, courtesy Robert Schoelkopf Gallery, New York

96 Elizabeth Osborne. *Still Life with Red Bowl,* 1979. Watercolor, 30 x 40 inches. Collection of Arlene and Avrom Doft, New York. Ph: Edward Peterson, courtesy of Fischbach Gallery, New York

97 William Bailey. *Still Life—Table with Ochre Wall,* 1972. Oil on canvas, 47¾ x 53¾ inches. Yale University Art Gallery, purchased with the aid of funds from the National Endowment for the Arts and the Susan Morse Hilles Matching Fund

98 Janet Fish. *Tanqueray Bottles,* 1973. Oil on canvas, 40 x 40 inches. Private collection

99 Carolyn Brady. *White Wicker Chair,* 1977. Watercolor on paper, 44 x 35½ inches. Ph: Bevan Davies, courtesy of Nancy Hoffman Gallery, New York

100 Naoto Nakagawa. *Flight,* 1978. Acrylic on canvas, 46 x 54 inches. Private collection. Ph: D. James Dee, courtesy of O. K. Harris Works of Art, New York

101 Audrey Flack. *Wheel of Fortune,* 1977–1978. Oil and acrylic on canvas, 96 x 96 inches. H.H.K. Foundation for Contemporary Art, Inc., Milwaukee, Wisconsin. Ph: Bruce D. Jones

102 Audrey Flack. *Queen,* 1976. Oil on canvas, 80 x 80 inches. Private collection. Ph: Gerald Murrell, courtesy of Louis K. Meisel Gallery, New York

103 Rebecca Davenport. *Opal Interior,* 1978. Oil on canvas, 6 x 7½ feet. Collection of the artist

104 Paul Wiesenfeld. *Interior with Apples,* 1975. Oil on canvas, 43½ x 38 inches. Permanent collection, Delaware Art Museum. Ph: Raymond Kopcho

105 Walter Hatke. *Front Room,* 1974–1976. Oil on canvas, 48 x 60 inches. Collection of the artist. Ph: Eric Pollitzer, courtesy of Robert Schoelkopf Gallery, New York

106 Douglas Bond. *Al Jolson's Revenge at Superstition Mountain,* 1976. Acrylic on canvas, 60 x 55 inches. Morton Neumann Family Collection. Ph: Eric Pollitzer, courtesy of O. K. Harris Works of Art, New York

107 Sylvia Mangold. *Opposite Corners #23,* 1973. Acrylic on canvas, 78 x 63¾ inches. Yale University Art Gallery, Susan Morse Hilles Fund. Ph: Joseph Szaszfai

108 John Clem Clarke. *Plywood with Three White Sections,* 1974. Oil on canvas, 90 x 48 inches. Collection of James Havard. Ph: Eric Pollitzer, courtesy of O. K. Harris Works of Art, New York

109 Paul Sarkisian. *Untitled,* 1979. Acrylic on canvas, 78 x 108 inches. Ph: Bevan Davies, courtesy of Nancy Hoffman Gallery, New York

110 Stephen Posen. *Flowers I,* 1978. Oil on canvas, 50 x 40 inches. Private collection. Ph: eeva-inkeri, courtesy of Robert Miller Gallery, New York

111 William Allan. *Brook Trout,* 1976. Watercolor, 20 x 27 inches. Collection of the artist. Ph: courtesy of the Hansen Fuller Goldeen Gallery, San Francisco

112 Jamie Wyeth. *Portrait of Pig,* 1970. Oil on canvas, 48 x 84 inches. Ph: courtesy of Coe Kerr Gallery, New York

113 Tommy Dale Palmore. *Reclining Nude,* 1976. Acrylic on canvas, 56 x 84 inches. Philadelphia Museum of Art; funds given by Marion B. Stroud and the Adele Haas Turner and Beatrice Pastorius Turner Fund

114 Don Nice. *Montana Totem,* 1978. Acrylic on canvas, 82½ x 48 inches. Ph: Bevan Davies, courtesy of Nancy Hoffman Gallery, New York

115 Richard McLean. *The Boilermaker,* 1977. Oil on canvas, 56½ x 69 inches. Private collection. Ph: Eric Pollitzer, courtesy of O. K. Harris Works of Art, New York

116 Ralph Goings. *Country Chevrolets,* 1978. Oil on canvas, 26 x 36 inches. Richard Brown Baker Collection. Ph: Eric Pollitzer

117 Robert Bechtle. *'59 Rambler,* 1967. Oil on canvas, 30 x 32 inches. Sloan Collection, Valparaiso University; gift of Mrs. McCauley Conner in memory of her father, Barklie McK. Henry.

118 John Salt. *Silver Plymouth in Woods,* 1979. Oil on canvas 41¾ x 63½ inches. Richard Brown Baker Collection. Ph: D. James Dee, courtesy of O. K. Harris Works of Art, New York

119 James Torlakson. *South City Diamond T,* 1976. Watercolor, 13½ x 18½ inches. The Fine Arts Museums of San Francisco, Achenbach Foundation for Graphic Arts, gift of Mr. and Mrs. George Hopper Fitch, 1977

120 Tom Blackwell. *Triumph Trumpet,* 1977. Oil on canvas, 71 x 71 inches. Collection of Louis and Susan Meisel

121 Robert Graham. *Lise Dance Figure I,* 1979. Painted bronze, 93 x 11 x 7 inches. Collection of the artist. Ph: courtesy of the artist and Robert Miller Gallery, New York

122 Alex Katz. *Sanford Schwartz,* 1978. Oil on aluminum, 71 x 10 inches. Private collection. Ph: eeva-inkeri, courtesy of Robert Miller Gallery, New York

123 Alex Katz. *Red Band,* 1978. Oil on aluminum, 18 x 47¼ inches. Private collection. Ph: eeva-inkeri, courtesy of Robert Miller Gallery, New York

124 George Segal. *The Tightrope Walker,* 1969. Plaster, metal, and rope, 6 feet 16 inches x 17 feet 5 inches. Museum of Art, Carnegie Institute, Pittsburgh, National Endowment for the Arts Matching Grant and Fellows of the Museum of Art Fund

125 George Segal. *Girl Holding Her Left Arm,* 1973. Plaster 31 x 28 x 7 inches. Ph: Eric Pollitzer, courtesy of Sidney Janis Gallery, New York

126 George Segal. *Girl in Robe VI,* 1974. Plaster, 25¾ x 16 x 7 inches. Ph: D. James Dee, courtesy of Sidney Janis Gallery, New York

127 Duane Hanson. *Bowery Derelicts,* 1969–1970. Polyester and fiberglass, polychromed, life-size. Collection Neue Galerie, Aachen. Ph: courtesy of O. K. Harris Works of Art, New York

128 Duane Hanson. *Ryan the Plumber,* 1977. Cast vinyl, polychromed in oil, life-size. Ph: D. James Dee, courtesy of O. K. Harris Works of Art, New York

129 John DeAndrea. *Seated Woman,* 1977. Vinyl, polychromed in oil, life-size. Private collection, New York. Ph: D. James Dee, courtesy of O. K. Harris Works of Art, New York

130 John DeAndrea. *Blond Woman Holding Dress,* 1977. Cast vinyl, polychromed in oil, life-size. Ph: D. James Dee, courtesy of O. K. Harris Works of Art, New York

131 John DeAndrea. *Woman Facing Wall,* 1978. Vinyl, polychromed in oil, and wood, life-size. Sydney and Frances Lewis Collection. Ph: D. James Dee, courtesy of O. K. Harris Works of Art, New York

132 Richard McDermott Miller. *Sandy in Defined Space,* 1967. Bronze, 75 x 37½ x 46 inches. Collection of the artist

133 Richard McDermott Miller. *Stout Woman II,* 1971. Bronze, 11½ x 18½ x 13 inches. Collection of the artist. Ph: Geoffrey Clements

134 Richard McDermott Miller. *Stout Woman III,* 1971. Bronze, 11 x 19 x 11 inches. Collection of the artist

135 Richard McDermott Miller. *Stout Woman I,* 1971. Bronze, 16¾ x 6 x 4¾ inches. Collection of the artist. Ph: Geoffrey Clements

136 Richard McDermott Miller. *Diving, Plummeting, Leveling-Off,* 1977. Bronze, 11 inches high. Collection of the artist

137 Isabel McIlvain. *Seated Figure,* 1979. Hydrocal, 23 x 10 x 7½ inches. Ph: eeva-inkeri, courtesy of Robert Schoelkopf Gallery, New York

138 Harvey Citron. *Female Figure Standing,* 1976. Bronze, 18 x 4 x 4 inches. Collection of the artist. Ph: Peter Johansky Studio

139 Robert White. *Portrait of Ann Jay,* 1974. Bronze, 11 x 22 inches. Collection of Mr. and Mrs. Robert Dean Jay. Ph: Bill Seeberger, courtesy of Graham Gallery, New York

140 Walter Erlebacher. *Jesus Breaking Bread,* 1975–1976. Bronze, 6 feet high. Archdiocese of Philadelphia. Ph: Will Brown

141 Walter Erlebacher. *Bishop John Neumann Greeting the Citizens of Philadelphia,* 1979. Maquette: plastelene, 9⅞ x 28½ x 15½ inches. Collection of the artist. Ph: Rick Echelmeyer, courtesy of the artist

142 Jud Nelson. *HOLOS/series 7, nos. 1-6 (Wonder bread),* 1979. Carved Italian statuary marble, 4 x 4 x ½ inches Nos. 1, 2, 6, courtesy of Carol Taylor Art, Dallas. Phs: Bevan Davies. Nos. 3, 4, 5, collection of the artist. Phs: Bevan Davies, courtesy of Robert Miller Gallery, New York

143 Marilyn Levine. *Judy's Hiking Boots,* 1974. Ceramic, 5½ x 4½ x 11 inches each. Collection of Bruce and Barbara Berger. Ph: courtesy of O. K. Harris Works of Art, New York

144 Fumio Yoshimura. *Bicycle with Parking Meter,* 1978. Linden wood, 68 x 53½ x 16½ inches. Ph: Bevan Davies, courtesy of Nancy Hoffman Gallery, New York

Index

Designed by Design Studio

Copyedited by Betsy Pitha

Production coordination by Nan Jernigan

Composition by Dumar Typesetting

Color separations by Offset Separations Corp.

Color Printed by Princeton Polychrome Press

Paper supplied by S. D. Warren Co.

Printed by Murray Printing Co.

Bound by Murray Printing Co.